Medieval Academy Reprints for Teaching 24

Medieval Academy Reprints for Teaching

Adolf Katzenellenbogen

ALLEGORIES OF THE
VIRTURES AND VICES IN
MEDIEVAL ART

From Early Christian Times
to the Thirteenth Century

Published by University of Toronto Press
Toronto Buffalo London
in association with the Medieval Academy of America

First published 1939 by the Warburg Institute, London,
as volume 10 in the series, Studies of the Warburg Institute.
Text translated by Alan J.P. Crick.
This edition is reprinted by arrangement with the heirs of
Adolf Katzenellenbogen.

CONTENTS

PAGE

INTRODUCTION .. VII

PART I. DYNAMIC REPRESENTATIONS OF THE CONFLICT
 BETWEEN VIRTUES AND VICES I

 CHAPTER I. The Illustrated Manuscripts of the "Psychomachia"
 and their Influence.................................... I

 CHAPTER II. The Virtues triumphant 14

 CHAPTER III. Man's arduous Ascent to God (The Ladder of
 Virtue) .. 22

PART II. STATIC REPRESENTATIONS OF SYSTEMS OF
 VIRTUES AND VICES.......................... 27

 CHAPTER I. Virtues in human Form 27

 CHAPTER II. Particular Allegories of Virtues and Vices 57

 CHAPTER III. The Virtue and Vice Cycle of Notre-Dame...... 75

 Appendix. The Influence of the Virtue and Vice Cycle of Notre-
 Dame.. 82

LIST OF ILLUSTRATIONS............................... 85

LIST OF ABBREVIATIONS 88

INDEX OF PLACES 91

INDEX OF NAMES AND SUBJECTS....................... 96

INTRODUCTION.

The mediaeval practice of representing moral concepts in personified form goes back to a classical tradition. The artists of the Middle Ages used two methods for depicting such themes — but both types spring from classical models.

In the East a regular form of representation for battle themes was already established in antiquity, in which the victor was represented as standing in triumph on the body of the vanquished. Battle representations recurred again and again in western art in many centuries of subsequent development extending in poetry from the Iliad to the Aeneid, and in representational art from mythological gigantomachy down to the historical scenes of battles between Romans and Barbarians. Early Christian poetry adapted the classical theme of the conflict of armed forces to the sphere of moral allegory, developed it further and endowed the opposing moral forces with the clearly defined features of personifications speaking, acting and struggling with one another. Artists also used the traditional battle scenes as a basis for dynamic representations of the conflict between virtues and vices. This picture cycle originated in the 5th century and survived right through the Middle Ages as an expression of the struggle in man's soul.

In the other group, moral concepts are represented as types, without being shown in conflict. They are here linked together by a complex system of linear pattern, which was already fixed in Roman times. These static representations of virtues and vices flourished from the ninth century onwards. Unlike the battle scenes, they no longer show traces of the confusion and excitement of the Early Christian era, but they come to be permeated and elaborated by the subtle mode of thought of the theologians. While the first group demonstrates the necessary practical settling of issues between good and evil, the second group gives the observer theoretical insight into the essential nature of those forces and their relations to one another.

One is thus enabled to trace in the broad stream of western art two distinct currents, which rise to great dimensions in centres of special learning or of flourishing craftsmanship, and cover every phase of human experience from

the basest earthliness to the intensity of spiritual rapture, until, in the early 13th century, they go to form a sum total of all morality — in the virtue and vice cycle of Notre-Dame in Paris. This milestone will provide the chronological limit of the following study[1].

The author is very grateful to Dr. Saxl and Professor Panofsky for valuable suggestions and constant encouragement during the preparation of this work. He wishes also to thank Mr. Alan Crick for undertaking the work of translation, and to Mr. Anthony Blunt and Mr. Arthur Watson, who checked the English text and the proofs.

[1] General literature concerning the iconography of mediaeval representations of virtues and vices:
Raimond van Marle, *Iconographie de l'art profane au moyen-âge et à la renaissance* II, Hague 1932, pp. 1 ff.
Karl Künstle, *Ikonographie der christlichen Kunst* I, Freiburg i. Br. 1928, pp. 156 ff.
Wilhelm Molsdorf, *Christliche Symbolik der mittelalterlichen Kunst*, Leipzig 1926, pp. 210 ff.
Émile Mâle, *L'art religieux du XIIIe siècle en France*, Paris 1925 (6th ed.), pp. 99 ff.
Joseph Sauer, *Symbolik des Kirchengebäudes*, Freiburg i. Br. 1924 (2nd ed.), pp. 233 ff., 414 ff.
Paul Clemen, *Die romanische Monumentalmalerei in den Rheinlanden*, Düsseldorf 1916, pp. 312 ff.
Hans von der Gabelentz, *Die kirchliche Kunst im italienischen Mittelalter*, Strasbourg 1907, pp. 211 ff.
Cf. further Otto Zöckler, *Die Tugendlehre des Christentums*, Gütersloh 1904, and Marie Gothein, "Die Todsünden" *(Archiv für Religionswissenschaft* X, 1907, pp. 416 ff.).
In the following text the most frequently quoted books are referred to by catchwords. The full titles are found on p. 88.

PART I.

DYNAMIC REPRESENTATIONS OF THE CONFLICT BETWEEN VIRTUES AND VICES.

CHAPTER I. THE ILLUSTRATED MANUSCRIPTS OF THE 'PSYCHOMACHIA' AND THEIR INFLUENCE.

The representation of the conflict between virtues and vices received its decisive impulse from the *Psychomachia* of Prudentius, an early 5 th century work[1]. In a graphic and telling manner the author depicts the battle for man's soul; he develops the Pauline thought that the Christian must arm himself with spiritual weapons in order to face successfully the forces of evil (Ephes. VI, 11 ff.), and deepens and expands the well-known parable of Tertullian, of the victory of the virtues over the vices[2], into an allegorical epic.

True to classical tradition, Prudentius personifies the opposing forces of the soul as female figures. In so doing, he lends the vices the character rather of mortal sinners than of inescapable demons and thus, using the wealth of everyday experience, he lessens the fear of the power of evil. He involves both parties in the motley turmoil of battle and makes them resemble those warriors whose deeds were sung by Roman poets and recorded by Roman artists[3]. He lets the warring females pit their wits against one another in violent dispute, such as was already a common feature in poetry[4]. And so these old-established forms served him as a means of giving his contemporaries a clear illustration of the unseen conflicts of the soul, which every true Christian must go through before he can emerge victorious.

[1] *Aurelii Prudentii Clementis carmina* ed. Joannes Bergman *(Corp. script. eccl. lat.* LXI), Vienna-Leipzig 1926, pp. 165 ff.

[2] *De spectaculis* XXIX *(Corp. script. eccl. lat.* XX), Prague-Vienna-Leipzig 1890, p. 28.

[3] This description is reminiscent not only of its classical model, the 10th Book of the Aeneid, but also of the battle scenes of Roman art. For the motives borrowed from the Aeneid, those of seizing combatants by the head and slaying or trampling on them, or of their falling off a horse or down from a chariot, were already common to both epic poetry and pictorial representation in the time of ancient Greece. Cf. *Psychomachia*, v. 282 sq.: "tunc caput orantis flexa cervice resectum eripit ..." with Aeneid X, v. 535 sq.: "... atque reflexa cervice oranti capulo tenus applicat ensem". — also *Psychomachia*, v. 32, 270 ff., 409 ff. with Aeneid X, v. 736, 892 ff., 573 sq.).

[4] Concerning the classical disputation, the "Syncrisis" cf. Erwin Panofsky, *Hercules am Scheidewege (Studien der Bibl. Warburg)*, Leipzig-Berlin 1930, pp. 42 ff.

The epic is constructed, in a clear and well-knit fashion, of seven battle scenes. At the beginning and at the end Veterum Cultura Deorum and Discordia, who are the worst menaces to the Christian faith without and within, are vanquished. Of the other scenes the first two depict the victory over the specially unbridled passions (Libido and Ira). In the middle of the poem Superbia, the root of all evil, appears on the scene. Later on the most dangerous embodiments of sybaritism (Luxuria and Avaritia) meet their well-earned fate.

The virtues now have to exert every effort to gain the victory. Fides, who, eager for the fray, enters the scene of battle, fells Veterum Cultura Deorum and tramples on her (v. 21 ff.).

Brandishing a torch, Libido comes to the attack, which Pudicitia wards off by throwing a stone; she then pierces the vice's throat (v. 40 ff.)[1].

In the following episodes the vices perish on account of their very nature or through their own malpractices. Out of furious chagrin that her shots slide harmlessly off the armour and helmet of Patientia, at whose side Job faithfully stands, Ira commits suicide (v. 109 ff.).

Superbia, in an attempt to ride down Mens Humilis and Spes, falls into a pit which Fraus has secretly dug as a trap for the virtues and then lightly covered over. Now it is an easy task for Mens Humilis to decapitate the suddenly fallen vice (v. 178 ff.).

In the next two scenes the epic reaches its climax. Riding in an ornate chariot, Luxuria draws near and with flowers and narcotic scents she saps the courage of her enemies. Whereupon Sobrietas, raising the flag of the cross, causes the team of horses to shy. In her hasty retreat Luxuria falls from her chariot. Struck by a millstone, she has to swallow her tongue and teeth and is thus stifled by the instruments of her gluttony (v. 310 ff.). The initial success of evil has been followed by a sudden defeat, which is turned once again into an illusory victory in the next episode.

Together with her daughter vices, Avaritia greedily collects the treasures abandoned by Luxuria's following and establishes her rule of terror over mankind. When Ratio protects with her shield those who are threatened, Avaritia with cunning simulation appears as Thrift and deceives the people. Operatio, however, hastens to help her own, throttles and crushes the strangler. She then distributes the treasures among the poor (v. 454 ff.). Prudentius

[1] Certain scenes (e. g. the crowning of the martyrs by Fides or the purification of the sword by Pudicitia) which Prudentius inserts as links between the scenes of combat give the poem its peculiar rhythm. The dramatic tension of the action is not constantly the same from the very beginning, but it is always relaxed between two main scenes, to be revived immediately afterwards.

thus allows only Luxuria and Avaritia to triumph for a short while, since it is precisely these two vices which man can least resist.

The defeat of Avaritia has settled the fate of the army of vices. Operatio commands that the fighting shall cease. When Pax arrives, the oppressors and seducers, Metus, Labor, Vis, Scelus and Fraus, flee (v. 604ff.).

Concordia leads the companies back to the camp but the peace is broken once again. Disguised as a virtue and unnoticed at the entrance to the camp, Discordia attacks Concordia; Fides, however, pierces Discordia's tongue. The vice bent on causing discord is herself punished by being torn to pieces (v. 644ff.).

Fides and Concordia, the victors over heathen disbelief and internal religious dissension, now summon the virtues to the building of a symbolic temple, in which Sapientia is enthroned superior to all the vagaries of human life, bearing as a symbol of her timelessness her ever-flowering sceptre of roses and lilies (v. 726ff.). The fury of the battle thus yields to a state of peace and perfection, showing how all temporal activity is only justified in as far as it possesses a higher significance[1].

The vividness of Prudentius' story conjures up in the reader's mind a wealth of visual images. One is not surprised therefore, that the epic was soon illustrated and, since it later became one of the most popular didactic works of the Middle Ages, that artists repeatedly copied the series of pictures.

Today, apart from a few minor fragments, sixteen illustrated manuscripts are in existence and these were produced in scriptoria often at great distances from one another. The oldest belong to the 9th century, while the latest is dated 1298[2].

[1] This mode of thought which proceeds step by step from that which is only valid under certain conditions to that which finds complete general acceptance is also characteristic of the pictorial art of this period. In S. Maria Maggiore in Rome, for example, the mosaics of the nave with their scenes from the lives of Old Testament forerunners of Christ, lead to the triumphal arch and scenes from the early life of Christ are here inserted in the framework of the symbols of eternity, the throne of judgement and the two churches represented by the holy cities of Jerusalem and Bethlehem.

[2] Richard Stettiner was the first to deal comprehensively with the illustrated *Psychomachia* manuscripts *(Die illustrierten Prudentius-Handschriften*, Berlin 1895) and to publish them (Plates, Berlin 1905). The results have been checked by Helen Woodruff ("The Illustrated Manuscripts of Prudentius"; *Art Studies*, 1929, pp. 33 ff.).

The sixteen manuscripts, according to the system of abbreviated designations established by Stettiner, are as follows:

P¹ (Paris, Bibliothèque Nationale, MS. lat. 8318) late 10th century, from the neighbourhood of Tours.

Le¹ (Leyden, University Library, Cod. Voss. lat. oct. 15) first half of the 11th century, Angoulême or Limoges.

The archetype of all these manuscripts no longer exists. But the manuscripts P^1 and Le^1, which, in spite of much modification and weakening, have preserved the essential features most faithfully, allow one to conclude that it was produced as early as the 5th century.

The first miniaturist found a firm basis for his task in the text of the epic, which gives clear and detailed impressions of the course of the symbolical struggle, as well as of the appearance and behaviour of the participants, and was consequently the greatest factor in determining the nature of the illustrations.

Certain phases of the battle, quarrel scenes and various other situations tempted the artist to translate them into his own language. In doing so, it seemed more important to him to make the series of pictures correspond to the drama of the action than to illustrate the manuscript in a mechanical fashion at regular intervals, one picture to a page for example, as is the case with the Vienna Genesis. He occasionally crowds the pictures together and, on the other hand, completely disregards large portions of the the poem. Thus the arrangement of the miniatures reflects directly the intensity of the action.

As in the text, the virtues and vices are depicted for the most part unarmed and in classical female garb. They are characterised by their actions and behaviour. Like the author, the illustrator does not make a fundamental distinction between them by lifting the virtues out of the normal sphere with the aid of symbolic attributes or by caricaturing the vices as embodiments of evil. On the contrary, he lends the vices all the charms of which the poem speaks; Superbia, for example, impetuous courage[1],

C (Cambridge, Corpus Christi College, MS. 23) first half of the 11th century, Malmesbury Abbey.
Lo¹ (London, British Museum, Add. MS. 24199) first half of the 11th century, Bury St. Edmunds?
Lo² (London, British Museum, Cotton MS. Cleopatra C. viii) first half of the 11th century, English.
Le² (Leyden, University Library, Cod. Burmanni Q 3) second half of the 9th century, St. Amand.
B¹ (Brussels, Bibliothèque Royale, MS. 974) second half of the 9th century, St. Amand.
V (Valenciennes, Bibliothèque Municipale, MS. 563) early 11th century, St. Amand.
P² (Paris, Bibliothèque Nationale, MS. lat. 8085) late 9th century, French.
Be (Berne, Stadtbibliothek, MS. 264) late 9th century, South German.
B² (Brussels, Bibliothèque Royale, MS. 977) late 10th century, Abbey of St. Laurent, Liége.
Ly (Lyons, Bibliothèque du Palais des Arts, MS. 22) second half of the 11th century, French.
B³ (Brussels, Bibliothèque Royale, MS. 975) middle of the 11th century, Abbey of St. Laurent, Liége?
G (St. Gall, Stiftsbibliothek, MS. 135) first half of the 11th century, St. Gall.
Lo³ (London, British Museum, Cotton MS. Titus D xvi) circa 1100, St. Albans.
P⁴ (Paris, Bibliothèque Nationale, MS. lat. 15158) 1298, St. Victor, Paris.
[1] P^1 fol. 51 r (Stettiner, pl. 2, no. 4).

4

Luxuria all the fascinations of a seductive woman[1]. The association, moreover, of few leading figures with numerous "supers", through which the main theme stands out in a clear light against the confused background of the fighting, is taken over unimpaired into the illustrations. Filling the whole depth of the stage, the figures frequently overlap[2]. The miniaturist thus allows himself to be guided by the text as by a stage direction[3].

The forms into which he pours his content are nothing new. They were already established in Roman classicism and served him, as well as some of his contemporary artists, as a vehicle for illustration, of which the validity was still unquestioned. What he wished to illustrate—episodes such as battle scenes, the advance of the adversaries to the attack, the flight of the conquered, the rule of terror of victorious vices, the distribution of booty, the return to the camp and the solemn final address to the virtues—this all corresponded to secular scenes in Roman relief sculpture, especially the great cycles on the triumphal columns[4]. Here war was represented in all its phases and subsidiary aspects, a general review in fact. Presumably there existed illustrated descriptions of these reliefs, which may have served in the artist's work-rooms as a pattern-book for battle pictures[5]. The traditional forms give the content, though of quite different origin, full scope for expression, because it is analogous.

And thus Superbia, who lies across her fallen steed[6], resembles those numerous dead or wounded cavalrymen, who have collapsed over the backs of their horses, which have given way beneath them[7]. Scenes of oration,

[1] P¹ fol. 52 r (Stettiner, pl. 3, no. 2).

[2] P¹ fol. 62 v (Stettiner, pl. 10, no. 4). — Le¹ fol. 42 r (pl. 25, no. 1).

[3] There are other instances in Early Christian art, where the artist, using literary descriptions as a basis, represented virtues as busy maidens. A fresco in the catacomb of S. Gennaro at Naples, third century, shows how three virtues help to complete the symbolical building of the Tower of the Church in the same way as is related in a parable in the "Shepherd of Hermas" (*Sim.* IX, 3 ff.; Funk, *Opera patrum apostolicorum* I, pp. 505 ff.). Cf. Hans Achelis, *Die Katakomben von Neapel*, Leipzig 1936, pl. 10.

[4] Cf. Karl Lehmann-Hartleben, *Die Trajanssäule*, Berlin-Leipzig 1926; and E. Petersen, A. v. Domaszewski, G. Calderini, *Die Marcussäule*, Munich 1896. — In his excellent work ("Die kunstgeschichtliche Stellung der Marcussäule", *Jahrbuch des deutschen archäologischen Instituts* XLVI, 1931, pp. 61 ff.) Max Wegner frequently traces the survival of typical forms which had come to be reflected in triumphal sculptures.

That this wealth of motives, in spite of stylistic changes, was still used in the 5 th century, is shown both in miniatures of battle scenes of a non-religious nature, the Ambrosian Iliad in particular, as well as in representations having Christian content, e. g. that of the Joshua story in the mosaics of the nave of S. Maria Maggiore.

[5] Theodor Birt, *Die Buchrolle in der Kunst*, Leipzig 1907, pp. 288 ff.

[6] P¹ fol. 51 v (Stettiner, pl. 3, no. 1).

[7] E. g. on the column of Marcus Aurelius (Petersen, pls. 32 B, 105 B).

such as that of the deceiving Avaritia[1], may be traced back to the "address" type[2]. The poor and needy, to whom Operatio makes gifts[3], take up the same attitude as some barbarians on a relief of the column of Marcus Aurelius, who beg for mercy[4]. While giving the command to return to the camp, Concordia stands behind the warriors with raised right arm in exactly the same way as the Roman Emperor stood, when ordering his troops to march (Figs. 1, 2)[5]. And when, in accordance with the text, the foot soldiers follow the cavalry on the homeward march, use is made of a thoroughly apposite rendering of a marching scene, an example of which was already provided on the column of Trajan (Figs. 3, 4)[6].

The attitudes of certain figures enable one to draw analogies. In his representations of the corpse of Libido or the fallen Luxuria[7], the illustrator succeeds in reviving certain forms from the wide range of classical portrayals of fallen warriors[8]. Some soldiers carrying sacks on a relief of Trajan's column[9] strike one as models for Labor, who escapes, bearing a heavy burden on his shoulders[10].

Forms of mythological pictures occur here and there. In illustrating the overthrow of Luxuria, for example, the artist draws upon the representation of Phaeton's fall from the sun-chariot[11]. He makes the vice fall headlong in the same way as the rash son of the gods, while the team of horses rears up on either side[12]. Ira in her short garment resembles a classical Fury even more closely and with greater justification since Prudentius occasionally gives the vices the name of these tormenting spirits[13].

Thus the first artist to illustrate the *Psychomachia* draws, in the main, on two related sources. He takes the subjects for his miniatures from the vivid battle description of Prudentius, while for their form he is indebted to battle scenes as represented in classical Roman art.

[1] P¹ fol. 60 r (Stettiner, pl. 6, no. 4).
[2] E. g. on the column of Trajan (Lehmann-Hartleben, pl. 16, no. XXVIII) or that of Marcus Aurelius (Petersen, pl. 39 A).
[3] P¹ fol. 60 v (Stettiner, pl. 7).
[4] Petersen, pl. 46 B.
[5] P¹ fol. 62 r (Stettiner, pl. 10, no. 3) — Column of Marcus Aurelius (Petersen, pl. 10 B).
[6] P¹ fol. 62 v (Stettiner, pl. 10, no. 4) — Lehmann-Hartleben, pl. 47, no. CI.
[7] Le¹ fol. 38 r, P¹ fol. 58 r (Stettiner, pls. 20, no. 3; 4, no. 4).
[8] E. g. on the column of Marcus Aurelius (Petersen, pl. 35 A).
[9] Lehmann-Hartleben, pl. 59, no. CXXIV.
[10] P¹ fol. 61 v (Stettiner, pl. 9, no. 2).
[11] E. g. Sarcophagus in the Ny Carlsberg Glyptothek, Copenhagen (Carl Robert, *Die antiken Sarkophagreliefs* III. 3, Berlin 1919, pl. CVIII, fig. 336).
[12] P¹ fol. 58 r (Stettiner, pl. 4, no. 4).
[13] Le¹ fol. 38 v (Stettiner, pl. 20, no. 4) . Cf. *Psychomachia*, v. 46, 96, 158.

The paths leading from the archetype to the various copies frequently fork and recross[1]. While the principle of literally exact illustration is maintained in one series of manuscripts (P[1], Le[1], C, Lo[1], Lo[2])[2], others show a heightening of the dramatic intensity of the allegorical struggle under the influence of the Rheims School of Carolingian miniaturists (Le[2], B[1], P[2])[3]. Owing to the animated drawing of contours, the attitudes of the figures give an impression of energy. The contrast between virtues and vices is greatly emphasized and exaggerated. In flat contradiction to the text, Humilitas and Spes, for example, no longer appear as women protected by spiritual strength but as well-armed warriors in the armour of Roman soldiers. Most of the vices are caricatured as weird powers of darkness (Fig. 5)[4]. Their hair, in tufts and unkempt, and their garments, often consisting merely of a tattered loin-cloth, give an immediate impression of violence and wildness. Their weapons are more frightful and have a greater diversity than usual. And so the vices present with great directness the idea of evil as a living force. This would naturally make them appear more dangerous and more greatly to be feared. The allegorical action loses connexion with phenomena of the natural world, a connexion which had still been preserved in the archetype, and the action now pursues its course in a sphere of unreality.

In the 11th century a reaction of steadily increasing intensity sets in. In G the figures appear in contemporary costume[5], in Lo[3] certain scenes resemble tournaments[6]. The miniaturist of P[4], who in 1298 treated the illustration material for the last time, makes the virtues appear as nuns and the vices as townswomen (Fig. 6)[7]. And so he places the action in a setting of greater reality, that of the world around him, for at that time there was again a tendency to apply the wealth of everyday experience to the discernment of good and evil[8].

The immediate influence of the illustration of the *Psychomachia* is seen

[1] Stettiner shows in a diagram how the copies are descended from the archetype and how they are divided into two groups (p. 201). H. Woodruff has convincingly modified this general scheme and perfected it.
[2] Stettiner, pls. 1 ff. and pp. 3 ff. — Woodruff, pp. 36 ff.
[3] Stettiner, pls. 69 ff. and pp. 33 ff. — Woodruff, pp. 40 ff.
[4] Le[2] fol. 125 v (Stettiner, pl. 89, no. 1).
[5] Stettiner, pls. 191, 192 and pp. 131 ff. — Woodruff, pp. 46, 47. — Adolf Merton, *Die Buchmalerei in St. Gallen vom neunten bis zum elften Jahrhundert*, Leipzig 1923 (2nd. ed.), pls. LXV, LXVI and pp. 67, 68.
[6] Stettiner, pls. 193 ff. and pp. 138 ff. — Woodruff, p. 47.
[7] Fol. 53 v. Cf. Stettiner, pls. 197 ff. and pp. 144 ff.
[8] The work of certain copyists, each of whom followed his bent, prepared the stock of motives. In the 11th century the illustrator of Ly, for example, depicts with unusual thoroughness of detail Avaritia's rule of terror (Stettiner, pls. 113 ff.). The miniaturist of G, on the other hand, combines several pictures, as a rule at the beginnings of the main sections (Stettiner, pls. 189, 191, 192).

most clearly in the 12th century. Not only were certain motives[1] taken from the diversity of illustration but also the essential structure, and consequently the pictures became confined, as a rule, to the representation of pairs of antagonists, who are taken out of their surroundings and severed from the general fighting.

This step towards a systematic simplification had already been hazarded by the miniaturist of P[1], when he illustrated a short tract, supplementary to the epic, on the contrast between eight virtues and vices, and for this purpose

[1] I. In the minor art forms:

Patientia attacked by Ira and the latter's defeat as pictorial illumination of the Mainerus Bible, late 12th century, Canterbury (Paris, Bibliothèque Ste. Geneviève, MS. 9, fol. 194 r; MS. 10, fol. 128 r). Cf. A. Boinet, "Les manuscrits à peintures de la Bibliothèque Ste. Geneviève de Paris" (*Bulletin de la Société française de reproductions de manuscrits à peintures* V, 1921, pp. 1 ff., pl. VIII).

Representations of the defeat of the vices were freely extended to similar fighting pairs. Cf. four enamel plaques of the Meuse School, circa 1160 (Langres, Musée), which were originally intended for a reliquary. Fortitudo stabs Debilitas to Death. Temperantia slays Intemperantia. Justitia presses back the escaping Injustitia and prepares to thrust at her with a spear. Humilitas has seized Superbia by the hair in order to give her the *coup de grâce*. The virtues clad in brightly coloured garments are differentiated by colour symbolism from the vices who are dressed in sombre fashion. (The author is indebted to Professor Swarzenski for drawing his attention to these plaques.)

Six vices of the *Psychomachia* (Superbia, Ira, Luxuria, Idolatria, Avaritia, Libido), some of which follow Ira's example and commit suicide, are shown on the base of a candlestick formerly in the Figdor Collection, late 12th century, Hildesheim *(Die Sammlung Dr. Albert Figdor-Wien* I. 5, Berlin-Vienna 1930, no. 465, pl. CLXVIII). They symbolize evil forced down into darkness and overcome by the radiant light of good. Cf. the inscription on the Gloucester candlestick, circa 1100 (London, Victoria and Albert Museum):

"Lucis onus, virtutis opus, doctrina refulgens,
Predicat, ut vicio non tenebretur homo."

Twelve virtues, who seize vices by the hair, crush and throttle them, decorate the ribs on the left side of the roof of the Heribert Shrine at Deutz, between 1165 and 1175. Cf. Falke-Frauberger, pls. 85—87; and Braun, *Heribertusschrein*.

II. As interpreted by the technique of the major art-forms:

The end of Discordia: The floor-mosaic of S. Maria del Popolo at Pavia (Museo Civico), 12th century. Cf. Toesca, *Pittura*, p. 90. — d'Ancona, pl. XIV and p. 41. The same theme on a floormosaic in Cremona Cathedral, 12th century. At the side of this Discordia representation Crudelitas and Impietas thrust spears into each other. Cf. Toesca, *Storia*, p. 1082. — Toesca, *Pittura*, fig. 64. — d'Ancona, pl. XIII and p. 41.

A mosaic from S. Maria Maggiore in Vercelli (Museo Leone) shows a bearded man ("Fol") fighting with a negro ("Fel"). Cf. Toesca, *Storia*, fig. 773 and p. 1083. — d'Ancona, p. 41.

Mosaic, in a bad state of preservation, with Felonia, Mendacitas and Furibundia in S. Donato in Murano (d'Ancona, pp. 41, 42).

The suicide of Ira and a fight between Largitas and Avaritia on a capital of the ambulatory round the apse of Notre-Dame-du-Port at Clermont-Ferrand, first half of the 12th century (Kingsley Porter, figs. 1181, 1182. — Mâle I, figs. 19, 20).

Psychomachy painting in the church of Tavant (Indre-et-Loire), 12th century (Henri Focillon, *Peintures romanes des églises de France*, Paris 1938, pl. 67).

The "upright man" treads on the devil of mendacity in order to tear out his tongue by the roots. A relief on the south front of Modena Cathedral, first quarter of the 12th century (Toesca, *Storia*, fig. 483 and pp. 759, 760).

borrowed the pairs of fighters in some instances from corresponding battle scenes of the *Psychomachia*, or treated them in a similar manner[1].

On the ivory front-cover of the Melisenda Psalter (between 1131 and 1144) the seven pairs of the *Psychomachia* and five other virtues (Bonitas, Benignitas, Beatitudo, Largitas, Laetitia) are arranged around a series of scenes from the life of David (Fig. 7)[2]. This association with the life of David may be traced back to the epic of Prudentius, for Spes in her verbal attack refers to the humble David, who overcame the arrogant Goliath (v. 291 ff.), and Sobrietas, too, has David in mind (v. 386ff.). The artist understands how to use the limited space for the pictures of the struggle in such a way that their deeper meaning is all the more clearly illustrated. He gives the virtues sufficient space to show their strength freely and dominate the scenes. The vices, on the other hand, are pressed into the corners, over to the sides or downwards, and condemned to impotence.

A similar theme has been dealt with in a Book of the Gospels, which belonged to Henry the Lion and which was completed about 1175 by the monk Hermann of Helmarshausen[3]. In the spandrels the miniaturist gives an extract from the *Psychomachia* illustrations with greater completeness than the artist of the ivory cover; he also gives explanatory comments. He is guided, moreover, by a delicate feeling for the rhythmic construction of the epic. In the left spandrel he illustrates as a rule the climax of each of the seven scenes of combat, while on the right he gives connecting scenes between the main sections[4]. The helplessly struggling vices are pressed down into a corner or are overlapped by the soffits. The active participants in the great struggle, who are rendered in profile, are followed, on the last leaf, by a strictly frontal representation, on the left, of the sisters Fides and Concordia, seated on a throne, and, on the right, of Sapientia similarly depicted; the reason for this is that the profile type of representation is more appropriate for temporal action, while the frontal is better suited for indicating timelessness.

In other cycles, the immediate influence of the *Psychomachia* is superseded

[1] Fols. 53 r — 54 v (Stettiner, pls. 8, 12 and 15, no. 1). Humilitas fights with Superbia, Abstinentia with Gula, Castitas with Fornicatio, Largitas with Avaritia, Patientia with Ira, Gaudium with Tristitia, Sobrietas with Accidia and Fides with Vana Gloria. The vices correspond to the series established by Evagrios of Pontos in his work "Περὶ τῶν ὀκτὼ λογισμῶν" (Migne *P. Gr.* 40, 1271 ff.).

[2] London, British Museum, Egerton MS. 1139. Cf. Adolph Goldschmidt and Kurt Weitzmann, *Die byzantinischen Elfenbeinskulpturen des X.—XIII. Jahrhunderts* II, Berlin 1934, pl. LXXIII and pp. 79, 80 with bibliography.

[3] Gmunden, Kgl. Ernst-August Fideikommissbibliothek, Schloß Cumberland. Cf. Jansen, pp. 61 ff. with bibliography. — Swarzenski, *Kunstkreis*, pp. 254 ff.

[4] There is a full description of this in Jansen, pp. 68, 69.

by that of moral tracts, which continue to use the vivid image of con-
flicting armies but only as a lifeless formula. Following the method already
adopted by Gregory the Great[1], they merely specify those engaged in the
"Conflictus virtutum et vitiorum", subdivide them into a number of
minor concepts and let them serve as mere mouthpieces for didactic
discussion[2].

Thus the battle between virtues and vices in the *Hortus Deliciarum* of
Herrad of Landsberg (late 12th century) owes its composition to a widely
disseminated tract of the first half of the 12th century *De fructibus carnis et
spiritus*, which is supposed to have been written by Hugo of St. Victor[3]. The
author of this tract opposes Humilitas with her "comites", the three theological
virtues (Fides, Spes, Caritas) and the four cardinal virtues (Prudentia, Justitia,
Fortitudo, Temperantia), to Superbia and her followers (Luxuria, Ventris
Ingluvies, Avaritia, Tristitia, Ira, Invidia, Vana Gloria). Herrad adopts this
system, in its firmly established sequence and remoulds it into a dramatic
scene at the opening of this picture cycle (Fig. 8)[4]. The lack of flexibility
and the systematically colourless enumeration of the tract still shows its
influence in the succession of figures uniformly represented as knights; this
rigidity is, however, broken by the established motive of Superbia's furious
riding.

Herrad wished to supplement the introductory scene by showing the fol-
lowing of Humilitas and Superbia, in their turn leaders of subsidiary virtues,
fighting with the leaders of the lesser vices, for even in the tract the principal
conceptions are divided into different classes. But since the seven virtues
and seven vices do not correspond as natural opposites, Herrad is only able
to make four pairs of contrasts out of them, namely Spes and Tristitia, Caritas
and Invidia, Prudentia and Vana Gloria, Temperantia and Luxuria. She
creates fitting antagonists for the remaining virtues and vices, thus increasing
the number of the fighting leaders to ten. The rank and file she composes

[1] *Moralia in Job*, lib. XXXI, cap. 45 (Migne *P. L.* 76, 620 ff.).
[2] Cf. H. Walther, *Das Streitgedicht in der lateinischen Literatur des Mittelalters (Quellen und Unter-
suchungen zur lateinischen Philologie des Mittelalters* V. 2), Munich 1920, pp. 110 ff.
[3] Migne *P. L.* 176, 997 ff. — The following investigation is partly based on the conclusions recorded
in an unprinted work of Stettiner on the *Hortus Deliciarum*. The author is greatly indebted to
Frau Prof. Stettiner for giving him access to this work.
[4] Fols. 199 v and 200 r (Straub-Keller, pls. XLIII, XLIV). A note beside an illustration of a tourn-
ament between two knights in the Albani Psalter, first half of the 12th century, indicates the in-
tended moral significance of the picture: "... sicut ipsi corporaliter sunt tumentes superbia et
maledictione, similiter nos spiritualiter oportet esse mansuetos in humilitate et deica benedictione"
(Goldschmidt, *Albanipsalter*, pl. 2 and p. 48). The conception of the fight between good and evil,
as expressed in the battles between men and monsters in Romanesque art, is more general.

of figures from the epic and of lesser concepts from the tract[1]. The composition of various episodes in the fight corresponds with the construction of the initial miniatures. Serried companies of vices led by a "principale vitium" launch an attack on the virtues, who follow the "principalis virtus". Herrad intersperses these general, tractarian pictures with individual phases of the fighting, which she borrows from the illustrations of the *Psychomachia* or forms by analogy with them. In this way she lends movement to the rather sticky flow of the scene sequence. As soon as Luxuria and Avaritia appear, the presentation becomes richer and more varied and adheres more closely to the illustrations of the *Psychomachia*, which, precisely in these two scenes, record the vicissitudes of the struggle in a particularly telling manner[2]. Herrad thus retained the forcefulness of the epic when she fused the *Psychomachia* with the instructive tract.

The *Psychomachia* bears only a faint relationship, on the other hand, to the cycle of virtues and vices which illustrates one of those lifeless and formal writings on the "Conflictus virtutum et vitiorum"[3]. The tract corresponds in the main with the first book of the *Poenitentiale* of Halitgarius of Cambrai (d. 830)[4]. The pictures were produced in Moissac at the end of the 11th century and we may assume that they go back to an original of the beginning of the century. They no longer take the slightest account of the battle motive but the characteristics of contrasting virtues and vices are represented in an exceptionally striking manner, unusually bold for that time.

In accordance with the formula already established by Gregory the Great, the text names five "vitia spiritualia" (Inanis Gloria, Invidia, Ira, Tristitia, Avaritia) and two "vitia carnalia" (Ventris Ingluvies, Luxuria), who, together with their offspring of subsidiary vices, are all descendants of Superbia; it then sets a number of virtues against an army of vices. There is not a single word describing the appearance of or the evil wrought by the powers of darkness. Yet the illustrator, completely disregarding any kind of system,

[1] She designates Idolatria as the enemy of Fides, Fallacia as that of Justitia, Blasphemia of Fortitudo; Patientia, however, is set against Ira, Sobrietas opposes Ventris Ingluvies and Largitas, Avaritia. The followings of Fides, Spes, Justitia, Fortitudo, Ira, Invidia, Ventris Ingluvies and Vana Gloria correspond exactly with those of the tract. In other cases, such as those of Caritas or Prudentia, the variations are inconsiderable. The following of Fallacia, namely Violentia, Rapina and Fraus, gives an instance of a completely new departure; in the tract these are subordinated to Avaritia. Both Idolatria and Largitas lack followings.

[2] Fols. 200 r, 2nd col. and 199 v, 3rd col. ff. (Straub-Keller, pls. XLIII ff.). The independent style of the artist renders it impossible to determine with certainty to which group of manuscripts this model belonged.

[3] Paris, Bibliothèque Nationale, MS. lat. 2077.

[4] Migne *P. L.* 105, 651 ff. The battle parable does not occur in Halitgarius of course, but it occurs in similar tracts.

gives a picture of the band of vices, which bursts with life and energy (Fig. 9)[1]. Principal vices and lesser vices mingle to form an odd miscellany. Superbia is enthroned in the midst of her wild crowd of flaming-haired companions who, completely unchecked, follow their evil pursuits. In this turmoil, Vana Gloria lifts high her veil. Invidia points enviously at the queen. Homicidium draws the fatal bow. Rapina hastens to hide her spoils in a piece of cloth. Gula stuffs food into her insatiable mouth. Impatientia is convulsed and bent. Tristitia mournfully supports her chin with her hand. Ira tears her hair and Avaritia has filled the folds of her dress. Humilitas remains undisturbed in the face of all this wickedness; she stands bearing the palm of righteousness and points up to the three angels. But fate overtakes Superbia. She hurtles headlong down, robbed of her fine garments, while Humilitas in humble genuflection bows to the ground. A great gap separates the words of the tract from the turbulent illustration, which gives indications of various sources. The goblin-like nature of the vices comes from the stock forms of *Psychomachia* illustrations. The portrayal of unclothed figures points to classical influences, perhaps those of the miniatures representing constellations on maps of the heavens.

The other miniatures illustrate the disputes between the eight leading virtues and their antagonists, disputes which have degenerated into mere statement and reply, all of a didactic nature. The artist, however, only once shows a scene of discussion—it corresponds with the customary representation of Joseph or Moses appearing before the throne of Pharaoh (Fig. 10)[2] — namely that in which Humilitas approaches a king designated as Exultatio, behind whom stands a vassal, Detractio (Fig. 11)[3]. Otherwise his characterisation of the opposing pairs is extremely varied.

Ira may be recognised by signs of her disposition (Fig. 12)[4]. She tears her hair, which is forthwith combed straight again by a myrmidon. Another attendant rends his garments. Patientia turns away from this wild scene, holding a set-square, while her companion points back at the vice.

Inanis Gloria and Timor Domini are represented by examples reminiscent of biblical parables. The vainglorious man attempts to arouse the admiration of an onlooker by showering gifts on a cripple. The God-fearing man, on the

[1] Fol. 163 r.
[2] E. g. fol. 65 v of the Paraphrases of Aelfric, first half of the 11th century (British Museum, Cotton MS. Claudius B iv), or p. 33 of the Montecassino Rabanus Maurus MS. of 1023 (*Miniature sacre e profane dell'anno 1023 illustranti l'enciclopedia medioevale di Rabano Mauro*, Montecassino 1896, pl. VIII).
[3] Fol. 164 v.
[4] Fol. 168 r.

other hand, engaged in conversation with a friend, secretly slips alms into a beggar's hand (Matth. VI, 3 ff.)[1].

And thus the 11th century miniaturist, with his wealth of imagination, which adopts religious and profane classical motives indiscriminately and places personifications, human examples, myrmidons and monsters side by side, succeeds in transforming the weakly constructed tract into vigorous representations of fiendish activity and model behaviour. Herrad of Landsberg, on the other hand, living in the 12th century with its more systematised thinking, uses a related text for the purpose of clarifying and establishing the battle of the *Psychomachia* on a wider basis.

[1] Fol. 165 v. This type of a group of three originated in the usual representations of Christ, performing a miracle and turning to an apostle (cf. Wilpert, pl. CXVI, 2).

Genre pictures of an allegorical nature are already found in the *Psychomachia*, where they illustrate Avaritia's rule of terror.

The remaining miniatures of the manuscript portray the following:

fol. 166 v left: Invidia sits sad and morose, head in hand, according to the classical tradition. It is easy to understand how she came to be designated Tristitia; behind her stands a myrmidon. — On the right Congratulatio fraterna, named Dilectio in the picture, with an accompanying figure. In the lower part of the illustration satyr-like demons fight viciously over a garment.

fol. 169 r left: Tristitia sits with her hands resting idly in her lap; she is called Desperatio because she leads people to despair. Her satellites are Death depicted with his scythe, like Saturn, a winged, dragon-like monster and a goblin with a raised sword. The text runs thus: "Geminam esse tristitiam novi, immo duas esse tristitias novi, ... unam, quae ad poenitentiam trahit, alteram, quae ad desperationem perducit. Tu quidem una ex illis esse cognosceris, sed omnino quae mortem operaris." — Right: Gaudium climbs up to heaven, towards the hand of God.

fol. 170 r left: Avaritia, turning out gold pieces from a purse into a large vessel; a satellite stands by. — Right: Misericordia, holding a palm-branch in her left hand, gives a garment to a poor man. Below, a land labourer working with a pick.

fol. 171 v left: Ventris Ingluvies, given the appellation Gula, sits gorging at a table. Below her a goblin is binding a dragon with a chain. — Right: Ciborum Parsimonia (unnamed), holding a book.

fol. 173 r left: Luxuria, richly dressed, loosens her girdle. A demon draws off her head covering, while a man approaches her with lustful intent. A monster curls its tongue around the vice's foot and pinches the toe of one of her fashionably pointed shoes with pincers. — Right: Castitas, turning away from these sinful happenings, holds a palm-branch in her hand and is depicted standing on a fallen demon.

CHAPTER II. THE VIRTUES TRIUMPHANT.

Mediaeval artists were not content with depicting the dramatic course of the struggle between the virtues and the vices or some of its crucial moments. They sought to proclaim in a yet more telling fashion the victory of the Good, and so they portrayed the triumph of the virtues, which stand in all their greatness over the bodies of the vanquished vices. Thus the conflict with all its changes of fortune is resolved into an apotheosis of the victorious powers, a motive, which may be traced back finally to the art of the ancient East, which alone, in contrast to that of the West, gave examples of an unhistorical, frontal representation of the triumph of gods and kings, who tread their crushed opponents in the dust, be they man or beast[1].

Already at a very early period Christian art made this motive its own. It applied the words of Psalm XC, 13 (91, 13): "Super aspidem et basiliscum ambulabis et conculcabis leonem et draconem", which are obviously based upon the idea of a divine triumph, to that early conception, which corresponded to the above-mentioned oriental portrayals[2]. In one instance Christ is standing in calm majesty on four animals, which are symbols of evil[3]. Or again, with the banner of the cross he finally thrusts the hostile forces beneath his feet[4]. Both modes of portrayal came to be regarded henceforth as standard forms for illustrating the victory of Christianity over all its adversaries and thus they could be used for expressing quite clearly in the narrower moral field the triumph of the virtues or of virtuous people over the forces of destruction.

The motive of the triumph of the virtues was first developed in the artistic crafts before it achieved its highest state of refinement in architectural sculp-

[1] The origins and development of this type have been exhaustively treated by B. Schweitzer, "Dea Nemesis Regina" *(Jahrbuch des deutschen archäologischen Instituts* XLVI, 1931, pp. 175 ff.), pp. 214 ff. — See also Saxl, p. 4.

[2] Smith, pp. 146 ff.

[3] E. g. Early Christian lamps from Egypt or an Alexandrian catacomb fresco (Smith, figs. 136, 138). Cf. further a 9th century book-cover in the Museo Cristiano in the Vatican (Goldschmidt, *Elfenbeine* I, pl. VII, no. 13).

[4] E. g. the Psalter in the University Library of Utrecht, Cod. 32, fol. 53 v (De Wald, pl. LXXXIV). On a mosaic in the church of S. Croce in Ravenna, built by Galla Placidia, Christ triumphs over and treads on the deadly sins. The inscription closes with the words:
"Te vincente tuis pedibus calcata per aevum
Germanae mortis crimina saeva tacent."
It is not yet clear in which way the *crimina* were depicted. Cf. E. Steinmann, *Die Tituli und die kirchliche Wandmalerei im Abendlande vom V. bis zum XI. Jahrhundert*, Leipzig 1892, p. 53.

ture. From the 9th century onwards it is to be found in *Psychomachia* illustrations, where occasionally virtues raise themselves by standing on their dead adversaries as on a pedestal[1]. The fact that the crushed fiends no longer feel the ignominy of their position obviously placed them and their terrible fate in too generous a light. In all other portrayals they are still more deeply humiliated. Unarmed and incapable of further resistance, they have to submit to their destruction with open eyes. This harsher conception was first expressed on a Carolingian ivory cover of the Ada group[2] (9th century; Fig. 13). Here are already definite peculiarities, which point to the future; in one case, for instance, one group corresponds to the other as in a mirrored reflection, a feature of composition frequently adopted in later times; in another case the arrangement within an arched framework gives an idea of the possibilities of future sculptural development.

The motive of the triumph of the virtues is capable of much elaboration. Earthly forms are placed beside the personifications as models of moral conduct. And so in a miniature of the Bamberg Apocalypse (executed 1001-2) Abraham is associated with God-fearing Obedience, Moses with Purity, David with Penitence and Job with Patience (Fig. 14)[3]. The picture strikes one as a variation on the theme of Patientia led by Job *(Psychomachia*, v. 162ff.), which became part of the conception of the triumph of virtue.

The triumphal motive is also applied to holy figures, which likewise stand upon the children of darkness, as in a Vitae Sanctorum manuscript of the

[1] Be fol. 35 v, B² fol. 130 v, Ly fol. 15 r (Stettiner, pls. 137; 171; 121, no. 2).

[2] Florence, Museo Nazionale, Carrand Collection, no. 30 (Goldschmidt, *Elfenbeine* I, pl. V, no. 10 and p. 12).

[3] Bamberg, Staatliche Bibliothek, Cod. A. II. 42, fol. 60 r. Cf. Heinrich Wölfflin, *Die Bamberger Apokalypse*, Munich 1921 (2nd. ed.), pl. 52 and pp. 33, 34. — *Mittelalterliche Miniaturen aus der Staatlichen Bibliothek Bamberg* II, Hans Fischer, *Reichenauer Schule* II, Bamberg 1929, pl. 3 and p. 16.

The inscription: "Jussa Dei complens. Mundo sis corpore splendens. Poeniteat culpae. Quid sit patientia disce" defines virtuous conduct as that which the Emperor Otto III, possessor of the manuscript, seeks to realise and which is represented by the four virtues and their Old Testament counterparts. The association of the pairs is canonical: "Abraham .. oboediens in praeceptis. Job .. pro tanta virtute patientiae duplici in fine remuneratione sublevatur. David .. pronus ad poenitentiam" (Isidorus Hisp., *De ortu et obitu patrum ;* Migne *P. L.* 83, 133 ff.).

Already in classical times praise of imperial virtues was usual. In a eulogy of Constantine of the year 310 it is said of Constantius: "Quid de misericordia dicam, qua victis temperavit? Quid de justitia, qua spoliatis amissa restituit? Quid de providentia, qua sociis sibi junctis se eiusmodi judicem dedit, ut servitutem passos juvaret recepta libertas, culpae conscios ad poenitentiam revocaret impunitas" *(XII Panegyrici latini* ed. Baehr-Baehrens, Leipzig 1911, pp. 204, 205).

At the coronation mass held for Charles the Bald the prayer was as follows: "Quaesumus, omnipotens Deus, ut famulus tuus, qui tua miseratione suscepit regni gubernacula, virtutum etiam omnium percipiat incrementa, quibus decenter ornatus et vitiorum monstra devitare et ad te, qui via, veritas et vita es, gratiosus valeat pervenire" (Migne *P. L.* 78, 238).

Cîteaux School of about 1115, where saints are portrayed standing upon a helplessly cringing naked figure, a winged devil or a dragon[1]. In other instances the triumph of the virtues is paralleled by the triumph of virtuous women. In a miniature of the *Speculum Virginum*, ascribed to Conrad of Hirsau[2] (circa 1070 - circa 1150; Fig. 15), Humilitas thrusts a sword into the breast of the fallen Superbia and on one side Jael stands on the corpse of Sisera (Judges IV, 21), whose head she has pierced with a nail, while on the other, as a further example of the victory of humility, Judith treads upon the slain Holofernes (Judith XIII, 1 ff.)[3].

Finally, in a portrayal which bears the stamp of a keen theologian (Fig. 16), a Ratisbon miniaturist (circa 1170–85) has combined the triumph of the 90th Psalm (Old Testament prophecy) with Christ's redeeming self-sacrifice

[1] Dijon, Bibliothèque Municipale, MS. 641, vol. IV, fols. 20 v, 21 r, 37 r. Cf. Oursel, pls. XXXIII, XXXIV.

This conception is already to be found in Prudentius, once again characteristic of his vivid imagery:

> "Haec calcat Agnes ac pede proterit
> stans et draconis calce premens caput,
> terrena mundi qui ferus omnia
> spargit venenis mergit et inferis,
> nunc virginali perdomitus solo
> cristas cerebri deprimit ignei
> nec victus audet tollere verticem"

(Peristephanon XIV, v. 112 ff. ed. Bergmann, p. 431).

[2] Cf. M. Manitius, *Geschichte der lateinischen Literatur des Mittelalters* III *(Handbuch der Altertumswissenschaft* IX. II. 3), Munich 1931, pp. 315, 316.

Watson, *Speculum*, pp. 465, 466, gives a list of eleven completely or partly illustrated copies, nine of which are of the 12th and 13th centuries. Two others, in Bonn and Trier, are included in the following list:

1. London, British Museum, Arundel MS. 44, second quarter of the 12th century, Middle German.
2. Cologne, Stadtarchiv, MS. W. f. 276a, circa 1180, from St. Maria, Andernach.
3. Bonn, Provincial Museum. 3 leaves, circa 1180, from Burgbrohl.
4. Trier, Dombibliothek, MS. Fol. 132, circa 1200, from St. Matthias?
5. Rome, Biblioteca Vaticana, Cod. Palat. lat. 565, first half of the 13th century.
6. Zwettl, Cistercian Abbey, Cod. 180, first half of the 13th century, Austrian.
7. Berlin, Preussische Staatsbibliothek, MS. Phill. 1701, first half of the 13th century, from the monastery of Igny?
8. Troyes, Bibliothèque de la Ville, MS. 252, first half of the 13th century, from Clairvaux.
9. ib., MS. 413, first half of the 13th century, from Clairvaux.
10. Arras, Bibliothèque Municipale, MS. 943—282, 13th century, from St. Vaast.
11. Leipzig, Universitätsbibliothek, MS. 665, end of the 13th century, Middle German.

For the Berlin MS. cf.: *Schöne Handschriften aus dem Besitz der preussischen Staatsbibliothek*, Berlin 1931, pp. 62, 63; and Joachim Kirchner, *Die Phillips Handschriften (Beschreibende Verzeichnisse der Miniaturen-Handschriften der preussischen Staatsbibliothek zu Berlin* I), Leipzig 1926, pp. 64 ff.; for the Zwettl MS.: Winkler, pp. 24, 25; for the Troyes MSS.: Lucien Morel-Payen, *Les plus beaux manuscrits et les plus belles reliures de la Bibliothèque de Troyes*, Troyes 1935, pp. 109, 110. For a general account cf. M. Strube, *Die Illustrationen des Speculum Virginum*, Diss. Bonn, Düsseldorf 1937.

[3] E. g. Arundel MS. 44, fol. 34 v. Cf. Watson, *Speculum*, p. 450. The miniature of the Berlin MS. is reproduced in Michel II. 1, fig. 228; that of the Zwettl MS. in Winkler, fig. 53.

(New Testament fulfilment) and the victory of Humilitas over Superbia (moral interpretation)[1].

Although the portrayal of the triumph of the virtues or of the righteous tried, in the smaller art froms, to achieve the maximum effect in various ways — arched frames (Carolingian ivory), deliberate multiplication of a theme (Bamberg Apocalypse) or static frontal representation (Cîteaux manuscript) — only later did it attain a suitable form in Romanesque sculpture[2].

The archivolt decoration of the Western French churches of Saintonge and Poitou gives the triumph motive full and striking expression, which in grandeur of conception far surpasses all other early efforts[3]. The archivolt was peculiarly suited to a composition of figures inclining towards a vertical axis.

A window in the south transept of the church of St. Pierre at Aulnay (Charente-Inférieure; circa 1130) is the earliest example of this type (Fig. 17[4]). The groups of figures are hewn directly from the actual masonry of one of the archivolts, which is composed mainly of the long shields of the virtues. Motionless, each virtue stands upon her languishing enemy, whom she dwarfs and crushes by her overwhelming size. No one pays attention to her helpless opponent. The vices appear in various guises, such as those already established in the Cîteaux manuscript. With the exception of a writhing dragon, they are naked demons with flaming hair, who struggle in their last convulsions. As yet the conception of the triumph of the forces of good over those of evil remains a general one.

In the west porch of the church of St. Gilles at Argenton-Château (Deux-Sèvres; circa 1135) on the other hand, there are six pairs of virtues and vices, named by inscriptions and arranged in a significant cycle, which extends all over the archivolts (Fig. 18)[5]. Here, executed in stone, is the doctrine which dominates human life (represented by the signs of the zodiac and the months), the Last Judgment with the Judge of the World (Christ,

[1] Munich, Bayerische Staatsbibliothek, Cod. lat. 14159, fol. 5 r (Boeckler, *Regensburg*, fig. 38 and p. 40).

[2] Individual representations: On a capital of the ambulatory round the apse of Notre-Dame-du-Port in Clermont-Ferrand, first half of the 12th century, Largitas and Caritas pierce each other's adversaries with crossed spears (Kingsley Porter, fig. 1180). On relief tablets of the 11th century on the chapel of St. Michael in Xanten two virtuous knights — they may perhaps be regarded as SS. Victor and Gereon — overcome a dwarfed demon and a dragon (Richard Klapheck, *Der Dom zu Xanten*, Berlin 1930, pp. 7 ff. with illustrations).

[3] Cf. Paul Deschamps, "Le combat des vertus et des vices sur les portails romans de la Saintonge et du Poitou" *(Congrès archéologique* LXXIX, 1912, vol. II, pp. 309 ff.).

[4] Cf. Kingsley Porter, fig. 980 and pp. 331, 332. — E. Lefèvre-Pontalis, "Aulnay-de-Saintonge" *(Congrès archéologique* LXXIX, 1912, vol. I, pp. 95 ff.).

[5] Kingsley Porter, figs. 987—996 and p. 333. — Cf. further Deschamps, pl. 74 A and Sanoner,

the Lamb of God), the Assessors (the Apostles) and the Parables (the Wise and the Foolish Virgins, virtues and vices, also the story of Lazarus in the spandrels of the porch). Thus the special function of the triumph of the virtues is now that of encouraging the faithful, even before they enter the church, to emulate the virtues in view of the coming Judgment Day[1]. It is for this reason that the two topmost figures held a crown (since broken off) and thus attracted the onlooker's gaze up to the reward of victory which beckoned to the conqueror of evil.

The virtues no longer have the defiant appearance which they had in the south window of Aulnay. They are now clad in long-sleeved garments. The vices appear as naked demons with claws on hands and feet. Their faces are often so distorted that they resemble the masks of enraged beasts. The composition, which corresponds to the variants given in the representations of the 90th Psalm, is rhythmical. The supreme virtues stand calmly over the small fiends, while those next to them, full of energy, give their subdued enemies the coup de grâce. The motive of peaceful triumph is resumed lower down[2].

The figured archivolts of the west porch of St. Pierre at Aulnay, which was built about ten years later than the south transept, are also by the same artist[3]. On this occasion the artist places all the virtues in the same attitude over the despairing and cringing vices[4].

"Analyse du portail de l'église St. Gilles à Argenton-Château (Deux-Sèvres)" in *Revue de l'art chrétien* XLVI, 1903, pp. 397 ff.

The name-inscriptions (Castitas-Libido, Patientia-Ira, Humilitas-Superbia, Fides-Idolatria, Largitas-Avaritia, Concordia-Discordia) are taken from the *Psychomachia*. Only Sobrietas and Luxuria are missing and these were omitted by the artist just as much for reasons of symmetry as for the fact that they are somewhat similar in nature to Castitas and Libido.

[1] An early superscription of Walafrid Strabo for the Reichenau exhorts the church-goers to cast out their vices before entering the church:

"Limina magnifici properas qui scandere templi,
Iram, odium, invidiamque tuo de corde revelle,
Frange supercilium nigraeque libidinis aestum.
Fer pacem sanctumque in corde benignus amorem,
Et quicquid vitii est, lacrimarum flumine purga:
Sic tibi perpetuae reseratur janua lucis." (*Monumenta Germaniae Historica, Poetae latini* II, p. 408). — Petrus Cellensis (12th century) says in a sermon on the Passion: "Undecima die pictura superaddatur, in qua virtutes sub pedibus suis vitia conculcant" (Migne *P. L.* 202, 732).

[2] Burgundian influences (Cîteaux miniatures) affect the style. Cf. an archivolt angel with the angel of St. Matthew in Etienne Harding's Bible (Oursel, pl. XVI). The figures are no longer identical with the architectural form; they now stand out, free of the casemates.

[3] As far as the inscriptions are concerned, only the sequence of the six pairs is changed (The inscriptions disappear completely from later representations). Cf. Kingsley Porter, figs. 984, 985 and pp. 331, 332. — Deschamps, pl. 72; note 234 gives further literature. — Mâle I, fig. 253; II, fig. 49 and p. 104.

[4] All exaggerated postures have now vanished. In this way the artist's work draws steadily farther away from the lack of repose of the late-Burgundian Romanesque and approaches the new, more composed style of the figures of the porch of St. Denis.

In numerous other representations in the West of France certain character-istics of the four "anonymous" sculptural groups in the south transept at Aulnay intermingle with elements from Argenton-Château and the west porch at Aulnay; thus the compactness of form and meaning, which marked the theme in its initial stages, was not achieved later on[1].

The theme of the triumph of the virtues as expressed in architecture gradually extended itself far beyond the limits of its original province[2] and thus, like the later *Psychomachia* manuscripts, it sometimes loses its original features, which are characterised by fierce unrestraint. In the psychomachy-archivolt of the Cathedral of Laon (late 12th century) the distorted and bestialised dwarf demons have become "humanised" female figures. Moreover the virtues no longer stand upon them to make their humiliation utter and complete[3]. The vices of the Strasbourg cycle (circa 1280) have assumed the

[1] In the psychomachy-archivolt of the church of Corme-Royal (Charente-Inférieure), circa 1135—40, the massiveness of the composition of the Aulnay south transept model has been transformed into a living whole (Kingsley Porter, fig. 1015). Instead of using rosettes to fill the gaps and act as an architectonic binding between the pillar-like figures of the victors, the artist places a bush behind each group, a motive much used afterwards. Cf. the somewhat later representations at St. Symphorien, Fontaines-d'Ozillac and Pont-l'Abbé-d'Arnoult (Charente-Inférieure; Kingsley Porter, figs. 1007, 977, 1004). The psychomachy-archivolt of Chadenac (Charente-Inférieure), 1140, is closely related to the last of these (Kingsley Porter, figs. 1034 ff.).

Faithful repetitions of the archivolt of the west porch at Aulnay are to be found at Fenioux (Charente-Inférieure), circa 1150, and Civray (Vienne), circa 1165; rather freer repetitions at Partenay (Deux-Sèvres), circa 1150, and on the refectory door of St. Aubin at Angers (Maine-et-Loire), third quarter of the 12th century. Cf. Kingsley Porter, figs. 997, 998; 1122 ff.; 1048 ff. and 965 ff. An abbreviated representation is given in the church porch of Blasimont (Gironde), circa 1145 (Kingsley Porter, fig. 1041).

Finally perhaps, mention should be made of the almost completely destroyed side-portal at Varaize (Charente-Inférieure) and the provincial representations of the churches of St. Hilaire at Melle (Deux-Sèvres), St. Pompain (Deux-Sèvres), Ivry-la-Bataille (Eure) and Castelvieil (Gironde). Cf. Kingsley Porter, figs. 999, 1000; 1011; 1058; 1474; 926, 927.

[2] It is to be found, for example, on a 12th century capital in the cloister of S. Cugat del Valles near Barcelona. On the Porte Mantile of Tournai Cathedral, circa 1170, Humilitas overcomes Superbia and Castitas Luxuria, who is armed with a torch. Cf. J. Warichez, *La Cathédrale de Tournai* I *(Ars Belgica* I), Brussels 1934, figs. 22, 23, 25. — Adolph Goldschmidt, "Die belgische Monu-mentalplastik des 12. Jahrhunderts" *(Belgische Kunstdenkmäler* I, Munich 1923, pp. 51 ff.), figs. 47, 48.

An archivolt of the gateway of the Chapter House at Salisbury, circa 1280, illustrates, for example, how Veritas tears out Falsitudo's tongue, how Fides tramples on the blindfold Infidelitas and Castitas hangs Luxuria. Cf. Prior-Gardner, fig. 32 and p. 39. — Gardner, fig. 207 and p. 173.

[3] The archivolt is in the north porch of the west front. Cf. Aubert, pl. 65. — Mâle II, pp. 104, 105.

The individuality of the various pairs, which was established by inscriptions only in Argenton-Château and in Aulnay West porch, is here determined on a more extensive system. Six of the eight pairs of virtues and vices belong to the *Psychomachia*. On this occasion Concordia and Dis-cordia are missing, while Hebetatio is the name given to the opponent of Sobrietas. On each side, new groups are added: Caritas and Paupertas, Mansuetudo and Violentia. Besides her usual weapon Castitas bears a book, and Caritas overcomes her enemy by a good and selfless action. She hands a garment to a freezing woman. The psychomachy-archivolt of Chartres Cathedral is discussed later (p. 80, note 1).

2*

appearance of burgher's wives (Fig. 19)[1]. This must have made the obser-
ver reflect and have caused him to look out for the vicious qualities in the
everyday world—and in himself.

And so the stream of representations of virtues triumphant, springing
from the smaller art forms, flows on in the wider bed of architectural sculpture,
fertilizing at the same time other fields of art.

Not only mural painting[2], but church equipment was influenced by sculpture,
and in this way the choice of representation frequently gains particular
significance.

On fonts the triumph of the virtues is an eloquent parable of the beneficial
effects of the sacrament[3]. The Folcardus font, no longer existing, in the
church of St. Maximin at Trier (mid-12th century) showed twelve unarmed
virtues, calm and assured, standing over their antagonists[4], while on the
fonts of Stanton-Fitzwarren (Wiltshire) and Southrop (Gloucestershire;
circa 1160) some of the excitement of the recent struggle is reflected[5].
On the pedestal of the bronze candlestick in Milan Cathedral (circa 1180)

[1] The twelve groups are represented on the frame of the north porch in the west front of the Cathe-
dral. Cf. Otto Schmitt, *Gotische Skulpturen des Straßburger Münsters* I, Frankfort 1924, pls. 83—96.
[2] I. In France:
 St. Gilles, Montoire (Loir-et-Cher): Castitas-Luxuria and Patientia-Ira. Cf. Frédéric Le-
sueur, "Les fresques de Saint-Gilles de Montoire et l'iconographie de la Pentecôte" *(Gazette
des Beaux-Arts* LXVI, 1924, vol. I, pp. 19 ff.). — Abbé Plat, "Montoire" *(Congrès archéologique*
LXXXVIII, 1925, pp. 293 ff. — Further representations at St. Jacques-des-Guérets (Loir-et-Cher),
Vic (Indre) and St. Martin de Laval (Mayenne). Cf. Lucien Lécureux, "Les anciennes peintures
des églises de Laval" *(Revue de l'art chrétien* LX, 1910, pp. 223 ff.).
 II. In England:
 Chalgrove Church (Shropshire), 12th century. Cf. Borenius-Tristram, p. 4. — On the frescoes
of the "Painted Chamber" in Westminster Palace, between 1262 and 1277, since destroyed by
fire but preserved in copies, the following inscriptions may be determined: Largesce-Covotise,
Debonerete-Ira, Fortitude. Cf. J. G. Noppen, "Mediaeval Paintings formerly at Westminster"
(Apollo XXI, 1935, pp. 207 ff.) figs. II, III; and Borenius-Tristram, pp. 14, 15.
 III. In Germany:
 Two window-surrounds in the Lower Church at Schwarzrheindorf, between 1151 and 1156:
Four virtues struggle with vices (Clemen, figs. 229, 230 and pp. 312 ff.). — A glass-painting in
the west choir of Naumburg Cathedral, second half of the 13th century. Three pairs are still
preserved: Benignitas-Invidia, Patientia-Ira, Spes-Desperatio. The virtues are placed in relation
to apostles, who stand on their heathen adversaries *(Kunstdenkmäler der Provinz Sachsen* XXIV,
fig. 73 and pp. 137 ff.).
[3] "Virtutesque rigant totidem cor crimine mundum" (Inscription on the bowl of the Hildesheim
font).
[4] Clemen, fig. 233 reproduces an old illustration.
[5] On the font of Stanton Fitzwarren the following pairs are represented: Largitas-Avaritia, Humi-
litas-Superbia, Pietas-Discordia, Misericordia-Invidia, Modestia-Ebrietas, Temperantia-Luxuria,
Patientia-Ira, Pudicitia-Libido. The font at Southrop shows Patientia-Ira, Largitas-Avaritia,
Temperantia-Luxuria, Misericordia-Invidia. Cf. Francis Bond, *Fonts and Font Covers*, London-
New York-Toronto 1908, pp. 174 ff. with illustrations. — Prior-Gardner, figs. 31, 171. — Gardner,
fig. 90 and pp. 87 ff.

psychomachy illustrates the battle between the forces of light and darkness[1].

On the church-door at present in Novgorod (between 1152 and 1154), the purpose of which is to shut out the sinfulness of the world from the church's domain, two virtuous knights stand resolutely upon the bodies of their enemies, whose hair is done in long plaits (Fig. 20)[2].

When the motive of triumphant psychomachy enters the smaller, two-dimensional art-forms, one readily observes the contrast with the scope for expression offered by architectural art. The craftsman who fashioned a reliquary in the Cathedral Treasure at Troyes (circa 1200) probably borrowed typical groups from large-scale sculpture, but he makes some of the virtues, with rarely paralleled violence, seize their naked adversaries by the legs or hair in order to stab them to death or flog them (Fig. 21)[3]. Towards the end of the 12th century a miniaturist worked two triumphal groups into the frame of an initial and achieved in this way a delightful interlocking design (Fig. 22)[4].

And thus the development of the theme is determined not only by changes in conceptions or theological programmes, but also by artistic laws inherent in the media in which the sculptors in stone and metal, enamelists and miniaturists work. Only the interplay of these forces produced that wealth which was latent in the extensive and complex development of the idea of the triumph of the virtues over the vices.

[1] Eight vices are overcome by enthroned virtues. Cf. Falke-Meyer, fig. 61 and p. 11. — Otto von Falke, "Der Bronzeleuchter des Mailänder Doms" *(Pantheon* VII, 1931, pp. 127ff., 196ff. with illustrations).

[2] One of the virtues is called in Russian "Strength" and one of the vices is named both in Russian and in Latin "Paupertas". Cf. Adolph Goldschmidt, *Die Bronzetüren von Nowgorod und Gnesen (Die frühmittelalterlichen Bronzetüren* II), Marburg 1932, pls. 28, 29 and pp. 12, 13.

[3] In the arcades on the sides are portrayed: Mansuetudo-Iracundia, Sobrietas-Ebrietas, Parsimonia-Gula (?), Caritas-Odium, Misericordia-Impietas, Veritas-Fallacia, Fides-Idolatria, Humilitas-Superbia, Largitas-Avaritia, Castitas-Luxuria, Patientia-Ira, Concordia-Discordia. The last six pairs are taken from the *Psychomachia*. Cf. Chamot, p. 33. — A. Gaussen, *Portefeuille archéologique de la Champagne*, Bar-sur-Aube 1861, Emaux, pl. 17.

In the same workshop in the North of France the crook of a bishop's crozier was produced (Florence, Museo Nazionale, Carrand Collection, no. 622). Six groups are shown (Caritas-Invidia, Fides-Idolatria, Pudicitia-Libido, Largitas-Avaritia, Concordia-Discordia, Sobrietas-Luxuria) and on the capital at the top of the staff are scenes from the life of David. Cf. Chamot, pl. 3a and pp. 31ff. with bibliography.

[4] Paris, Bibliothèque Nationale, MS. lat. 11629, fol. 3 r, Northern French.

CHAPTER III. MAN'S ARDUOUS ASCENT TO GOD
(THE LADDER OF VIRTUE).

Both in the illustrated manuscripts of the *Psychomachia* and in the portrayals of the triumph of the virtues, man, who is the actual theatre of this unseen warfare, a warfare achieving reality only by virtue of the creative power of the artist, remained deliberately excluded and reduced to an onlooker. In those representations, however, which have as their theme his perilous ascent to God, man plays an important part. Everyone was thus enabled to see, in these visionary pictures, how he and his kind might win the reward of heaven, if, with the aid of the divine powers, he were to resist evil.

The work of a Greek church-father, John Klimakos (d. circa 600), laid the foundation of this graduated conception rooted in Neo-Platonism[1]. The starting point of his "Κλίμαξ τοῦ παραδείσου" is Jacob's dream, in which angels were seen ascending and descending on a ladder between heaven and earth (Genes. XXVIII, 10ff.). The monk too, leaving all worldliness behind, must strive to climb such a ladder. It is his task first of all to overcome his sinful desires, then to achieve the virtues, if he wishes to attain in the end the topmost rung and there join the Pauline trinity of virtues, Faith, Hope and Charity.

The oldest surviving illustrated manuscript of this tract (11th century) depicts all the stages of the arduous ascent in a comprehensive frontispiece (Fig. 23)[2]. Aided by angels, the monks try to climb up to Christ and the Garden of Paradise, while devils maliciously seek to drag them with long hooks into the jaws of hell. The whole vision of the conflict between the powers of good and evil thus serves as an introduction, which does not conform to the text in certain details.

Further miniatures illustrate the course of the monk's ascent to heaven and he is usually shown after the close of a chapter, i. e. between two "steps". He stands each time on the topmost rung of a ladder which has an increasing

[1] Migne *P. Gr.* 88, 631 ff.

[2] Rome, Biblioteca Vaticana, Cod. gr. 394, fol. f v. — Cf. Tikkanen, *Klimax-Hs.* — Walter Dennison and Charles R. Morey, "Studies in East Christian and Roman Art" *(University of Michigan Studies, Humanistic Series* XII, 1918, pp. 1 ff.) fig. 2. This mode of representation was canonised in the Mt. Athos Handbook of Painting (trans. by Godeh. Schäfer, Trier 1855, pp. 379, 380).

number of steps. He is frequently surrounded by allegorical female figures, clothed somewhat in the classical manner, personifications of helpful virtues or hindering vices; they lend him support or strive to force him down respectively. Only once do the vices achieve their aim and then the band of virtues is driven off (Fig. 24)[1]. Bravely defying every peril, however, the monk gains the topmost rung and Faith, Hope and Charity tender him wreaths[2].

[1] fol. 94 r. Hyperephania (Arrogance), Hypnos (Sleep), Gastrimargia (Gluttony), Thymos (Anger), Pseudeulábeia (Feigning Piety) and Kenodoxia (Inordinate Ambition) push the monk backwards, while Synetheia ponera (Bad Habit) drives away three virtues. Below, Oxythymia (Irascibility) and Koros (Satiety) are represented next to the dark pit of ignorance in which a naked figure is sitting.

[2] The miniaturist of the Vatic. gr. 394 usually adds a second scene to the picture and this addition is, as a rule, a variation on the main theme. Seated on a throne, the author instructs monks and at the same time points out allegorical female figures, personifications of spiritual forces, both good and evil, of which he is just about to speak. For the most part these figures stand, in the same way as the listening monks, near the throne of the saint, as if they too were following his speeches.

The picture of the ascending monk usually refers to the chapter immediately preceding; the scene of instruction, however, concerns that which follows.

The pictorial content of those miniatures which depict virtues and vices is as follows:

Before the 1st step, fol. 7 r right: The monk turns away from the figure of Bios in order to follow Aprospatheia (Dispassionateness).

Between the 1st and 2nd steps, fol. 12 r right: The monk on the rung of the ladder, by which Aprospatheia is standing.

2nd—3rd steps, fol. 14v right: The monk forsakes his parents and follows Xeniteia (Flight from the World).

fol. 17 v left: The monk and Xeniteia on their wanderings.

3rd—4th steps, fol. 19 r: Surrounded by monks, the author points to David, who draws attention to Hypakoe (Obedience) and Xeniteia.

6th—7th steps, fol. 54 v right: Siope (Secretiveness), standing behind the author, places a finger before her mouth.

7th—8th steps, fol. 62 r right: The author points to Aorgesia (Placidity) and Praotes (Gentleness).

8th—9th steps, fol. 66 r left: Mnesikakia (Malice) tries to pull the monk from the ladder, Tapeinophrosyne (Humility) helps him. — Right: The author points to Mnesikakia.

9th—10th steps, fol. 67 v left: Mnesikakia forces back the climbing monk. — Right: The author points to Katalalia (Slander) standing behind a monk.

10th—11th steps, fol. 69 v left: The monk stands on the ladder and triumphs over Katalalia. — Right: The author speaks of Polylogia (Garulity) and Katalalia.

11th—12th steps, fol. 71 r left: Mnesikakia and Katalalia hinder the monk's ascent, Agape (Love) and Siope help him.

12th—13th steps, fol. 72 r left: Akedia (Sloth) pushes the monk back. — Right: The vice at the author's feet.

13th—14th steps, fol. 74 r left: Akedia sleeping at the foot of the ladder. — Right: The author points to the eating Gastrimargia.

14th—15th steps, fol. 78 v left: Apatheia (Spiritual Peace) and Sophrosyne (Temperance) help the climber.

15th—16th steps, fol. 89 v left: Philargyria (Greed) lies at the foot of the ladder. — Right: The author points out a female figure who is driving off two others.

17th—18th steps, fol. 92 r right: Next to one of the monks undergoing instruction stands the naked figure of Anaisthesia (Insensibility).

18th—19th steps, fol. 94 r left: As described above. — Right: At the side of the scene of instruction Proseuche (Prayer) flogs the sleeping Hypnos.

This visionary frontispiece was not only gradually simplified and copied again and again by Greek artists[1], but it was also adopted by Western art when the Byzantine wave rolled westward in the 12th century.

It was reserved for Herrad of Landsberg to extend the meaning of the ladder of virtue and at the same time lend it clarity (Fig. 25)[2]. In that she lets representatives of various classes, laymen and clerics, strive upwards, she combines a social with an ethical scale. While angels in mid-air ward off the attack of the devils, almost all the climbers fall victim, because of their own spiritual weakness, to the attraction of earthly pleasures. The powers of evil are represented by the common temptations of the world and one

19th—20th steps, fol. 95 r left: Proseuche raises her hands towards the monk on the ladder.

20th—21st steps, fol. 97 r left: Kenodoxia and Apistia (Unbelief) force the monk down. — Right: The author points out Deilia (Cowardice), who is running away.

21st—22nd steps, fol. 98 r left: A devil flies before the monk on the ladder, who is protected by an angel. — Right: The author points to Kenodoxia and Hyperephania.

22nd—23rd steps, fol. 102 r left: The winged Hyperephania and Kenodoxia beset the monk. — Right: The author indicates the winged Hyperephania.

fol. 105 r right: Similar to fol. 98 r right, except for a small devil, the offspring of Blasphemy, who is associated with the two vices.

23rd—24th steps, fol. 107 r left: Praotes and Haplotes (Probity) help the monk. — Right: The author points out the winged figures of Akakia (Virtue) and Poneria (Vice).

24th—25th steps, fol. 109 v right: The author points out Tapeinophrosyne.

27th—28th steps, fol. 144 r: Parastasis (Zeal) and Proseuche on either side of the scene of instruction.

fol. 149 r: Proseuche, threatened by a demon shooting arrows, hands a monk a wreath.

28th—29th steps, fol. 149 v: The author points to Apatheia (Spiritual Peace) in a mandorla. She is surrounded by virtues.

29th—30th steps, fol. 151 v left: At the top of the ladder, the monk bows before Christ. — Right: The author indicates Apatheia, Pistis (Faith), Elpis (Hope) and Agape.

fol. 154 r: The trinity of the virtues tenders wreaths to the monk.

(In the Codex 418 of the Library of the Sinai Monastery scenes from monastic life, instead of the personifications, illustrate the contents of the chapters. Cf. Tikkanen, *Klimax-Hs.*, pp. 5, 6).

The introduction of personifications into scenes of actuality is a familiar feature of Byzantine art. The Psalter Paris. gr. 139 offers numerous examples. Praotes, for example, appears at David's anointing (fol. 3 v). In his fight with the lion, David is aided by Ischys (Power; fol. 2 v), and by Dynamis (Strength) in his combat with Goliath, behind whom Alazoneia (Boasting) turns to flee (fol. 4 v). Cf. Omont, pls. II—IV.

[1] Rome, Biblioteca Vaticana, Cod. gr. 1754, fol. 2 r, 11th—12th century (Tikkanen, *Klimax-Hs.*, pp. 8, 9). — Paris, Bibliothèque Nationale, Ms. gr. 1158, fol. 256 v, 12th century.

The miniatures of other copies of the 11th and 12th centuries no longer depict demons and are reduced finally to the mere representation of a ladder appearing above the writing author (Paris, Bibliothèque Nationale, MS. Coislin 88, fol. 1 vo, 12th century).

Vatic. gr. 1754 gives an illustrated list of contents on fol. 1 v. Small scenes in the thirty rung-spaces of a ladder bent round into horse-shoe shape, illustrate the theme of each chapter (Tikkanen, *Klimax-Hs.*, pp. 6 ff.).

[2] fol. 215 v (Straub-Keller, pl. LVI). Cf. further Mâle II, fig. 50 and p. 107.

The 15 steps of the ladder remind one of the *Scala coeli minor* of Honorius Augustodunensis (Migne *P. L.* 172, 1239 ff.).

may easily observe once again the swing of the pendulum towards reality and everyday life[1].

A miniature of the *Speculum Virginum* differs from this group of pictures, in that neither virtues nor angels help the struggling climbers in their fight against evil powers (Fig. 26)[2]. The miniaturist has combined the stories told in the tract, of two visions of the Holy Martyr Perpetua, those of her perilous ascent of the ladder up to heaven and of her fight with a repulsive Egyptian, and generalised them in such a way that the virtuous virgins simply carry the day.

Finally, in a Swabian miniature (between 1138 and 1147) St. Benedict is placed in a frame composed of Jacob's ladder and the ladder of virtue, for, in the rules of his order, Jacob's ladder is regarded as the prototype of the "Scala humilitatis", by the ascent of which the monk has to prove himself in twelve stages[3].

Thus is portrayed clearly and impressively in the psychomachy representations and the pictures of the ladder of virtue the fulfilment of the noblest task imposed on man according to mediaeval ethics, that of subduing by the application of all his powers the evil of this world, of overcoming his sinful desires in order to gain thereby the reward of eternal heavenly bliss.

We have seen how *Psychomachia* illustration originated in the 5th century as a late development on a new allegorical basis, of classical portrayals of battle scenes. The originally realistic nature of the pictures was gradually transformed into a frequently terrifying unnaturalness, until finally there was a renewed approach to reality. It was moreover compatible with the structural sense of the Middle Ages and their desire for clear expression to condense the multifarious details of the struggle into a few groups and to develop its triumphal aspect. The 12th century sculpture of South-West France gives particularly eloquent testimony of this. Byzantine art also made its contribution to the theme of the battle between the virtues and the vices; here, for the first time, man, striving to heights of perfection, is actually engaged in the struggle between the opposing forces.

[1] An example of the application of the theme to mural painting is a 12th century fresco in Chaldon Church (Surrey). Protected by angels, the virtuous mount up to Christ. But the sinners fall headlong and are dragged away by devils to worse torments. Cf. O. Elfrida Saunders, *A History of English Art in the Middle Ages*, Oxford 1932, fig. 23 and pp. 82, 83.

[2] London, British Museum, Arundel MS. 44, fol. 93 v (see p. 16, note 2). Cf. Watson, *Speculum*, pl. IV and pp. 452 ff. — Bruck, fig. 150.

[3] Stuttgart, Landesbibliothek, Cod. hist. Fol. 415, fol. 87 v (Löffler, pp. 56, 57; *Reallexikon zur deutschen Kunstgeschichte* I, illustration on col. 696). Cf. further *Benedicti Regula*, cap. VII, pp. 30 ff.

The basic thought of the victory of good over evil is clearly reflected in all these representations and thus, in spite of the variety in individual expression, certain artistic principles are constantly recurring and remain dominant. These may be summed up as follows: —

The representations are imbued with dramatic tension, produced by the dualism of a conflict between opposing forces, stopped dead at a particular moment (Individual scenes of the illustration of the *Psychomachia*, the death struggle of the vices in the representations of the triumph of the virtues, the various stages of the ascent of the ladder of virtue).

Virtues and vices are placed directly together in a single, unified picture.

The fighting personifications wield actual weapons, while it is only very rarely that symbolical attributes indicate the supremacy of the victors.

The psychomachy representations, however, are by no means the full measure of the lessons concerning good and bad qualities in man, which mediaeval artists wished to hold up to the observer as an encouragement or a warning. For Christ is shown not only in his growing ascendancy as conqueror of snake and basilisk, lion and dragon, but is also conceived undramatically, enthroned in complete immobility among the four major prophets and the symbols of the Evangelists who proclaim the greatness and eternity of his might. Thus the dynamic conception of the psychomachy is supplemented by a series of static representations. These no longer show groups of virtues participating with earthly weapons in a realistically depicted action, which is to be interpreted symbolically. They are rather direct images of an intellectual scheme. In the following chapters we shall try to discern the origins and to make clear the far-reaching and complicated development of this mode of portrayal.

Part II.

STATIC REPRESENTATIONS OF SYSTEMS OF VIRTUES AND VICES.

The static representations of systems of virtues and vices did not develop as a unity in the way psychomachy did. Instead of the variations on the single motive of the struggle for the possession of the human soul, a number of themes are here broached and these, by reason of their subtlety, very often result in highly complicated compositions which place heavy demands on the observer's perspicacity. In some instances it is merely companies of virtues that appear in human form (Chapter I); in others, extended and highly ramified systems of virtues and vices, who adopt particular allegorical guises (Chapter II). The master who created the virtue and vice-cycle of Notre-Dame fused both kinds of representation with elements of psychomachy to form a comprehensive whole (cf. infra Chapter III).

CHAPTER I. VIRTUES IN HUMAN FORM.

Freed from the changing fortunes of the struggle with the dark powers of earthly vanity, the virtues, from Early Christian days, have been associated with the portrayal of well-known personalities. They indicate quite clearly the essential moral worth of the person portrayed and this moral aspect is valued more highly than any dignity or beauty of outward appearance.

The highly varied mode of representation of late Roman art passed on to this developing cycle of illustration the tradition of refraining from erecting any visible barriers between two different spheres (i. e. men and gods, or historical truth and the world of abstractions), but at the same time it also made it possible to ascribe a particular sphere of existence to the personifications by subdividing the area of the composition.

To the traditional features of the first group belong those types of il-

lustration, which, for instance, show Virgil between two inspiring Muses (Fig. 27)[1] or a deified imperial virtue beside the ruler[2].

As examples of the second group one might cite those representations on which the elements of nature are so arranged in a pictorial composition that definite conceptions of the laws governing them and their place in the cosmos arise in the mind of the onlooker. When, for example, on a Roman mosaic from Lambaesis (Lambèse; third century A. D.) the bust of Bacchus in a central medallion is surrounded by four smaller circles in which there are head-and-shoulder representations of the Seasons, the composition stresses the thought that each of the four plays its part in the fertilisation of nature (Fig. 28)[3]. A relief from Heddernheim reflects a similar idea[4]. In this instance Mithras slaying the bull is surrounded by four medallions with the heads of the wind-gods; the intention is to proclaim the universal power of Mithras.

Both types of pictorial composition live on in Early Christian art. Most of the examples which have survived, come from Egyptian monasteries, i. e. from the neighbourhood of Alexandria, which by reason of the works of its artists and the allegorical exegesis of its theologians, served as a model for later work.

In one series of representations there are no signs of stereotyping or of regular partition of the pictorial area between the figures. Thus Eirene (Peace) and Dikaiosyne (Righteousness) stand in a circle of biblical figures on a dome fresco in El Bagawat (5th century)[5]. Virtues also appear as the retinue of a central figure, as in the dedicatory picture of the Vienna Dioscurides (first decade of the 6th century; Fig. 29)[6]. The Byzantine princess Anicia Juliana is here enthroned between two virgins, similar to herself, who are designated

[1] Mosaic from Hadrumetum (Sousse) in Tunis (Museo del Bardo), first century A. D. Cf. *Mosaïques* II, no. 133.

[2] On coins for example. Thus Spes tenders a blossom to Vespasian (Mattingly-Sydenham II, p. 63, no. 396). Pietas stands between Titus and Domitian (II, p. 128, no. 96 and pl. IV, no. 58). Concordia and Aurelian shake hands (V. 1, p. 271, no. 59 etc.); so do Fides and Carausius (V. 2, p. 511, no. 562). Liberalitas and Providentia also frequently stand beside the emperors.

[3] Algiers, Museum. Cf. *Mosaïques* III, no. 181. Related mosaics associate the Seasons with Bacchus, e. g. in St. Roman en Gal (I, 1, no. 243), in Carthage (II, no. 825), or with Venus, as in El Djem (II, no. 71). A mosaic from Sousse shows Glaucus surrounded by heads of the wind gods (II, no. 188); a mosaic from Pesaro the Seasons and Leda, cf. Pirro Marconi, "Il mosaico Pesarese di Leda" *(Bolletino d'arte* XXVI, 1932, p. 445).

[4] Franz Cumont, *Textes et monuments figurés relatifs aux mystères de Mithra* II, Brussels 1896, mon. 251, pl. VII.

[5] The former bears a sceptre and the symbol of life, the latter a cornocupia and a balance. Cf. W. de Bock, *Matériaux pour servir à l'archéologie de l'Egypte chrétienne*, St. Petersburg 1901, pls. XIII, XV and pp. 27 ff.

[6] Vienna, Nationalbibliothek, Cod. Med. gr. 1, fol. 6 v (Paul Buberl, *Die byzantinischen Hand-*

as Megalopsychia (Noblemindedness) and Phronesis (Cleverness). In this miniature the figure area remains unbroken in spite of the complicated structure of the frame.

In other representations, however, the artist has clarified the composition by arranging the figures in stiff rows. Thus, for example, winged half-figures of twelve virtues bearing discs form a continuous frieze on either side of Christ round the walls of a cell in the Monastery of Jeremiah in Sakkara (5th century)[1]. In the niche of another cell a semicircle of heads of virtues forms an arch above Mary and the child Christ[2]. The arrangement of the pictorial area is still more complicated in some cases. In frescoes of two chapels at Bawît (5th century) the busts of Faith, Hope, Charity and Patience are enclosed in the medallion-like spaces formed by the geometrical design of two interweaving bands (Fig. 30)[3]. It is now impossible to determine whether the typical medallion arrangement of the mosaic of the Seasons or of the Mithras relief was not also used at that time for moral themes. It certainly achieved canonical status, however, when it was adopted for the Majestas Domini (Wooden door of S. Sabina, Rome, circa 430)[4].

The Greek Orient, which from now on portrayed virtues only occasionally and restricted itself even then to simple themes, retained the loosely constructed form of the "retinue" picture. In a John Chrysostom manuscript (circa 1078) Aletheia (Truth) bearing a candle in both hands and

schriften I. Der Wiener Dioskurides und die Wiener Genesis (Beschreibendes Verzeichnis der illuminierten Handschriften in Österreich, new series IV), Leipzig 1937, pl. V and pp. 26 ff.

Born of classical tradition, the picture type of the group of three signifies various things. The two framing figures proclaim both the dignity of the main figure (the usual representations of the Roman emperor between two members of his retinue, Christ between the apostle-princes) and the greatness of his sway (Roman Consul between Rome and Constantinople on Byzantine ivories), or they inspire the central figure (Virgil between two Muses; cf. Fig. 27. — David between Sophia and Prophetia in the Paris. gr. 139, fol. 7 v; cf. Omont, pl. VII.).

Sophia, who, according to a story of Gregory of Nyssa, appeared to St. Gregory Thaumatourgos by night in a vision (Migne P. Gr. 3, 191), also lends Mark her divine inspiration (Codex Rossanensis, fol. 121 r) or Solomon (Copenhagen, Gl. kongl. Bibl., MS. 6.2⁰, fol. 83 v, 10th—11th century). Cf. Antonio Muñoz, Il codice purpureo di Rossano e il frammento Sinopense, Rome 1907, pl. XV. — Greek and Latin Illuminated Manuscripts X—XIII centuries in Danish Collections, Copenhagen-London-Oxford 1921, pl. 1.

According to John of Gaza, the painting of the winter baths at Gaza, circa 540, showed, among other things, Sophia and Arete helping Atlas to bear the disc of the sun (Paul Friedländer, Johannes von Gaza und Paulus Silentiarius, Leipzig-Berlin 1922, pp. 171 ff.).

[1] Inscriptions of Faith, Hope, Charity, Patience, Prudence and Strength are still preserved. Archangels are also represented there as winged half-figures. Cf. Quibell III, pls. IX, X and p. 9.

[2] Quibell IV, pls. XXII, XXIII and p. 134.

[3] Cf. Jean Clédat, Le monastère et la nécropole de Baouît (Mémoires publiés par les membres de l'Institut français d'archéologie orientale du Caire XII), Cairo 1904, pls. XXXI, LXVI ff. and pp. 63, 92, 93.

[4] Saxl, fig. 211 and p. 98.

Dikaiosyne with the balance appear behind the throne of the Emperor Nike-phoros Botaniates[1]. The Book of the Gospels of John II Komnenos (1118 –1143) shows the coronation of the Emperor and of his son Alexios by Christ. Meanwhile on either side, Eleemosyne (Mercy) and Dikaiosyne bow to the heavenly ruler and beg that he, whose word signifies God's mercy and righteousness, may bestow these virtues on the earthly monarchs (Fig. 31)[2].

The artists of the Latin West, however, did not grow weary of portraying again and again groups of virtues within firmly established frameworks; western thought indeed displayed particular interest in the systematisation of ethics. The Carolingian miniaturists already attempted to sever the al-legorical figures from the main theme, thereby drawing a dividing line between the particular historical scene and its basic significance. It was the clear, fundamentally classical system of the four cardinal virtues (Prudentia, Justitia, Temperantia, Fortitudo)[3] which they added to the portrayals of notable personages, especially of rulers. For Alcuin and other writers of the Carolingian period had praised afresh and with considerable emphasis the nature of these spiritual forces and had prayed to God for these great possessions on behalf of their rulers[4].

It will be convenient here to consider first the general connexions between

[1] Paris, Bibliothèque Nationale, MS. Coislin 79, fol. 2 r (Omont, pl. LXIII and p. 33).
[2] Rome, Biblioteca Vaticana, Cod. Urb. gr. 2, fol. 19 v. Cf. Jean Ebersolt, *La miniature byzantine*, Paris-Brussels 1926, pl. XXXI, no. 1 and pp. 33, 34.
On a miniature of the *Carmen de rebus siculis* of Petrus Ansolinus de Ebulo, late 12th century, the cardinal virtues and the theological virtues are grouped about Henry VI seated on his throne (Berne, Stadtbibliothek, MS. 120, fol. 146a). Cf. Petri Ansolini de Ebulo *De rebus siculis carmen* a cura di Ettore Rota (Muratori, *Scriptores* XXXI, 1), Città di Castello 1904, pl. LII.
In the *Ludus de Antichristo*, written about 1150, Misericordia bearing an olive-branch and Justitia with balance and sword appear on either side of Ecclesia. The Antichrist is supported by Hypocrisis and Haeresis (Migne *P. L.* 213, 949 and 953).
[3] Socrates had defined them as forces of the soul, which work together to perfect the human being (Xenophon, Ἀπομνημονεύματα, Γ, IX, 4 ff.). Cicero had handed them on to Christian thinkers *(De officiis* I, 5) and Ambrose had stamped them as gifts of divine grace, by representing them as being supported by Christ, the foundation of all things *(De officiis ministrorum*, lib. I, cap. 50; Migne *P. L.* 16, 106 sq.).
[4] Alcuin writes thus: "Magnum te faciat Deus et vere beatum, domine mi rex, et in hac virtutum quadriga, de qua paulo ante egimus, ad coelestis regni arcem geminis dilectionis pennis saeculum hoc nequam transvolare concedat" *(Dialogus de rhetorica et virtutibus;* Migne *P. L.* 101, 946) or again:
> "Sit via prudens, via fortis, arcta,
> justa seu solers, bene temperata,
> huius ut cursus peragamus aevi
> tramite recto" *(Sequentia de S. Michaele ; Monumenta Germaniae Historica, Poetae latini* I, p. 349).
Cf. further Rabanus Maurus, *Tractatus de anima*, cap. 10: "His itaque quattuor virtutibus quasi solidissimis columnis omnis regiae dignitatis honos decusque attollitur, feliciterque cuncta gubernantur atque exornantur" (Migne *P. L.* 110, 1118).

the virtues and then the details of their appearance, sequence and distinguishing characteristics.

The recognised mode of portrayal becomes established in the 9th century. On the dedicatory miniature of the Bible of S. Callisto (between 876 and 888) the four cardinal virtues appear behind the throne, rounded for perspective, on which Charles III, the Fat, is sitting[1]. But in the picture of the Psalmist in the first Bible of Charles the Bald (mid-9th century) they are already separated from the mandorla-like central picture and are arranged in the corners[2].

The dedicatory miniature of the Cambrai Gospels (second half of the 9th century) represents a higher stage of development (Fig. 32)[3]. The centre of the miniature fills a diamond-shaped frame which encloses a king whose identity cannot be established. In the remaining corners the artist has drawn circles which serve as frames for the virtues. He thus arranges the four spiritual forces around the ruler by means of a logical and systematic division of the parchment, which is, moreover, covered with rows of dots; thus the representation is deliberately two dimensional. The pictorial content fuses with the formal composition to form a parabolic unity. Just as the four circles open into the diamond-shaped central frame, so should the king in the interests of his high office let himself be influenced and filled by the cardinal virtues.

The traditional form of the medallion-picture, such as appears in the mosaics of the Seasons or the Majestas Domini, would accordingly seem almost predesigned for the composition of groups of four and is thus used not only for the four major prophets, the elements etc., but for the unity of the four virtues; this process was favoured by the predilection of theological authors for the correlation of the Seasons, the Evangelists, the cardinal virtues and other groups by means of numerical symbolism.

The formative principles applied in the representations of psychomachy are radically different. The pictorial composition of the latter was dynamic and

[1] Rome, S. Paolo fuori le mura, fol. 1 r. The virtues are shown full-length. Prudentia with a book, Justitia with a balance, Temperantia with outstretched hands, Fortitudo armed. Cf. Schramm, *Kaiser und Könige*, fig. 41 and pp. 64 ff.; *Herrscherbild*, p. 193, note 162. — Boeckler, *Abendl. Min.*, p. 109 with bibliography.

[2] Paris, Bibliothèque Nationale, MS. lat. 1, fol. 215 v. Half-figures of the virtues, the upper ones dressed and wearing a veil, the lower ones only wearing veils, rising out of clouds. They are bearing palm-branches and point to the central picture. Cf. Köhler, pl. 72 and Text II, pp. 57 ff. — Boeckler, *Abendl. Min.*, pp. 108, 109 with bibliography.

[3] Cambrai, Bibliothèque Municipale, MS. 327, fol. 16 v. The virtues are shown full-length. Their attributes correspond cf. p. 31, note 1, but Temperantia is holding a torch and a jug. Cf. Schramm, *Kaiser und Könige*, fig 32. and pp. 58, 59; 180 with bibliography.

31

unified; here, however, we have a static, articulated type of composition. There is no dramatic tension. Only the virtues are represented. Distinguished by symbols, they become part of a sphere of illustration which no longer bears any relation to reality, and represent, within a significantly constructed linear framework, the moral qualities treated in the main theme.

Up to the 10th century the four medallions of the virtues occupy the corners. From this time onwards they are frequently enclosed in a frame, four nails, as it were, fixing the main theme as an important piece of moral teaching, eternally valid. Occasionally only busts accompanied by inscriptions are executed in the medallions, instead of full-length or half-figures decorated with attributes. Progressive refinement causes the medallion-pictures of the virtues to depart farther and farther from their classically pre-conditioned, original form in order to adapt themselves to the bold thought associations of mediaeval thinkers. The type is thus capable of much change and expansion, wherein its real strength first becomes fully apparent.

The medallion-picture shows its scope by including within its compass secular and ecclesiastical personages. It exalts the rulers of the earth above their transitory existence, as the enthroned king in the Cambrai Gospels for instance, or the Emperor Henry III, who is shown in the dedicatory miniature of the Codex Aureus in the Escurial (between 1033 and 1046), presenting the book to the Virgin Mary, while the Empress Agnes is being blessed by the Queen of Heaven[1]. In the same way it lends a deeper meaning to the Old Testament figure of David (the first Bible of Charles the Bald), or to scenes from the life of Gregory the Great (Flemish miniature, first half of the 12th century[2]).

When the individual is considered and treated in a wider connexion, an increased articulation of the frame-design follows. On a Rhenish miniature of about 1130, Archbishop Frederick I of Cologne (1099–1131) is seated enthroned below the figure of Christ, who is giving his benediction; the whole is framed in by head-and-shoulder portrayals of the prophets and apostles and by the virtue-medallions. The archbishop sits well sheltered

[1] Cod. Real Biblioteca de El Escorial, Vitr. 17, fol. 3 r. The inscriptions surrounding the medallion-pictures read thus: "Justitia virtus eximia et alta — Temperantia inter agnum et leonem media — Fortitudo contra vitia bellatrix invicta — Prudentia doctrix disciplinae." Cf. Boeckler, *Evangelienbuch*, fig. 7 and pp. 17; 9, note 1 with bibliography.

[2] Valenciennes, Bibliothèque Municipale, MS. 512, fol. 4 v. In the top half of the picture the saint is enthroned between his parents. The lower part shows him visited by an angel. The virtues are shown full-length. Sapientia holds a book, Temperantia mixes the contents of two vessels, Fortitudo tears open a lion's jaws and Justitia bears a balance. In the *Vita* of the saint, written by Paulus Diaconus, occurs the following: "Unde non est dubium eum perfectionem ipsarum assecutum esse virtutum, quarum tam efficaciter intimare valuit effectus" (Migne *P. L.* 75, 45).

in the Civitas Dei amidst its salutory influences as if he were protected by the walls of the heavenly Jerusalem, the gates of which are figures of the Old and New Testaments and the towers, virtues (Fig. 33)[1].

Similar powers also take the place of the cardinal virtues. Thus the four women's busts surrounding a figure of King Solomon writing, which form part of the initial-illumination at the beginning of the Book of the Proverbs in the Arnstein Bible (second half of the 12th century), represent the intellectual gifts which Solomon praised[2]: "Ego sapientia habito in consilio (Prov. VIII, 12); mea est prudentia, mea est fortitudo (VIII, 14); per me principes imperant et potentes decernunt justitiam (VIII, 16)."

Since the cardinal virtues are regarded in a special sense as the benefits of grace which man gains from the eucharist, they are included in liturgical scenes. They occupy the corners of a miniature of the Autun Sacramentary (844–5), in which the Abbot Raganaldus blesses the people from the altar[3]. In a Rhenish Sacramentary of the early 11th century they surround the scene in which Christ gives the sacrament to St. Dionysius and his companions (Fig. 34)[4].

Not only particular personages and liturgical scenes but initial-pages are also framed by the cardinal virtues; the Holy Scriptures are, of course, a fount from which these spiritual forces flow[5]. Departing from custom, the Book of the Gospels of the Abbess Hitda of Meschede (circa 1030) shows,

[1] Cologne, Dombibliothek, MS. Fol. 59, lectionary of Archbishop Frederick, fol. 1 r. The virtues are portrayed half-length. Fortitudo armed (Surrounding inscription: "Constans, fortis, dirumpes vincula mortis"), Prudentia with book and snake ("Vinces prudenter, quicquid toleras patienter"), Justitia with balance ("Justiciae normam pietas non deserat umquam"), Temperantia with two vessels ("Fervorem vite discretio temperet in te"). Cf. Heinrich Ehl, *Die ottonische Kölner Buchmalerei*, Bonn-Leipzig 1922, fig. 103 and pp. 246 ff. — Clemen, fig. 513.

[2] London, British Museum, Harl. MS. 2799, fol. 57 v. The virtues are holding scrolls with name-inscriptions. Cf. George F. Warner, *Illuminated Manuscripts in the British Museum* III, London 1901, pl. 18.

The Book of the Gospels of Henry the Lion (cf. p. 9, note 3) also contains, on fol. 172 v, an author, John the Evangelist, surrounded by virtues: Fortitudo armed, Prudentia with book and snake, Justitia with balance, Temperantia with a vessel and three flowers, all represented as half-figures. Cf. Jansen, pp. 85, 86.

[3] Autun, Bibliothèque Municipale, MS. 19, fol. 173 v. Prudentia with cross-staff and book, Fortitudo armed, Temperantia with jug and torch, Justitia with balance; all are represented full-length. Cf. Köhler, pl. 68 b and Text II, pp. 96 ff.

[4] Paris, Bibliothèque Nationale, MS. lat. 9436, fol. 106 v. The virtues shown as half-figures, Prudentia with book, Temperantia with two vessels, Fortitudo armed, Justitia with balance. Cf. Abbé V. Leroquais, *Les sacramentaires et les missels manuscrits des Bibliothèques publiques de France*, Paris 1924, pl. XXXII.

[5] 10th century Cologne missal (Paris, Bibliothèque Nationale, MS. lat. 817, fol. 77 v). — Ste. Chapelle Book of the Gospels, between 967 and 983, Trier (Paris, Bibliothèque Nationale, MS. lat. 8851, fol. 16 v); cf. Boeckler, *Evangelienbuch*, fig. 168. Head-and-shoulder portraits of the virtues are given in both cases.

The Ratmann Sacramentary, completed 1159 (Hildesheim, Cathedral Treasure, MS. 37, fol.

besides the heads of the cardinal virtues (at the beginning of the Gospel of St. Matthew)[1], the theological virtues together with Humilitas (at the beginning of the Gospel of St. John; Fig. 35)[2], thus comprising as a whole the system of seven based on Humilitas, a system frequently adopted in literature[3].

Thus, in many places and at various times, the representation of systems of virtues adopts the typical form of the medallion-picture, and in such a way that connexions and influences cannot always be established. The growth of this branch of illustration may be clearly observed, however, in the Ratisbon book-illuminations. Here, about the year 1000, the miniaturists steadily developed a traditional design, refined and clarified it continuously

118 v). Prudentia with snake and dove, Fortitudo armed, Justitia with balance, Temperantia mixing the contents of two vessels. Cf. Boeckler, *Abendl. Min.*, p. 119 with bibliography.

A missal belonging to Count Fürstenberg-Stammheim is closely related. But Prudentia's dove is missing. Concerning both MSS. cf. further Stephan Beissel, "Ein Missale aus Hildesheim und die Anfänge der Armenbibel" *(Zeitschrift für christliche Kunst* XV, 1902, cols. 265 ff., 307 ff.).

In the Helmarshausen Book of the Gospels, 1194, Jesus Sirach is framed by head-and-shoulder representations of the cardinal virtues, who are holding scrolls with name-inscriptions (Wolfenbüttel, Herzog-August-Bibliothek, MS. Helmstedt 65, fol. 62 r). Cf. Jansen, fig. 33.

[1] Darmstadt, Landesbibliothek, MS. 1640, fol. 25 r. Cf. Elisabeth Schipperges, *Der Hitda-Codex (Rheinische Meisterwerke V)*, Bonn 1938, fig. 10.

[2] Fol. 173 r.

Another peculiar instance: In the Golden Book of the Gospels of Echternach, between 983 and 991 (Gotha, Landesbibliothek, MS. I. 19, fol. 114 r), half-figures of special virtues of Mary (Virginitas, Sobrietas, Continentia, Castitas), holding scrolls with name-inscriptions, border the "In principio". Cf. Anton Chroust, *Monumenta palaeographica*, second series, 9th part, pl. 8. — On fol. 3 r frame-medallions of the cardinal virtues surround two archangels, who bear a tablet on which is a warning to the reader.

[3] Head-and-shoulder representations of the Beatitudes (Matth. V, 3 ff.) are also given, e. g. in the sacramentary from St. Maximin at Trier, last quarter of the 10th century (Paris, Bibliothèque Nationale, MS. lat. 10501, fols. 8 v, 9 r; cf. Goldschmidt, *Illumination* II, pl. 15) and in the Codex Aureus in the Escurial (fols. 3 v, 4 r; cf. Boeckler, *Evangelienbuch*, figs. 8, 9).

Only very rarely were both virtues and vices incorporated in the frame of a miniature. In the illustration of the Fall of the angels in the W. de Brailes Psalter, circa 1240, Caritas, Humilitas and Patientia in the upper border are ascribed to the heavenly sphere, while Avaritia, Superbia and Ira down below illustrate the fiendish opposition (Fitzwilliam Museum, Cambridge). Cf. Sydney C. Cockerell, *The Work of W. de Brailes*, Cambridge 1930, pl. XV and p. 15. — Eric George Millar, *The Library of A. Chester Beatty*, London 1927—30, pl. LXXXIX a, and pp. 122, 123.

It also remains an exception for spandrels or initials to serve as settings for individual virtues. The Book of the Gospels of Henry the Lion shows in the spandrels Spes and Fides as knights (fol. 13 v), Fortitudo conquering the lion and Prudentia with book and snake (fol. 14 r), Justitia with balance and measuring-rod and Temperantia with bottle and spray of blossom (fol. 14 v), all as half-figures. Cf. Jansen, p. 68.

In an Origen manuscript from St. Bertin, circa 1130, virtue-medallions are worked into the frame of an I-initial. Only Fides is designated by name, Patientia, by a sword piercing her neck, Prudentia, by a snake (St. Omer, Bibliothèque Municipale, MS. 34, fol. 1 v). A Northern French miniaturist of the *Decretum Gratiani*, c. 1170, fills out an I-initial with medallions of the cardinal virtues, who are bearing scrolls with name-inscriptions (Berlin, Preussische Staatsbibliothek, MS. lat. Fol. 1, fol. 1 r).

and at the same time lent it fresh moral significance born of theological profundity.

The starting point for the development of this series was the picture which Romualdus caused to be inserted in the Codex Aureus of St. Emmeran towards the end of the 10th century (Fig. 36)[1]. It shows the abbot in a diamond-shaped frame at the corners of which there are circular medallions with the busts of four virtues (Sapientia, Prudentia, Misericordia, Justitia). A second rectangular frame encloses the four circles and in the corners of this second frame there are squares containing the symbols of the Evangelists.

In the Book of the Gospels of the Abbess Uota of Niedermünster (1002 –1025) the double frame design is less rigid and an interplay of forces begins[2]. The loosened structure of the picture supports various broadly conceived themes. The central design surrounds the world-creating hand of God in the midst of four virgins, the models in accordance with which the works of creation were endowed with gifts. This central design extends beyond the outer frame with its pictures of the cardinal virtues, the immutable characteristics of God, just as the act of creation, an unparalleled concentration of the divine powers, is brought into relief against the omnipotence of God (Fig. 37)[3].

The dedicatory miniature shows the same design. Here there is a double ring of eight virtues surrounding Mary and the Child, to whom Uota presents the Book of the Gospels. The virtues are not designated in any way[4].

On another leaf, the sacrament of the mass, celebrated by St. Erhard, is included with the portrayals of the "Domina abbatissa" and three virtues, in accordance with the *Regula S. Benedicti*[5]. A virgin, who lays her hands over heart and breast, illustrates clearly the "Unice pietatis affectus"[6]. The command: "Et sive secundum Deum sive secundum saeculum sit opera, quam iniungit, discernat et temperet"[7] is explained by a scene entitled

[1] Munich, Bayerische Staatsbibliothek Cod. lat. 14000 (Cim. 55), fol. 1 r. Cf. Swarzenski, *Regensburg*, pl. 1, no. 1 and pp. 32 ff. — Boeckler, *Abendl. Min.*, pp. 109, 110 with bibliography.
[2] Munich, Bayerische Staatsbibliothek, Cod. lat. 13601 (Cim. 54). Cf. Swarzenski, *Regensburg*, pp. 88 ff. — Boeckler, *Abendl. Min.*, p. 112 with bibliography.
[3] Fol. 1 v (Swarzenski, *Regensburg*, pl. XII, no. 28 and pp. 91, 92). The attributes of the cardinal virtues as on p. 33, note 4.
[4] Fol. 2 r (Swarzenski, *Regensburg*, pl. XII, no. 29 and pp. 92, 93. — Goldschmidt, *Illumination* II, pl. 76).
[5] Fol. 4 r (Swarzenski, *Regensburg*, pl. XIII, no. 31 and pp. 97 ff. — Goldschmidt, *Illumination* II, pl. 77 b).
[6] "...abbas... pium patris ostendat affectum" *(Benedicti Regula*, cap. II, p. 15).
[7] *Ib.*, cap. LXIV, p. 120.

"Discretionis temperamentum". A woman engaged in teaching punishes the naughty children with wise restraint, while a basket of fruit serves as a reward for the well-behaved. Lastly, a female half-figure holds a large book of rules. The index-finger of her right hand, placed across her mouth, commands silence as a sign of the „Districtionis rigor"[1].

A little later, the dedicatory miniature in the Book of Gospels of Henry II (between 1014 and 1024) shows the traditional design in its clearest form; it is now threaded throughout with inscriptions (Fig. 38)[2]. The emperor is seen as mediator, not only formally but literally, between heavenly and earthly figures ("Imperii solio fulget Heinricus avito. Caesar et Augustus trabeali munere dignus"). Just as his endeavours stand in general need of the benefits of heavenly grace, incorporated in the descending dove of the Holy Ghost ("Spiritus alme Deus regem benedicito clemens"), so must his decisions be determined by the noblest qualities of a monarch. In addition to "Sapientia" and "Prudentia", who are portrayed in two medallions, one on each side of him ("Consiliis sacris apta est sapientia regis—Suggerit hinc cautam causis prudentia normam"), "Justitia" and "Pietas" appear in the upper corners of the frame. For already in the Old Testament it runs: "Posside sapientiam, quia auro melior est, et acquire prudentiam, quia pretiosior est argento" (Prov. XVI, 16) and: "Aufer impietatem de vultu regis et firmabitur justitia thronus eius" (Prov. XXV, 5)[3]. The lower circular medallion illustrates the practical maintenance of the imperial virtues. A henchman awaits the emperor's signal to behead a tyrant ("Caesaris ad nutum dampnant lex jusque tyrannum"). Pictures of "Lex" and "Jus", statute and general law, accompany the judgment scene[4]. Rectangles and medallions are worked together and interlace more definitely according to their significance than hitherto. The sentence: "Discernant leges pietas justitia mites" indicates the connexion between the four smaller figures in the rectangles. At the same time there exists in the upper sphere a close affinity of content between the four virtues as spiritual entities, and in the lower sphere Lex and Jus, great actualities, belong to the judgment scene.

[1] "Consideretur semper in eis inbecillitas et nullatenus eis districtio Regulae teneatur in alimentis" (cap. XXXVII, p. 75).
[2] Rome, Biblioteca Vaticana, Cod. Ottob. lat. 74, fol. 193 v. Cf. Swarzenski *Regensburg*, pp. 123 ff. — Goldschmidt, *Illumination* II, pl. 78. — Schramm, *Kaiser und Könige*, fig. 86 and pp. 112, 113.
[3] Cf. further Isidorus Hisp.: "Regiae virtutes praecipue duae: justitia et pietas. Plus autem in regibus laudatur pietas, nam justitia per se severa est" *(Etymologiae,* lib. IX. III. 5, ed. W. M. Lindsay, Oxford).
The Lorsch Chronicle stresses particularly both these imperial virtues: "Cuius quanta fuerint justitiae et pietatis insignia, testatur illa nobilis, quam condidit et in qua conditus est, Babenbergensis ecclesia" *(Monumenta Germaniae Historica, Scriptores* XXI, p. 402).
[4] "Jus generale nomen est, lex autem juris est species" (Isidorus Hisp., *Etymologiae,* lib. V. III. 1).

The Ratisbon miniaturists thus succeeded in comprising for the first time within a highly developed geometrical design a body of carefully worked out ideas (far beyond the scope of the then usual themes), such as the teaching of the moral significance of the creation, of the monastic life and the monarchy. In doing this and in fusing word and picture into a unity, they anticipated in a unique manner the endeavours of succeeding epochs. For it was not till the 12th century that the development of the "virtue-medallion" branch of representation begins elsewhere to aim, like the Ratisbon "prelude", at a more complicated theme and an elaborated distribution of the page.

About 1155, the Flemish miniaturist of the Floreffe Bible conveys in a picture with the motto: "Exemplar morum datur ista figura bonorum" Gregory the Great's exposition of the opening of the Book of Job (Fig. 39)[1]. With unusual boldness he welds together three different spheres of interpretation. The central rose-design, which incorporates the purified realm of moral thought as the basic significance of all activity, dominates the picture. Above it the artist sets the historical event and below it, the typological fulfilment[2].

The seven sons of Job, who are shown with their three sisters sitting at table in the top part of the illustration (Job I, 4), correspond, regarded typologically, with the twelve apostles below the central design, because the number seven, if one multiplies together its components, three and four, produces twelve[3]. Considered from the moral standpoint, they signify the seven gifts of the Holy Ghost[4], of which Isaiah (XI, 1 ff.) speaks: "Et egredietur virga de radice Jesse et flos de radice eius ascendet. Et requiescet super eum spiritus Domini, spiritus sapientiae et intellectus, spiritus consilii et fortitudinis, spiritus scientiae et pietatis et replebit eum spiritus timoris Domini". According to Hugo of St. Victor, they are differentiated from the virtues by the fact that they are the first impulses in the heart, like seeds of virtues scattered on the soil of our heart, while the virtues on the other hand are like the seed which springs from these gifts[5]. The miniaturist shows in the seven small medallions of the centre rose the seven virtues produced by the gifts of the Holy Ghost (Oboedientia, Humilitas, Prudentia, Patientia, Tem-

[1] London, British Museum, Add. MS. 17738, fol. 3 v. Cf. Michel II. 1, fig. 229.
[2] A miniature in the *Hortus Deliciarum* is related in point of form (fol. 67 v; Straub-Keller, pl. XXIII and pp. 18, 19). "Christus rex et sacerdos" is surrounded by a wreath of virtue-medallions. Oboedientia, Abstinentia, Compassio, Justitia, Paupertas, Sobrietas, Largitas, Castitas, Poenitentia, and Confessio all hold scrolls, the inscriptions of which refer to spiritual instead of animal sacrifices.
[3] *Moralia in Job*, lib. I, cap. 14 (Migne *P. L.* 75, 535).
[4] *Ib.*, cap. 27 (Migne *P. L.* 75, 544).
[5] *Summa sententiarum*, tract. III (Migne *P. L.* 176, 114).

perantia, Benignitas, Providentia); a dove descends on each of the virtues. From the eighth and lowest medallion the right hand of God sends forth from the sphere of pure moral forces rays of virtue on to the apostles. In the centre, Caritas stands between Fides and Spes, for the three daughters of Job are regarded as counterparts to the theological virtues[1]. Just as at the very top of the picture Job, the prototype of Christ, kneeling beside his burnt-offering, prays God for mercy on his children (Job I, 5), so Christ between the apostles pleads with his Father on their behalf[2]. David and Paul are also given as representing the Old and the New Covenants. The foot of this pictorial complex, in the construction of which the idea of God dominates throughout ("vita contemplativa"), is formed by the representation of certain deeds of mercy ("vita activa")[3], a virtue which Job possessed in full measure[4]. One can hardly imagine a more striking example of mediaeval exegesis.

The miniaturists thus conceived of the most varied groups of moral forces as human figures and fitted them into designs with an eye to significant inter-relation between the parts, while in literature these moral forces were only given by name or described according to their significance or effects. But even the closely-knit medallion representations had their limitations. They were broken by the intensified powers of perception of the miniaturists or the authors. It was as if the power of mystical contemplation broke through the forms of rational comprehension.

In the 13th century a German miniaturist developed a scene of intense dramatic quality from a moral interpretation of Christ's death on the cross by Bernard of Clairvaux. In a sermon on the Passion, Bernard had as-sociated definite virtues (Patientia, Humilitas, Caritas, Oboedientia, Miseri-cordia, Sapientia) with the death on the cross[5] and, on another occasion, he had ascribed symbolically as an ornament for the head of the cross Caritas, for the foot, Humilitas, and for the arms, Oboedientia and Patientia[6]. The miniaturist, with a proclivity to mystical thought, intensifies this subsequent exposition and transforms it into a painfully shared experience. The onlooker

[1] *Moralia in Job*, lib. I, cap. 27 (Migne *P. L.* 75, 544).
[2] *Ib.*, cap. 22 (Migne *P. L.* 75, 541).
[3] This interpretation follows from the inscription:
 "Signum vitarum sunt hec depicta duarum,
 Quarum practica prima, secunda theorica vita.
 Prima gemit, plorat, dolet et patiendo laborat,
 Anxia turbatur, dum circa multa vagatur.
 Altera letatur, recreatur, dum speculatur.
 Unum nam cernit, pro quo iam plurima spernit."
[4] *Moralia in Job*, lib. XXI, cap. 19 (Migne *P. L.* 76, 207).
[5] Migne *P. L.* 183, 263 ff.
[6] *Ib.*, 275.

does not see for instance the picture of a crucifix framed by virtues, rather is he made to realise that it is the virtues who are crucifying Christ in order to prove themselves at his death (Figs. 40, 41). Directly, as in a vision, and with unsparing clearness, the voluntary sacrifice of the Son of God is revealed as the real significance of the historical crucifixion[1].

The preserved copies are basically the same and only differ in certain particulars[2]. As a rule, three virtues drive nails through the hands and feet of Christ, while the fourth pierces his chest with the lance or catches his blood in the chalice. The designations of the various figures are freely chosen from the names given by Bernard, Oboedientia, Misericordia, Humilitas and Caritas for instance, or Misericordia, Sapientia, Oboedientia and Fides. Sometimes no names are given. The accompanying figures also vary (Mary and St. John, saints, founders, Ecclesia and Synagogue, heads of the prophets above the cross).

It speaks for the strength of the medallion tradition that in both the oldest known copies (circa 1250–60; Fig. 40) the two virtues in the upper part of the picture are portrayed as half-figures fulfilling their bitter task from circular medallion-frames. In other miniatures, however, even these remains of a strictly formal design disappear and the virtues stand or hover at the points of the cross (Fig. 41).

The binding force of the medallion type of representation is further shown in another picture of a mystical nature. The book-illuminators of St. Amand near Valenciennes repeatedly illustrated the ascension of St. Amandus according to a vision of St. Adelgundis[3].

[1] The relation of the illustration to the text was first discovered by Hanns Swarzenski (p. 19, note 1). Cf. also Alanus ab Insulis: "In passione, inquam, fuit misericordia, quae filium Dei... affixit patibulo" *(Sermo II de S. Cruce; Migne P. L.* 210, 224).

[2] Hanns Swarzenski gives a list of the surviving copies (p. 96, note 1). The following are of the 13th century:

 1. Düsseldorf, Landesbibliothek, MS. B. 31, fol. 122 v, circa 1250, perhaps from the Cistercian Abbey of Heisterbach (Hanns Swarzenski, fig. 158).

 2. Cologne, Stadtarchiv, MS. W. f. 255, circa 1250–60 (Hanns Swarzenski, fig. 162).

 3. Besançon, Bibliothèque Municipale, MS. 54, fol. 15 v, circa 1260, from the diocese of Basle (Hanns Swarzenski, fig. 569).

 4. Donaueschingen, Library of Prince Fürstenberg, MS. 185, fol. 8 r, later than 1254, from the diocese of Strasbourg (Hanns Swarzenski, fig. 505).

 5. Oxford, Keble College, legendary, fol. 7 r, soon after 1271, from the Monastery of the Holy Cross, Ratisbon (Hanns Swarzenski, fig. 343).

 6. Engelberg, Stiftsbibliothek, MS. 61, fol. 5 v, second half of the 13th century, from the Engelberg Convent (Hanns Swarzenski, fig. 540).

 7. Ratisbon, Cathedral Treasure, miniature of a reliquary, circa 1280 (Hanns Swarzenski, fig. 391).

[3] *Acta Sanctorum*, January II, p. 1037.

The oldest surviving miniature (late 11th century) shows the old man ascending into heaven accompanied by groups of the blessed (Fig. 42)[1].

Now a copyist of the latter half of the 12th century introduces into the picture a passage from the Vita of the saint written by Milo of St. Amand. In the enumeration of the gifts which everyone offers to the church, it reads: "Fertur ab hoc coccus gemino bis tinctus amore"[2]. The artist turns the double conception here mentioned into two virgins designated as "Dilectio Dei" and "Dilectio proximi" (Inscription: "Quam bene bis tinctus coccus foris ornatus et intus.") and lets them bear the saint up to heaven (Fig. 43)[3]. Here too there is a circle drawn behind each of the virtues and their particular sphere of existence is indicated in this way. With the aid of the two allegorical figures, the saint goes through the various spheres, formed by the branching framework, which divides the once unpartitioned space of heaven into graduated regions in which the groups of the blessed are separated from one another[4].

If it is now the miniaturists who with visionary power develop the weak beginnings of the text into striking pictures, the authors are also able to build a bridge from the abstract to the concrete and indicate a definite line for the miniaturists to follow.

In Psalm LXXXIV, 11 (85, 10) the four virtues are referred to as if they were human beings: "Misericordia et veritas obviaverunt sibi, justitia et pax osculatae sunt". When the artists seized upon this theme, they followed the text and depicted two pairs of virgins embracing and kissing each other. The earliest surviving representations are to be found in psalters of the 9th

[1] Valenciennes, Bibliothèque Municipale, MS. 502, fol. 119 r (Boeckler, *Abendl. Min.*, pl. 50 and pp. 57, 58, 114). The representation resembles the western type of the Ascension.

[2] Lib. IV, v. 499 (*Monumenta Germaniae Historica, Poetae latini* III, p. 609).

[3] Valenciennes, Bibliothèque Municipale, MS. 501, fol. 31 r. The representation now approximates to the eastern type of the Ascension.

[4] In a copy of the late 12th century the inscriptions are omitted (Valenciennes, Bibliothèque Municipale, MS. 500, fol. 67 r). Cf. Boeckler, *Abendl. Min.*, p. 120.

In a miniature of the death of Lambertus of St. Bertin (d. 1125) there may be seen in semicircles on either side of Christ, who is receiving the soul of the departed, Mary and St. Martin, Eleemosina and Patientia as mediators. Patience bears a sword on her neck (Boulogne, Bibliothèque Municipale, MS. 46, fol. 1 v, circa 1125–30). The Vita of the abbot, written between 1116 and 1119, praises both virtues: "Erga delinquentes fratres omnem sollicitudinem gerebat, ut reatum suum recognoscerent, et cognitum, quod sui proprie proprium erat, *misericordia*, qua semper affluebat, statim remitteret, recordans, quod in evangelio dictum est: Beati misericordes, quoniam ipsi misericordiam consequentur. *Patientiae* perfectum opus in omnibus causis suis exhibebat amicos in hoc concilians, inimicos vero pro hoc vincens" (*Monumenta Germaniae Historica, Scriptores* XV, p. 949).

century, e. g. in the Utrecht Psalter (Fig. 44)[1]; here, moreover, Mary, according to v. 12: "Veritas de terra orta est et justitia de caelo prospexit", holds up the child Christ (Veritas) for Justitia, who is bowing down from heaven to receive him.

The theologians of the 12th century sought for an explanation of the passionate meeting and embraces of the four spiritual forces. The first man, says Bernard of Clairvaux[2], was endowed with them only to lose them again at the Fall. Thereupon they quarreled with each other. Veritas and Justitia, the stricter ones, said that man must die. Misericordia and Pax on the other hand demanded mercy on his behalf. And now Misericordia and Veritas hasten to the throne of God the Father in order to submit their accusations. They then meet before God the Son, who, as a wise judge, resolves the conflicting demands of both parties and decides that, if any man die a good death out of love for another, Death cannot hold him, since he owes nothing to Death. God the Son promises that he himself will effect such a redeeming sacrifice and by this wise verdict of the Redemption he also reconciles Justitia and Pax, so that they kiss one another, as described in the Psalm. On the strength of this exposition the miniaturists occasionally included thoughts of the Incarnation in the content of their pictures and associated both groups with the Tree of Jesse[3], the Visitation (Fig. 45)[4] or the Nativity[5].

[1] Utrecht, University Library, Cod. 32, fol. 49 v. Cf. De Wald, pl. LXXVIII. (One or more of the virtues appears in other psalms, according to the text, e. g. Ps. XXXIX, XLI, XLII, XLIV, LXXXVIII etc.). There is a faithful copy in the Canterbury Psalter, mid-12th century (Cambridge, Trinity College, MS. R. 17. 1; cf. M. R. James, *The Canterbury Psalter*, London 1935). The same composition, exceptional in that it is strengthened by a linear design, occurs in a Salzburg missal, circa 1140. In the prefatory sign, Justitia and Veritas are placed above and below the half-figures of the two horizontally arranged pairs (Stuttgart, Landesbibliothek, Cod. Bibl. Fol. 20, fol. 80 v). Cf. Swarzenski, *Salzburg*, fig. 382.
Both groups are also given in the Byzantine Cod. gr. 1927, fol. 156 r, of the Biblioteca Vaticana, 12th century. Cf. Tikkanen, *Psalter*, p. 96.
Justitia and Pax: Stuttgart Psalter, 9th century (Stuttgart, Landesbibliothek, Cod. Bibl. Fol. 23, fol. 100 v. Cf. Ernest T. De Wald, *The Stuttgart Psalter*, Princeton 1930, p. 76).
[2] Migne *P. L.* 183, 383 ff. — Rupert of Deutz has much the same *(De glorificatione Trinitatis et processione S. Spiritus;* Migne *P. L.* 169, 187 sq.). — Cf. further Hugo of St. Victor (Migne *P. L.* 177, 623).
[3] Bible of Lambeth Palace, London, MS. 3, fol. 198 r, first half of the 12th century (Saunders, pl. 40 and p. 38. — Millar, pl. 41 and pp. 83, 84).
[4] Peterborough Psalter, mid-13th century (Brussels, Bibliothèque Royale, MS. 593, fol. 10 r), almost certainly copied from destroyed frescoes in the choir of Peterborough Cathedral. Cf. Cornell, pp. 130, 131. — Saunders, p. 104. — Millar, pp. 66, 67.
Justitia and Pax (v. 11) — Visitation — Veritas and Justitia (v. 12): Book of the Gospels of Henry the Lion, fol. 110 v (see p. 9). Cf. Jansen, p. 79.
[5] Veritas and Justitia — Nativity: Single leaf in Westphalia, privately owned, circa 1175 (Swarzenski, *Kunstkreis*, fig. 211 and pp. 268, 269).
Misericordia and Veritas—Christ: Peterborough Psalter, circa 1220 (Cambridge, Fitzwilliam

While the words of the Psalm are confined to allusions, it was reserved for a seeress endowed with grace, St. Hildegard of Bingen (1098–1179), to see in certain visions of her *Liber Scivias* clearly defined pictures of societies of virtues of a particular kind; they even spoke quite frequently[1]. They play an important part in the allegorical universe which the saint reviews in temporal sequence. All details of form and size, of clothing and bearing are impressed on her consciousness and are interpreted by means of divine revelation. Sometimes, contrary to the normal conception of the outward appearance of the virtues, certain beings reveal themselves to her, dissolved in light or having unusual characteristics.

The miniaturist, who illustrated the visions about 1175, tries to reproduce faithfully the wealth of the text. He even sometimes includes the openings of speeches from the body of the text on scrolls which he places in the hands of the virtues or unrolls beside them[2].

Two spiritual forces endowed with God's grace appear already in the introductory vision. They stand at the foot of the hill on which the Divine Majesty is enthroned: Timor Domini covered all over with eyes, because he is able to see into the heavenly kingdom, and Humilitas, whose head is covered by the stream of rays, shedding divine strength[3].

In the third part of the visions, in which Hildegard now sees the whole course of salvation in the rigid form of a City of God, the walls of which correspond with the various epochs, virtues are visible at many points among the symbolic architecture, for they decorate the Old Testament time of preparation as well as the redemption by Christ.

Where there is a wall representing the time from Noah to Abraham and Moses, five spiritual forces occupy the tower which represents the divine will preparing salvation; they stand in niches with a common roof. They sprang up

Museum, MS. 12, fol. 12 v). Cf. Saunders, pl. 64 and pp. 60, 61. — Millar, pl. 71 b and p. 48.

Both groups — Sedes Sapientiae: Besides the enthroned Mary, who is interpreted as the "Sedes Sapientiae", the throne of Christ, of the true Solomon, in the fresco on the east wall of the Church of the Baptism in Brixen, mid-13th century (Joseph Garber, *Die romanischen Wandgemälde Tirols*, Vienna 1928, fig. 71 and pp. 99, 100). For the interpretation cf. Petrus Damiani, *Sermo in nativitate Beatissimae Virginis Mariae* (Migne *P. L.* 144, 736 sq.).

Pietas and Justitia embrace each other and are shown in the same attitude as Misericordia and Veritas on the Quedlinburg knotted carpet which was begun under the Abbess Agnes (1186–1203). The noblest virtues of Sacerdotium (enthroned bishop) and Imperium (monarch) are thus united. The cardinal virtues stand on either side. Pudicitia is shown as a half-figure in the sole remaining medallion-frame (Betty Kurth, *Die deutschen Bildteppiche des Mittelalters*, Vienna 1926, pls. 12–14).

[1] Migne *P. L.* 197, 383 ff. Cf. Liebeschütz, particularly pp. 22 ff. with bibliography.
[2] Wiesbaden, Landesbibliothek, Cod. 1. Cf. the descriptions in Keller and Baillet.
[3] Pars I vis. 1, fol. 2 r. Cf. Keller, pl. 3 and pp. 26 ff. — Baillet, fig. 2 and pp. 57 ff.

in the Old Testament according to the divine will as foretellers of the coming manifestation of redemption. The miniaturist depicts them in two ways. He first lays out the arcades flat in every direction and then shows them once again side by side on the ground-plane (Figs. 46, 47)[1]. The division between the figures thus remains a spacial one. Amor coelestis bears a palm-branch and flowers, the promised reward of eternal life. Disciplina is protected against sinful lusts by a purple garment signifying the law of God and the mortification of the flesh. Verecundia hides her face from the sight of sin. On Misericordia's breast appears the picture of Christ, who had mercy upon men. And finally the armed Victoria stands over a lion and figures of sinners, because ever since the fall of Adam she destroyed iniquity. Two virtues, who stand apart and have outgrown the others, turn towards this tower: Patientia crowned because she gained the victory through Christ, and Gemitus holding a crucifix as a constant reminder of the sufferings of Christ.

If, as in this and several other visions which show the forces of worldliness[2] and of the Church[3], the virtues are only introduced as contemplative figures, they can also be made to perform a completely different task, that of joining in the actual building of the symbolical city. The old conception of the virtues carrying stones to the Tower of the Church thus gains fresh life[4]. Hildegard tells how spiritual forces descend a ladder which hangs against the "Column of the Redeemer" and go down into the souls of willing human beings in order to climb up again laden with stones, the good deeds, so that the work of Christ may be soon completed. Seven virtues, interpreted as the gifts of the Holy Ghost, particularly attracted her attention. The miniaturist depicts them on either side of the column (Fig. 48)[5]. Humilitas, representing the most distinguished characteristic of Christ, wears a golden chaplet. In the mirror

[1] Pars III vis. 3, fols. 138 v and 139 r. Cf. Keller, pl. 21 and pp. 78 ff. — Baillet, figs. 16, 17 and pp. 104 ff.

[2] Pars III vis. 6, fol. 161 v. Abstinentia stands before an arcaded wall and her crown is breathed upon by the dove of the Holy Ghost. She is surrounded by Largitas, on whose breast a lion (Christ) is seen and around whose neck is wound a snake, and by Pietas, on whose breast there appears an angel. Veritas, who holds the deformed head of Lies and treads on the heads of devilish false-hoods, is to be seen between winged Pax and Beatitudo aeterna, who bears a radiant vessel. Discretio is shown nearby, in the rays of heavenly grace, holding a fan and jewels — a crucifix is leant against her. Salvatio animarum is also present. Cf. Keller, pl. 24 and pp. 89 ff. — Baillet, fig. 21 and pp. 109, 110.

[3] Pars III vis. 9, fol. 192 r. In a building by the "Tower of the Church" there appears a group of virtues. Sapientia stands on an edifice of seven columns, against which Justitia is leaning because she lets herself be guided by Wisdom. Fortitudo, an armed knight, tramples on the aged dragon. The concluding figure is three-headed Sanctitas, who achieves perfection in a three-fold way. Cf. Keller, pl. 27 and pp. 102 ff. — Baillet, fig. 24 and pp. 112, 113.

[4] Cf. p. 5, note 3.

[5] Pars III vis. 8, fol. 178 r. Cf. Keller, pl. 26 and pp. 97 ff. — Baillet, fig. 23 and pp. 110 ff.

of her breast can be seen the reflection of Christ radiating humility. Two strips are woven into the garment of Caritas and these represent love of God and love of one's neighbour. Timor Domini is covered with eyes, for he sees God in all his wonders. Oboedientia lies in heavy bonds because she always adheres to the path of righteousness. Fides wears a red necklace, the symbol of constancy even unto martyrdom. Spes reverently turns towards a crucifix. The dove of the Holy Ghost hovers over and strengthens Castitas, who shows the picture of a boy symbolising innocence. Above them all, Gratia Dei is seen in a blaze of light.

In the first vision, two spiritual forces had experienced the effects of divine omnipotence. Towards the end, five virtues are grouped around Christ, the ruler of the final epoch[1]. God the Father and God the Son thus provide, in the fullness of their mercy, the beginning and the end of the course of the redemption, which is finally resolved in the state of salvation after the Judgment of the World. The various groups of virtues seen by the saint and reproduced by the miniaturist, form, within this extensive frame, a great community extending through the whole passage of time[2].

This general survey of the range of the medallion-pictures has made it possible to realise how systems of virtues no longer conformed to rigid geometrical designs once they assumed in the mind of the miniaturist or author the definite character of active or speaking persons. If, as is usually the case, they have not reached this stage, then the numerous connexions between the various thought-structures are visibly expressed by a subtle sub-division of the surface of the parchment.

The medallion branch of representation of virtues, to which we again turn our attention, achieved a wide distribution not only in the realm of miniature-painting but also on church furniture and equipment, especially in the 12th century, without introducing any essential new features.

[1] Pars III vis. 10, fol. 203 v. At the foot of the "Sedens lucidus" are Desiderium coeleste with scroll, Constantia with two windows in her breast (mirror of faith) and a leaping stag (heavenly longing) above them, Compunctio cordis with scroll. The head and shoulders of Contemptus mundi holding a branch are encircled by a floating wheel, since the activity of God is self contained and ever manifest. By the side of Contemptus mundi is Concordia winged and with a radiant countenance. Cf. Keller, pl. 28 and pp. 108 ff. — Baillet, fig. 25 and pp. 113, 114.
[2] The Scivias-Codex in Heidelberg University Library, circa 1200 (MS. Sal. X. 16) contains here and there some poor miniatures. Cf. A. von Oechelhaeuser, *Die Miniaturen der Universitäts-bibliothek zu Heidelberg* I, Heidelberg 1887, pp. 75 ff. — The illustrations to St. Hildegard's *Liber divinorum operum* in the Biblioteca Governativa of Lucca, early 13th century (Cod. 1942), are a match in expressiveness for the miniatures of the Wiesbaden MS. They also show illustrations of several virtues, Caritas, Humilitas, Pax and Sapientia for instance. Cf. Liebeschütz, p. 10 with bibliography, p. 27.

The usual equation of the four horns of the Old Testament altar (Exod. XXXVIII, 2) with the cardinal virtues[1] repeatedly found its counterpart in artistic practice such as was first established at the beginning of the 11th century in South German work-shops. Portable altars here constructed show in corner medallions the busts of crowned cardinal virtues, occasionally with aureoles, who at most hold a scroll and are only designated by inscriptions. They are arranged around a half-length representation of Christ or the Agnus Dei (Fig. 49)[2]. On the golden antependium from Basle Cathedral (circa

[1] As the Venerable Bede has it: "Ex quo videlicet altari cornua fiunt quattuor, cum quattuor virtutibus saepe ante dictis justorum corda muniuntur" *(De tabernaculo et vasis eius ac vestibus sacerdotum,* lib. II, cap. 11; Migne *P. L.* 91, 450).

[2] I. Bottom of a portable altar from Watterbach (Munich, Bayerisches Nationalmuseum). Cf. Braun, *Meisterwerke* I, fig. 30 and p. 7. — Creutz, fig. 2 and col. 167. — Kleinschmidt, cols. 13, 14.
Bottom of a portable altar (Paris, Musée de Cluny, no. 13073). Cf. Creutz, fig. 1 and cols. 164 ff. — Kleinschmidt, col. 14.
Related to these, the back of Henry II's reliquary of the true Cross in the Reiche Kapelle in Munich, between 1016 and 1024. The frame originally bore twenty four plates with heads of crowned virgins (virtues?). Cf. Bassermann-Schmid, pl. XVII C and pp. 23, 24. —Creutz, col. 164.
II. Of later portable altars, the following may be mentioned:
The Eilbertus Altar from the Guelph Treasure, circa 1150–60 (Berlin, Schlossmuseum). On the upper plate there are two cardinal virtues standing one above the other on each side of the consecration stone. Prudentia holding a disc with the picture of a dove, Temperantia mixing wine and water, Fortitudo armed, Justitia with balance. Cf. *Welfenschatz,* pl. 35 and pp. 127 ff. with bibliography. —Swarzenski, *Kunstkreis,* pp. 310 ff.
An altar from Öttingen, circa 1160, Meuse School (Augsburg, Cathedral Treasure). On the under side the Crucifixion between half-figures of the cardinal virtues. Fortitudo armed, Justitia with plumb-level and set-square, Temperantia with two vessels, Prudentia with snake. Cf. Falke-Frauberger, pl. 77 and pp. 73, 74. — Braun, *Meisterwerke* II, fig. 27 and p. 7. — Kleinschmidt cols. 16, 17.
III. Other altars:
An antependium from Lisbjerg, first half of the 12th century (Copenhagen, National Museet). Beneath three rows of arcades on each side of the central representation, figures of saints and of Pax, Spes, Fides, Patientia, Caritas and Modestia, who, without any particular underlying principle, hold books, a sceptre, an apple and cross Cf. Braun, *Meisterwerke* II, fig. 6. — Hauttmann, illustration on p. 607.
The Alton Towers Triptych, circa 1150, Meuse School (London, Victoria and Albert Museum). Above and below the Crucifixion, circular medallions with half-figures of Caritas and Justitia. Cf. Falke-Frauberger, pl. 79 and p. 131. — Braun, *Meisterwerke* I, fig. 52 and p. 11.—Cornell, p. 128.
Of the altar furnishings for the Remaclus Altar, which Master Godefroid made about 1150 for the Abbot Wibald of Stablo, two discs have been preserved and these bear the half-figures of Fides, who holds a baptismal font — cf. "Una fides, unum baptisma" (Ephes. IV, 5) — and Operatio (Frankfort, Museum of Arts and Crafts, and Basle, R. von Hirsch Collection). The inscription: "Factis atque fide Remaclus vexit ad astra" illustrates the same principle whereby St. Amandus ascended into heaven because of his love for God and his fellow men (cf. p. 40). Above the porch was originally a representation of Christ, which was extended into a rose-design by means of a circle of cardinal virtues, rivers of paradise and symbols of the Evangelists. Cf. Falke-Frauberger, XXIV and pp. 62, 63, 130. — Otto von Falke, "Das Sigmaringer Museum II" *(Pantheon* I, 1928, pp. 115 ff. with illustrations).
The representation of individual virtues is scenically extended on a circular plate of the same art-cycle, circa 1160 (Berlin, Schlossmuseum). Caritas behind an altar offers the Bread and the Wine to the eager faithful, who press around (Falke-Frauberger, illustration facing p. 1, pp. 71, 72).

1020), the greatest achievement of this group, they are shown above an arcature enclosing Christ, the archangels and St. Benedict, and bear witness to the perfection of the Lord of the universe and of his following[1].

The development thus prepared reached its climax in the enamel plaques of Nicholas of Verdun for the Klosterneuburg Ambo—completed 1181, transformed into a reredos in 1329 — especially because here, for the first time, the number of virtues exceeds the normal. The spandrels of the lowest arcade, which contains incidents from the Old Testament "sub lege", are filled by the half-figures of twenty-two virtues[2]. The prophets over the middle arcade (New Testament scenes) and the angels over the top arcade containing the "ante legem" counterparts of the New Testament scenes, correspond with these. That the half-figures should occupy the spandrels of the arcades is quite in accordance with old-established tradition. Even on Early Christian column-sarcophagi small busts of prophets are introduced symbolically above Christ and the Apostles[3].

It is not surprising to find representations of virtues on shrines, for in all descriptions of the lives of the saints the manifold virtuous qualities of these model fighters and sufferers for the faith are highly praised. The Vita of St. Geneviève states quite explicitly that "the spiritual companions" of the patron saint of Paris "were virgins, who bore the following names: Fides, Abstinentia, Magnanimitas, Patientia, Simplicitas, Innocentia, Concordia, Prudentia, Caritas, Veritas, Disciplina. They were closely associated with her throughout her life"[4]. Twelfth-century sermons moreover maintain the justifiability and necessity of such ornamentation. "If the relics of the saints were to remain hidden and did not shine forth with the symbols of the

[1] Paris, Musée de Cluny. Cf. *Die Kunstdenkmäler des Kantons Basel-Stadt* II, Basle 1933, fig. 9. — Hauttmann, illustration on p. 341. — Creutz, p. 168.

[2] The figures, some of which were renovated in 1329, represent the following: Virtus, Gaudium, Oboedientia, Misericordia, Timor, Pax, Temperantia with two vessels, Caritas with loaf and vessel, Pietas, Largitas, Sapientia, Prudentia with snake and book, Sobrietas, Concordia, Fortitudo conquering the lion, Justitia with balance, Spes, Fides, Humilitas, Patientia, Castitas and Veritas. With the exception of Caritas only the cardinal virtues hold attributes. Most of the virgins carry scrolls. Cf. Karl Drexler, *Der Verduner Altar*, Vienna 1903. — Hans Rupprich, "Das Klosterneuburger Tafelwerk des Nikolaus Virdunensis und seine Komposition" *(Jahrbuch der österreichischen Leo-Gesellschaft*, 1931, pp. 146 ff.). — Cornell, pp. 142, 143. — Falke-Frauberger, pp. 88, 89.

On a miniature sequence of the *Figurae Bibliorum*, 13th century (Eton College, MS. 177, fols. 3 r–7 v), ten virtues correspond with New Testament scenes surrounded by Old Testament prototypes. Several virtues bear branches. Caritas (the Nativity), Humilitas (the Baptism), Patientia (the Bearing of the Cross) and Oboedientia (the Crucifixion) are designated by inscriptions. Cf. Montague Rhodes James, *A descriptive Catalogue of the Manuscripts in the Library of Eton College*, Cambridge 1895, pp. 96 ff. — Cornell, pl. E and p. 133.

[3] Sarcophagus in the Lateran Museum, no. 138 (Wilpert, pl. CXXIV, 2).

[4] *Vita S. Genovefae* ed. C. Künstle, Leipzig 1910, p. 7.

virtues", says Thiofridus of Echternach (d. 1110), "what could stir up a longing for heaven in the hard and stony heart of man? What would be capable of freeing it from vice and restoring it to virtue?"[1]

On the front of the Deutz Shrine (between 1165 and 1175), St. Heribert is accompanied, in the manner of the rarer "retinue" type, by his companions in immaculateness, Caritas and Humilitas, who are represented as reverential serving-maids (Fig. 50)[2]. The other shrines, however, only contain busts of virtues on a significantly subdivided background.

On one of the sides of the roof of the Maurinus Shrine in St. Pantaleon, Cologne (after 1181), cardinal virtues occupy the upper spaces between the quatrefoils containing the martyrdoms of saints[3]. The corresponding spaces below are filled by the busts in relief of three apostles and a father of the church, who display to the onlooker scrolls with inscriptions of precepts concerning virtuous behaviour and its reward.

The artists steadily increase the number of virtues. Thus, in the spandrels of the arcade of the Albinus Shrine in St. Pantaleon, Cologne (circa 1185), Pax, Patientia, Castitas, Largitas, Continentia, Humilitas and Bonitas appear out of clouds[4]. The group is similar to that named in the pattern-sequence of the Epistles, Galatians V, 22 ff. for instance, or to those qualities which the 12th century catalogue of Honorius Augustodunensis enumerates among many other virtues[5]. The spandrel figures were obviously influenced by the Klosterneuburg Ambo.

Master Nicholas takes up once again the motive of enchased busts of virtues in the Shrine of the Three Kings at Cologne Cathedral (1180–1200). On the narrow face at the back of the shrine Patientia is placed beside the scene of the Flagellation of Christ, and on the triangle of the gable the theological virtues are arranged. Sixteen further virtues were attached to the Old Testament figures until a caprice of restoration relegated them to the upper storey[6].

[1] Migne, *P. L.* 157, 406.

[2] Deutz, parish-church.
The inscription: "Has, presul Christi, vite socias habuisti" refers to the Vita of the saint written by Rupert of Deutz: "Igitur et illi laude digni sunt sancti, qui per *caritatem* vel propter aedificationem infidelium, fusis ad Deum precibus, virtutes operati sunt, et hic atque ceteri jure honorandi sunt, quicunque propter *humilitatis* custodiam quodammodo fugere studuerunt datam sibi coelitus, et ultro prosequentem eamdem virtutum gratiam. Sed iam earumdem virtutum sancti huius narrationem ingrediamur" (Migne *P. L.* 170, 408). Concerning the shrine cf. Braun, *Heribertusschrein*, fig. 4. — Falke-Frauberger, pl. 83 and pp. 84 ff., 132. — Witte, pp. 58 ff.

[3] Falke-Frauberger, pl. 48 and pp. 40 ff. — Braun, *Meisterwerke* I, figs. 70, 71 and pp. 14, 15. — Witte, p. 55.

[4] Falke-Frauberger, pls. 53, XIX and pp. 51, 129, 142. — Witte, pp. 62, 63.

[5] *Speculum Ecclesiae, In conventu fratrum* (Migne *P. L.* 172, 1087 ff.).

[6] There were figures of Largitas, Benignitas, Prudentia, Misericordia, Bonitas, Sapientia, Concordia, Sobrietas, Parcitas, Castitas, Mansuetudo, Justitia, Oboedientia, Humilitas, Temperantia

Reliquaries were also ornamented with virtues like shrines and here again the artists followed well thought-out schemes of illustration. Old and New Testament teachings are combined on the box-like lower part of the head-reliquary of Pope Alexander (circa 1145), for the gifts of the Holy Ghost are represented as virgins bearing scrolls with inscriptions of the Beatitudes (Figs. 51, 52)[1].

The main theme illustrated on the reliquary of St. Gondulf from St. Servaes in Maastricht (circa 1160–70) is finally derived from a passage of St. Paul (Galat. V, 5 ff.): "Nos enim spiritu ex fide spem justitiae exspectamus. Nam in Christo Jesu neque circumcisio aliquid valet neque praeputium, sed fides, quae per caritatem operatur. Currebatis bene; quis vos impedivit veritati non oboedire?" Such a group is united below the half-figure of the saint (Fig. 53). The central field is occupied by Veritas, represented as an armed knight, because, like Strength, she is always ready for the fray. The four other figures (Fides, Spes, Caritas, Justitia) serve to decorate the semi-circular panels which extend the central square into a quatrefoil[2].

and Pax. Some of them have been destroyed, others were restored in the 18th century. Some of them hold crowns, Prudentia has a book. Cf. Jos. Braun, "Die Ikonographie des Dreikönigenschreins" (*Kunstwissenschaftliches Jahrbuch der Görresgesellschaft* I, 1928, pp. 29 ff.). — Falke-Frauberger. pls. 61, 62 and pp. 54 ff. — Witte, pls. 61 ff. and pp. 64 ff.

One of the shorter sides of the Shrine of Charlemagne, completed 1215 (Aix-la-Chapelle, Cathedral Treasure), shows busts of the theological virtues above Mary and two angels. Cf. Falke-Frauberger, pl. 96 and pp. 95 ff. — Braun, *Meisterwerke* II, fig. 85 and pp. 17, 18. — Witte, p. 71.

The following shrines produced by the Meuse School about 1160–70, are also worthy of mention:

The Shrine of St. Symphorianus (Church of St. Symphorien near Mons). Of the 12th century work the busts of Justitia, Fortitudo and Prudentia on the sides of the roof have been preserved. Cf. Comte J. de Borchgrave d'Altena, "La châsse de Saint Symphorien" (*Revue belge d'archéologie et d'histoire de l'art* III, 1933, pp. 332 ff.).

The Shrine of St. Gislenus (Church of St. Ghislain near Mons). On the sides of the roof there were originally half-figures of virtues carrying books and embodying the moral content of the Ten Commandments. Still preserved are Fides (1st Commandment), Spes (2nd), Caritas (3rd), Patientia (5th), Pudicitia (6th), Temperantia (10th). Cf. Max Creutz, "Die Goldschmiedekunst des Rhein-Maas-Gebiets" (*Belgische Kunstdenkmäler* I, Munich 1923, pp. 123 ff. and fig. 119). — Falke-Frauberger, p. 77. — Marvin Chauncey Ross, "The Reliquary of Saint Amandus" (*The Art Bulletin* XVIII, 1936, pp. 187 ff.), fig. 8.

The Shrine of St. Bernard (Troyes, Cathedral Treasure). On the back of the roof Humilitas, Patientia and Fortitudo overcoming a lion.

The Amalaberga Shrine (Church of Susteren, Prov. Limburg). Gaudium, Prudentia with snake and dove, Justitia with balance, Temperantia with vessels and Pax with olive-branch.

[1] Brussels, Musées Royaux du Cinquantenaire.

The artist has added to the gifts of the Holy Ghost Sapientia and, finally, Perfectio. Cf. K.-H. Usener, "Sur le chef-reliquaire du pape Saint Alexandre" (*Bulletin des musées royaux d'art et d'histoire* VI, 1934, pp. 57 ff.). — Falke-Frauberger, pl. 69 and pp. 61, 62. — Braun, *Meisterwerke* I, fig. 50 and p. 11.

[2] Brussels, Musées Royaux du Cinquantenaire.

Fides bears a font, Spes an olive-branch and a disc with a cross on it, Caritas a loaf and a vessel,

Since virtues on fonts proclaim the purifying effect of the sacrament, the master of the Hildesheim font (circa 1240–50) inserted them in the four ribs dividing the bowl; the symbolical number four is a particularly marked characteristic of this font (the rivers of paradise, the cardinal virtues, the Prophets, the symbols of the Evangelists)[1].

The pedestals of crosses frequently bear medallions with representations of the cardinal virtues[2]. Numerous book-covers contain head-and-shoulder

Justitia a balance; all the virtues are winged. Cf. Borchgrave d'Altena, fig. 12 and pp. 14ff. with bibliography. — Falke-Frauberger, pl. 80 and p. 80.

The following completely or only partly preserved reliquaries of the Meuse School, circa 1160–70, may also be mentioned:

Reliquaries of the Holy Cross in Liége, Ste. Croix, and in London, Victoria and Albert Museum. Above the fragment of the true Cross an enamel plaque with the half-figure of a winged Misericordia or two plaques with Misericordia and Justitia. Cf. Borchgrave d'Altena, fig. 15 and p. 17. — Falke-Frauberger, fig. 19 and p. 66.

Triptych reliquary of the Arenberg Collection (Nordkirchen) with Veritas and Judicium. Cf. Borchgrave d'Altena, p. 16.

Reliquary in Notre-Dame, Tongres. Fides with book-casket, Spes with branch and a disc with a cross on it, Caritas with a loaf and a vessel.

An enamel plaque with head and shoulders of a winged Humilitas holding crown and cross (Stoclet Collection, Brussels). Cf. Borchgrave d'Altena, fig. 16.

Enamel plaques with winged half-figures of Fides and Religio, whose scrolls bear the First and the Third Commandments (London, British Museum). Cf. Borchgrave d'Altena, figs. 13, 14 and p. 17.

Four enamel plaques on which virtues and Old Testament scenes are arranged and combined symbolically (Vienna, St. Stephen). Below Abraham's sacrifice (Genes. XXII, 1 ff.), Justitia with balance; below the blessing of Jacob (Genes. XLVIII, 14 ff.), Prudentia with a snake; below Aaron writing a T (Exod. XII, 7), Pietas with a book; below the emissaries with the cluster of grapes (Numbers XIII, 24 [23]), Temperantia with two vessels. Cf. Viktor Griessmaier, "Six enamels at St. Stephen's, Vienna" *(Burlington Magazine* LXIII, 1933, pp. 108 ff. with illustrations).

[1] Hildesheim, Cathedral. Cf. Ambrose, *Liber de paradiso* III (Migne, *P. L.* 14, 296 ff.) and the representation of the mystical paradise (p. 69).

Prudentia with book and snake; the inscription on the scroll reads: "Estote prudentes sicut serpentes" (Matth. X, 16). Temperantia mixing water and wine; inscription: "Omne tulit punctum, qui miscuit utile dulci" (Horace). An armed Fortitudo with scroll on which is written: "Vir, qui dominatur animo suo, fortior est expugnatore urbis" (Prov. XVI, 32). Justitia with balance and scroll: "Omnia in mensura et pondere pono" (Wisdom of Solomon XI, 21 [20]). The virtues are given as half-figures.

The inscription, in as far as it refers to the virtues, reads:

"Os mutans Phison est prudenti simulatus.
Temperiem Geon terre designat hiatus.
Est velox Tigris, quo fortis significatur.
Frugifer Eufrates est justitiaque notatus."

Cf. also p. 20, note 3. Concerning the representation cf. Erwin Panofsky, *Die deutsche Plastik des elften bis dreizehnten Jahrhunderts*, Munich 1924, pl. 47 and pp. 110 ff. with bibliography.

[2] Altar cross, mid-12th century (Fritzlar, St. Peter). Prudentia with snake and scroll, Fortitudo armed, Justitia with balance, Temperantia with vessel and spray of blossom. The virtues are shown as half-figures. Cf. Falke-Meyer, pl. 103 and p. 19.

Altar cross, circa 1200, Hildesheim (Berlin, Schlossmuseum). Fortitudo armed (Inscription: "Fortitudo. Constans est, secura malis non frangitur ullis."), Temperantia with two vessels ("Temperantia. Exornat mores"), Justitia with set-square ("Justicia. Pesat res eque, dat convenientia cuique.") Prudentia with snake ("Prudentia. Invenit, anticipat, ratione gerenda gubernat."),

representations of virtues round the edges, as a rule combined with the Evangelists or their symbols[1]. In his *Diversarum artium schedula* Theophilus directs the maker of censers to engrave circles on the bowl and in them to represent the virtues as half-length female figures to be designated by name[2]. The practising artist's injunction does not depart from the allegorical exposition of the theologians, for, according to Honorius Augustodunensis, the bowl is suspended by four chains because Christ incarnate was filled with the cardinal virtues[3].

And so, in order that they may convey a special meaning beyond that of their actual practical purpose, many things are finally imbued with moral

Caritas with cross and a sceptre of blossom ("Caritas. Hoc ex principio virtutum manat origo. Hinc omnes surgunt, huc omnes redeunt".). The virtues are given as half-figures. Cf. Falke-Frauberger, p. 111. — Swarzenski, *Kunstkreis*, p. 289, note 91.

[1] The back-cover of Henry II's pericope-book, circa 1010, Ratisbon? (Munich, Bayerische Staatsbibliothek, Cod. lat. 4452 (Cim. 57)). The Lamb of God in the midst of crowned cardinal virtues (cf. p. 45, note 2). Cf. Georg Leidinger, *Das Perikopenbuch Kaiser Heinrichs II. (Miniaturen aus Handschriften der kgl. Hof- und Staatsbibliothek in München* V), Munich, pl. 67 and p. 52. — Bassermann-Schmid, pl. XVII D and pp. 15 ff.

The front-cover of a sacramentary, 11th century (Bamberg, Staatliche Bibliothek, Cod. A. II. 25). Ivory relief of the Madonna and Child surrounded by crowned virtues. Cf. Bassermann-Schmid, pl. XVIII B and p. 22.

Hermann of Lerbecke has described the covers, now in fragmentary state of preservation, of a Minden MS., circa 1030 (Berlin, Preussische Staatsbibliothek, MS. theol. lat. Fol. 2): "Hic liber valde est pulcher, quatuor doctorum ymaginibus de ebore excisis (front-cover) et eorum aliis ymaginibus argenteis, videlicet disciplina, sapientia et scientia et intellectus in forma reginanarum adornatus" (back-cover; see Prov. I, 2 ff.). Cf. Wilhelm Vöge, "Die Mindener Bilderhandschriftengruppe" *(Repertorium für Kunstwissenschaft* XVI, 1893, pp. 198 ff.), p. 200.

The following were executed by members of the Meuse School, circa 1160–70:

The front-cover of a Book of the Gospels from Notre-Dame in Namur (Brussels, Bibliothèque Royale, MS. 465). Round the edge are symbols of the Evangelists, winged half-figures of Fides, Spes, Humilitas, Pietas, all of whom hold white discs, and head-and-shoulder portrayals of Caritas and Religio. Cf. Bibliothèque Royale de Belgique. *Exposition de reliures* I, du XIIe siècle à la fin du XVIe, Brussels 1930, pl. II.

The front-cover of a Flemish Book of the Gospels (Manchester, John Rylands Library, MS. 11). Around the margin are six apostles and head-and-shoulder representations of Fides, Spes, Caritas and Humilitas, who are winged and hold discs. Cf. James, pl. 29 and p. 30. — Falke-Frauberger, fig. 28 and p. 81.

The front-cover of a Book of the Gospels in the Library of the University of Liége. An ivory of the Majestas Domini is framed by Fortitudo vanquishing a lion, Justitia engaged in weighing, Temperantia (all three winged) and Fides. Cf. Falke-Frauberger, fig. 25 and pp. 74, 75.

Of a later date, the front-cover of a Book of the Gospels in the Landesmuseum, Darmstadt. An ivory of the Crucifixion is surrounded by medallions of the cardinal virtues. Attributes as on p. 32, note 2, but Prudentia is holding a snake. Cf. Falke-Frauberger, fig. 24 and p. 74.

On the front-cover of a missal (Pierpont Morgan Library, New York), first quarter of the 13th century, Virginitas and Humilitas stand on either side of Mary and the child Christ. Cf. Léon Dorez, *Les manuscrits à peintures de la Bibliothèque de Lord Leicester à Holkham Hall, Norfolk*, Paris 1908, pl. IX.

[2] Theophilus Presbyter, *Schedula diversarum artium* I, cap. 60 *(Quellenschriften zur Kunstgeschichte* VII), Vienna 1874, p. 257.

[3] *Gemma animae*, cap. 12 (Migne *P. L.* 172, 548).

significance—chalices[1], patens[2], aquamaniles[3], liturgical bowls[4], crowns[5], doors[6], chandeliers[7] and tombs[8].

[1] The Tremessen Chalice, late 12th century. On the stem are rendered the half-figures of the cardinal virtues below the rivers of paradise and on the base full-length figures of the Beatitudes. The inscription reads: "Gaudia summorum, qui quaeris habere polorum — Harum sectator virtutum sis et amator." Cf. Braun, *Altargerät*, fig. 37 and p. 193.
 The handled chalice of Wilten (Vienna, Kunsthist. Museum), late 12th century. On the stem the half-figures of the cardinal virtues below the rivers of paradise. Cf. Braun, *Altargerät*, fig. 20. — Karl Weiß, "Der romanische Speisekelch des Stiftes Wilten in Tirol" *(Jahrbuch der k. k. Central-Commission zur Erforschung und Erhaltung der Baudenkmale* IV, 1860, pp. 3 ff.).
[2] The Bernward Patens of the Guelph Treasure, second half of the 12th century (Cleveland, Museum). Christ in the centre of a rose design enclosing the symbols of the Evangelists and half-figures of the cardinal virtues, who are holding scrolls with name-inscriptions. Cf. *Welfenschatz*, pls. 70, 71 and p. 156. — Swarzenski *Kunstkreis*, fig. 319 and pp. 371, 372.
[3] Aquamanile in the shape of a woman's head, from Lower Lorraine, mid-12th century (Budapest, National Museum). On the crown of the head a dais with a figure seated on a throne. On the four sides of the dais reliefs of the cardinal virtues with inscription-scrolls and attributes. Cf. Falke-Meyer, fig. 307 and p. 53.
[4] On the inside of a great number of crudely engraved 12th and 13th century bronze bowls, which were made in Cologne and Aix-la-Chapelle for liturgical ablutions, a central allegorical female figure is surrounded by a circle of head-and-shoulder portrayals of women and a herbaceous design on the edge. Groups of virtues or vices, and frequently groups composed of pairs of antithetical representations of each, which are designated by inscriptions (often misunderstood and wrongly reproduced), are portrayed in this manner. Such rose-patterns, as far as their form is concerned, are reminiscent of the Bernward Patens (cf. p. 51, note 2). Full description in Anton C. Kisa, "Die gravierten Metallschüsseln des XII. und XIII. Jahrhunders" *(Zeitschrift für christliche Kunst* XVIII, 1905, cols 227 ff., 293 ff., 365 ff.).
[5] On the crown which the Byzantine Emperor gave to King Andrew of Hungary between 1046 and 1054, there are two enamel plaques with the figures of Veritas, who points to her mouth, and Modestia, who crosses her arms (Budapest, National Museum). Cf. van Marle, fig. 195.
[6] Three panels of the bronze door of S. Zeno, Verona, late 12th or early 13th century, show Fortitudo overcoming a lion, Justitia engaged in weighing and Temperantia with two vessels. Cf. Albert Boeckler, *Die Bronzetür von San Zeno (Die frühmittelalterlichen Bronzetüren* III), Marburg 1931, pl. 45 and p. 46.
[7] On the twelve towers of the chandelier in Hildesheim Cathedral presented by Bishop Hezilo (1054–1079) stand the names of 24 Old Testament figures and 24 virtues, while the inscription applies to the cardinal virtues and the theological virtues. Cf. *Kunstdenkmäler der Provinz Hannover* II. 4, pl. IX and pp. 80 ff. — R. Herzig, "Der große Radleuchter im Dome zu Hildesheim" *(Zeitschrift für christliche Kunst* XIV, 1901, cols. 13 ff.).
 The inscription on the Bayeux Cathedral Chandelier, mid-11th century, destroyed 1562, shows similar lines of thought: "Turres virtutes, fidei de rupe tenentes.
 Illis est murus fidei fundamine nixus."
 Cf.'L. de Farcy, "Une couronne de lumière en décor" *(Revue de l'art chrétien* LIX, 1909, pp. 187 ff.).
 The Aix-la-Chapelle Chandelier, between 1165 and 1184, shows, on the bases of the candlesticks, angels who present to the observer the opening words of the Beatitudes. Cf. Clemen, fig. 516 and p. 786. — Viktor Grießmaier, "Zu den Gravierungen des Aachener Kronleuchters" *(Strzygowski-Festschrift*, Klagenfurt 1932, pp. 72 ff.).
[8] Tomb of St. Junianus in the church of St. Junien (Haute-Vienne), last quarter of the 12th century. Medallions of the cardinal virtues and the theological virtues arranged on each side of the Majestas Domini. Cf. Renée Fage, "Saint-Junien" *(Congrès archéologique* LXXXIV, 1921, pp. 214 ff.), pp. 227 ff.
 Virtues were formerly represented over the apostles and a disciple of Christ on the mausoleum above the sarcophagus of the patron saint in St. Gilles (Gard). Cf. Paul Deschamps, "Etude sur la

Thus the "virtue-medallion" type of illumination, closely associated with the text of the religious books it illustrated, succeeded, by means of the clear, well integrated design and explanatory inscriptions, in linking up spiritual forces of various kinds, especially the cardinal virtues, with a wide and varied range of thought. Moreover, it allowed complicated schemes of ideas to be clearly and intelligibly set out in a limited space. Carolingian art had established once again the validity of the traditional type of composition, and the Ratisbon book-illuminators had boldly expanded the range of themes, which reached their fullest development in the Floreffe Bible. At the same time it was not always made easy for the learned observer to grasp the meaning of the pictures; they tended rather to spur him on to further and deeper reflection. The master craftsmen, on the other hand, regarded it as their special task to provide objects of devotion for the many, for the uneducated among the faithful. They too followed closely the numerous connexions between these systems of thought. But the unpretentious beauty of the virgins, whose restrained gestures touch the heart of the devout onlooker, is more effective than this subtlety.

The major art-forms provide fewer examples of the "virtue-medallion". The method of articulating the area for representation by means of a subtle linear division only finds its natural justification in mosaics and in mural painting[1]. Yet even here no essentially new features are introduced into the conventional picture. Only two notable artists among the sculptors have represented virtues in medallion-frames.

renaissance de la sculpture en France à l'époque romane" *(Bulletin monumental* LXXXIV, 1925, pp. 5 ff.), p. 58.

On the longer sides of the tomb of Clement in Bamberg Cathedral, circa 1237, there are reliefs with the cardinal virtues seated. Justitia with sword and balance, Temperantia with two vessels, Fortitudo conquering the lion, Prudentia with a snake. Cf. Richard Hamann, "Das Grab Clemens' II. im Bamberger Dom" *(Zeitschrift des deutschen Vereins für Kunstwissenschaft* I, 1934, pp. 16 ff.).

[1] I. Floor-mosaics:

A mosaic in St. Remi in Rheims (begun 1090, destroyed in the 18th century) contained the rivers of paradise, elements, seasons, the liberal arts, the months, the zodiac, the cardinal points and the cardinal virtues (Camille Enlart, *Manuel d'archéologie française* I, 2, Paris 1920, 2 nd ed. p. 803). The inscriptions of Prudentia and Justitia are still preserved on an otherwise almost completely destroyed floor-mosaic in St. Irénée in Lyons (Lucien Bégule, *Les incrustations décoratives des Cathédrales de Lyon et de Vienne,* Lyons 1905, pp. 22, 23). A mosaic over the tomb of the Countess Mathilda (d. 1151) in S. Benedetto di Polirone near Mantua shows, inter alia, the cardinal virtues bearing palm-branches. Cf. Toesca, *Pittura,* p. 88. — d'Ancona, p. 41. — aus'm Weerth, pl. V.

Plaster-floor of the apse of Hildesheim Cathedral, circa 1150, destroyed for the greater part in 1850. Christ is enthroned in the centre of a circle divided by four radii. He is surrounded by four groups each of three virtues. The following are recognisable: Fortitudo, Sapientia, Justitia, Spes, Gaudium, Juventus. Cf. *Kunstdenkmäler der Provinz Hannover* II. 4, pp. 13, 14. — aus'm Weerth, pp. 10, 11 with illustration.

II. Mural paintings and wall-mosaics:

Painting on the ceiling in St. Michael's, Hildesheim, late 12th century. On either side of the

About 1095, at the time of the early development of architectural sculpture, the figures of virtues enclosed in aureoles and thus separated from one another, were carved out of two capitals of the ambulatory round the apse of the monastery church of Cluny[1].

Tree of Jesse, Evangelists, their symbols, rivers of paradise, cardinal virtues etc. Cf. Watson, *Tree*, pl. XXVII.

Painting in the Chapel of All Saints in the cathedral cloister at Ratisbon, circa 1155. The representation of the opening of the Last Judgment is accompanied by eight representations of the theological virtues above the conical vaults (Hans Karlinger, *Die hochromanische Wandmalerei in Regensburg*, Munich-Berlin-Leipzig 1920, pl. 8 and p. 17).

Owing to their less rigid setting, the Ratisbon groups of virtues are suggestive of Byzantine influences, for the Byzantine artists were also wont to pour typically western thought into looser forms.

A row of sixteen virtues in more or less classical garb serves as a kind of base for the scene of the Ascension on a mosaic inside a dome of St. Mark's, Venice, circa 1200. The older Ravennese tradition (Rows of apostles on the dome-mosaics of the baptisteries) has clearly influenced their arrangement. The content, on the other hand, bears unmistakably western traits. The following are portrayed: a crowned Caritas, Spes, Fides with a sceptre of blossom, Justitia with balance and strong-box, Fortitudo overcoming a lion, Temperantia with two vessels, Prudentia with two snakes, and, as usual last of this group of seven, Humilitas. They all bear scrolls, as do the figures coming next—Benignitas, a worried Compunctio, Abstinentia holding a small vessel and loaves, Misericordia, Patientia, Castitas, Modestia and Constantia holding two discs with pictures of heads on them. These, as well as Humilitas, are connected with the Beatitudes by scrolls bearing inscriptions. Cf. Demus, figs. 12–14, pp. 25 ff., 88, 89 (with bibliography). There is the same combination on the Alexander Reliquary (cf. p. 48). Several virtues are again represented on the outside archivolt of the central porch (Toesca, *Storia*, fig. 522). On the 13th century mosaics inside the porch there are medallions with the half-figures of Spes bearing scroll and sceptre of blossom, of a crowned Caritas with a sceptre and Justitia with a balance (Demus, fig. 46).

Above the columns of the south transept in the Cappella Palatina in Palermo, between 1154 and 1166, there are medallion representations of the theological virtues. Cf. N. Kondakoff, *Histoire de l'art byzantin* II, Paris 1891, p. 39.

Paintings on the quadrants at the apex of the west vault of St. Maria Lyskirchen, Cologne, first half of the 13th century. Half-figures of the cardinal virtues. The attributes as on p. 32, note 3, but Prudentia is holding a snake. (Clemen, fig. 404 and pp. 583 ff.).

A painting in the nuns' choir in the Cathedral at Gurk, circa 1260, belongs to the rarer "retinue" type. An enthroned Mary is interpreted as the "Sedes Sapientiae" (cf. p. 41, note 5). On either side of her may be seen Caritas and Castitas, the special characteristics of the Mother of God, also Solitudo (Luke I ,28), Verecundia and Prudentia (v. 29), Virginitas (v. 34), Humilitas and Oboedientia (v. 38). Cf. Karl Ginhart and Bruno Grimschitz, *Der Dom zu Gurk*, Vienna 1930, pls. 68 ff. and pp. 60 ff.

[1] One of the capitals shows Fides kneeling to receive the host (now broken off), Spes bearing a sceptre of blossom and a heart (?) which she presses to her breast, and Caritas, who gives alms out of a strong-box. The fourth figure is almost completely destroyed. On one capital identification remains uncertain. According to the inscriptions, Prudentia is supposed to be represented twice, once in coat-of-mail ("Dat cognosendum Prudentia, quid sit agendum") and once in female garb when she castigates a child of whom only one foot now remains ("Dat nobis monendum Prudentia, quid sit agendum"). The two other figures were Spring with a book ("Ver primos flores, primos adducit odores") and Summer, who is bowing towards a now completely destroyed figure ("...fervens, quas decoquit aestas"). The inscriptions do not always correspond with the figures. Why are the Seasons represented as women, why should Spring carry a book, why is the discerning Prudentia clad in Fortitudo's armour and represented twice, while other cardinal virtues are missing? Why was the inscription applying to the admonishing figure of Prudentia never carved although

More than hundred years later, the sculptor of the socle reliefs of Notre-Dame succeeded in performing the more comprehensive task of presenting to church-goers, this time for their closer inspection, a system of virtues essentially more subtle and more richly correlated.

In order to supplement the views here expressed as to the nature of the "virtue-medallion", the various fundamental characteristics of this mode of representation may perhaps now be further considered briefly in this connexion.

There are many differences in the appearance of the virtues. In the Early Christian period they appear full-length, half-length or as busts. Their classical dress (long garment and cloak-like wrap) continues to remain obligatory. Knightly armour only becomes usual for representations of Fortitudo. Since the 11th century, the virtues were usually represented half-length or as busts, especially in the minor arts, and this type of representation illustrates with clear emphasis the relation of the virtues to the main theme.

It is impossible to establish any definite rules for their arrangement within the picture, except for the observance of a hierarchical symbolism. As in Hitda of Meschede's Book of the Gospels, for instance, where the medallion with Caritas is placed in the frame at the top of the picture, while Fides and Spes are worked into the sides of the frame, because Charity is greater than Faith and Hope (1 Cor. XIII, 13; cf. Fig. 35). Humilitas, the root of all virtues, is placed below to form the base. The reliquary of St. Gondulf serves to

already painted in? Surely because the scheme of figure ornamentation or that of the inscriptions has become confused. Kenneth John Conant, "The Iconography and the Sequence of the Ambulatory Capitals of Cluny" (*Speculum* V, 1930, pp. 278 ff.), identifies the capitals according to the inscriptions.

Provincialised and degenerate representations of the cardinal virtues in male form (Temperantia bears a sword!) may be seen on a capital of the church of Volvic (Puy-de-Dôme), 12th century.

The quartet of the virtues combined in one figure on a lost key-stone of the rood-loft in Mainz Cathedral. A man was displayed with arms and legs stretched out to form a cross; in his hands he held a balance and jugs, and with his feet he trod upon a lion and a dragon. His scroll read: "Quatuor hic posita: mixtura, leo, draco, libra signant temperiem, vim, jus, prudenter habentem" (Reitzenstein, p. 244).

Three medallions with half-figures of the theological virtues on the architrave on the west porch of Verona Cathedral, circa 1140.

The Beatitudes are also represented on capitals of the cloister of Moissac (Kingsley Porter, fig. 279); in the latter half of the 12th century as veiled figures holding scrolls, standing above the imposts in the north aisle of St. Michael's, Hildesheim (*Kunstdenkmäler der Provinz Hannover* II. 4, pl. XXX, fig. 150) and on a now partly destroyed pulpit in Magdeburg Cathedral (Greischel, pls. 54, 55).

Representations of virtues and vices: Small supporting figures of Patientia, Usura, Avaritia and Humilitas on the consoles of the lintel over the west door of Piacenza Cathedral, circa 1140. Cf. d'Ancona, p. 42. — Martin, pl. 32, nos. 2 and 3.

show that the various arrangements were capable of being otherwise interpreted by the men of the Middle Ages, with their peculiar aptitude for widely differing expositions of the same thing (Fig. 53). Since the top of the picture signifies the longing for heaven, the upper place is accorded to Spes. Fides is to be seen below, for the depths include the hidden things on which Faith is based. The sides are reserved for the eternally two-fold Love, of God and of one's neighbour, and also for Justitia.

The attributes of the cardinal virtues were established in Carolingian times (Fig. 32)[1]. Prudentia, the "Scientia scripturarum"[2], bears a book, the impressive symbol of the discernment between good and evil. Justitia holds the balance belonging to her from very early times[3]. Temperantia holds a torch and pours out a jug full of water, for, as Julianus Pomerius says: "Ignem libidinosae voluptatis extinguit"[4]. Fortitudo is armed with spear and shield, for she must endure all hardships with unshaken spirit[5]. These objects do not merely serve as a kind of motto enabling one to draw summary conclusions as to the identity of the allegorical figures but they also give one insight into the essential character of each virtue and this insight is often deepened by means of inscriptions. The mode of designation is linked up with the classical tradition of individualising personified abstractions by means of objects which were familiar to all, e. g. Justitia by a pair of scales.

Once recognised as typical, the attributes of the cardinal virtues, with the exception of those of Temperantia, at first maintained their validity. Temperantia's attributes were exchanged, in the course of the 11th century, for a cup and bottle. Mixing water with wine, the virtue reduces the overpotent drink to one of moderate strength (Figs. 33, 34)[6]. In the 12th century there begins a greater loosening and an increase in the number of innovations in the stock of attributes. Justitia occasionally holds a set-square[7], a plumb-level and set-square[8], or a pair of scales and measuring-rod[9], in order to

[1] Cf. further p. 31, note 1, p. 33, note 3.

[2] Isidorus Hisp., *Libri differentiarum* II. 39. 154 (Migne *P. L.* 83, 94).

[3] Georg Frommhold, *Die Idee der Gerechtigkeit in der bildenden Kunst*, Greifswald 1925. — Ernst v. Moeller, "Die Wage der Gerechtigkeit" *(Zeitschrift für christliche Kunst* XX, 1907, cols. 269 ff., 291 ff., 345 ff.).

[4] *De vita contemplativa*, lib. III, cap. 19 (Migne *P. L.* 59, 502).

[5] "Animi fortitudo ea debet intellegi, quae non solum diversis pulsata molestiis inconcussa permaneat, sed etiam nullis voluptatum illecebris resoluta succumbat" (Julianus Pomerius, *ib.* lib. III, cap. 20; Migne *P. L.* 59, 503).

[6] Cf. p. 32, note 2, p. 33, note 1, p. 33, note 4, p. 33, note 5, p. 35, note 3, p. 45, note 2, p. 46, note 2, p. 48, note 2, p. 49, note 1, p. 49, note 2, p. 50, note 1, p. 51, note 6, p. 51, note 8, p. 52, note 1.

[7] Cf. p. 49, note 2.

[8] Cf. p. 45, note 2.

[9] Cf. p. 34, note 3.

determine right with greater accuracy. As the punisher of wrong she holds a sword[1]. Fortitudo looks for a battle and, in the same way as Hercules, Samson or David before her, fearlessly tears open the jaws of a lion, symbol of fiendish strength[2]. Temperantia bears a spray of blossom[3] as well as the usual vessels, Prudentia frequently a snake and a dove, or one of these (Fig.33)[4], in accordance with the Bible: "Estote ergo prudentes sicut serpentes et simplices sicut columbae" (Matth. X, 16). If, in the attributes of the earlier period, a balance was maintained between their actual and their symbolical meaning, this latter henceforth gained a steadily increasing preponderance. This tendency develops in such a way, that Prudentia no longer holds the actual dove but merely a representation of it on a circular disc[5].

The theological virtues also develop new attributes; Spes an olive-branch, Fides a font, and Caritas a loaf and a vessel (Fig. 53) or a strong-box from which she generously distributes alms[6]. The many other virtues who appear so often in whole rows on liturgical objects bear scrolls in practically every case.

Only later, in the cycle of Notre-Dame, were the members of a great company of virtues individualised by means of a hitherto unknown wealth of attributes. It is proposed to deal with this later.

[1] Cf. p. 51, note 8.
[2] Cf. p. 32, note 2, p. 34, note 3, p. 46, note 2, p. 47, note 6, p. 50, note 1, p. 51, note 6, p. 51, note 8, p. 52, note 1.
[3] Cf. p. 33, note 2, p. 34, note 3, p. 49, note 2.
[4] Cf. p. 33, note 1, p. 33, note 2, p. 33, note 5, p. 34, note 3, p. 45, note 2, p. 46, note 2, p. 47, note 6, p. 48, note 2, p. 49, note 1, p. 49, note 2, p. 50, note 1, p. 51, note 8, p. 52, note 1.
[5] Cf. p. 45, note 2.
[6] Cf. p. 48, note 2, p. 53, note 1.

CHAPTER II. PARTICULAR ALLEGORIES OF VIRTUES AND VICES.

As well as portrayals of virtues in human forms there are representations of certain vivid allegories of virtues and vices. Individual virtues and vices as well as complete systems of them were symbolised as certain people, animals, plants or objects, the structure or essential character of which had gained moral significance.

Examples of virtuous men and of sinners are the natural illustrations of the influence of those spiritual forces pleasing to God or those worthy of condemnation. Notable Old Testament figures are thus associated with virtues because they are exemplary in respect of certain particular qualities. Abraham, for instance, is placed beside Oboedientia, Moses is associated with Munditia, Job with Patientia (Bamberg Apocalypse; cf. Fig. 14) or Judith and Jael with Humilitas *(Speculum Virginum;* cf. Fig. 15)[1]. The same principle was put into practice with exceptional thoroughness in two Ratisbon miniatures, painted in 1165. In the various sections of the two pictures, apart from the "Filia Syon" and the "Filia Babilonis", scenes from the lives of virtuous and sinful men of the Bible and of ancient history are placed in direct contrast with one another. Each time a virtue or a vice is included in the scene so that the observer may realise the true meaning of the parables (Figs. 54, 55)[2].

[1] Cf. also the combination of gifts of the Holy Ghost with Old Testament figures on a liturgical bowl in Xanten (p. 61, note 5).

[2] Munich, Bayerische Staatsbibliothek, Cod. lat. 13002, fols. 3 v, 4 r. The following are opposed to one another:

Filia Babilonis (Rev. XVII) and Cupiditas.

Filia Syon below the buildings of the heavenly Jerusalem, the towers of which contain the cardinal virtues and Caritas.

Croesus imprisoned and Opulentia.

Joseph exalted (Genes. L, 18 ff.) and Prudentia.

The hanging of Haman (Esther VII, 10) and Honoris Appetentia.

The honouring of Mordecai (Esther VI, 11) and Longanimitas.

The downfall of Pharaoh (Exod. XIV, 27 sq.) and Potentia.

The giving of the law to Moses (Exod. XXXIV, 27 ff.) and Mansuetudo.

The suicide of Saul (1 Sam. XXXI, 4) and Gloria.

The anointing of David (1 Sam. XVI, 13) and Humilitas.

The death of Ahab (1 Kings XXII, 34 ff.) and of Jezebel (2 Kings IX, 33 ff.) and Voluptas.

The ascension of Elijah (2 Kings II, 11 ff.) and Sobrietas.

There is a full description in Boeckler, *Regensburg*, pp. 24 ff., figs. 15, 16 — A weak copy in an

The parable of the Wise and Foolish Virgins also serves to illustrate clearly the difference between good and evil (Matth. XXV, 1 ff.)[1].

The sculptors of the Romanesque period, especially those in South-West France, frequently seized upon the theme of human depravity. Two sinners in particular give warning examples, the wanton and the miser, who is condemned as being rapacious and a usurer[2]. Prudentius had already given an impressive picture of the dangerous misrule of Luxuria and Avaritia, who succeed for a certain time in establishing themselves successively as tyrants. Thereafter, two types of human beings who have yielded to the two vices and consequently suffer damnation, are repeatedly represented in close association with each other. The breasts and abdomen of the lustful woman are sucked out by toads and repulsive serpents. The avaricious man is shown with a purse hanging about his neck[3].

This series originated from the capitals in the south porch of Toulouse Cathedral (late 11th century), where the illustration of the miser is developed into the parable of the rich man and Lazarus[4]. On archivolts of the two blind side-porches of Ste. Croix in Bordeaux (circa 1120) both motives are illustrated five times and devils come to fetch the sinners for punishment (Figs. 56, 57)[5]. Innumerable representations of one or both figures are to be

illustrated MS. of Conrad of Scheyern, painted in 1247 (Munich, Bayerische Staatsbibliothek, Cod. lat. 17403, fols. 6 r, 6 v).

The aerial journey of Alexander the Great was established as the stock example of arrogance. Cf. Wolfgang Stammler, "Alexander d. Gr." (*Reallexikon zur deutschen Kunstgeschichte* I, cols. 332 ff.).

[1] E. g. the representations on churches in South-West France (p. 18) or on Notre-Dame, Paris (p. 75).

[2] "Quae sunt illae sanguisugae duae dicentes: Affer, affer et nunquam saturantur? Luxuria et avaritia; nam quanto magis quisque luxuriatur, tanto amplius delectatur. Similiter quanto quisque sibi divitias cumulat, tanto magis semper augmentare desiderat" (Honorius Augustodunensis, *Quaestiones et responsiones in Proverbia*, cap. 30; Migne *P. L.* 172, 328).

[3] The theologians are agreed that sinners are punished through the organs of their lusts. So writes Gregory the Great: "Unde bene per prophetam dicitur: Descenderunt in infernum cum armis suis (Ezek. XXXII, 27). Arma quippe peccantium sunt membra corporis, quibus perversa desideria, quae concipiunt, exsequuntur. Unde recte per Paulum dicitur: Neque exhibeatis membra vestra arma iniquitatis peccato (Rom. VI, 13). Cum armis ergo ad infernum descendere est cum ipsis quoque membris, quibus desideria voluptatis expleverunt, aeterni judicii tormenta tolerare, ut tunc eos undique dolor absorbeat, qui nunc suis delectationibus subditi undique contra justitiam juste judicantis pugnant" (*Moralia in Job*, lib. IX, cap. 65; Migne *P. L.* 75, 913).

Snakes and toads (Is. LXVI, 24; Ecclesiasticus X, 13) also served in a general way to torment sinners, the avaricious man for instance, as shown in an illustration of hell in the Beatus Apocalypse from San Domingo de Silos, completed 1109. Luxuria is here represented by a couple lying in bed (British Museum, Add. MS. 11695, fol. 2 r). Cf. Wilhelm Neuss, *Die Apokalypse des hl. Johannes in der altspanischen und altchristlichen Bibel-Illustration*, Münster in W. 1931, fig. 37 and pp. 131, 132.

[4] Rey, figs. 57 ff. and pp. 78 ff. Repetitions are to be found on the churches of Moissac, circa 1125–30 (Kingsley Porter, figs. 366 ff.), and La Graulière (Corrèze), circa 1140; cf. Rey, figs. 199, 200.

[5] Kingsley Porter, fig. 921.

found on the jambs of porches[1], on church façades[2] and capitals[3]. The wanton in her agonised suffering is usually to be seen alone, while the miser, as a rule, is held by demons since the purse around his neck gives no immediate indication of his inevitable punishment. The master-craftsman of the Paris sequence of reliefs also places these two types of sin beside one another.

Occasionally the depraved pair is associated directly with the Last Judgment (Fig. 58)[4] or a whole group of sinners is shown to the observer[5]. But it was reserved for the Notre-Dame cycle to give a comprehensive picture of the iniquity of the world.

Those who are beatified in the Sermon on the Mount provide in a certain

[1] Cf. the Luxuria on the porch of Charlieu (Loire), circa 1150 (André Rhein, "Charlieu"; *Congrès archéologique* LXXX, 1913, pp. 247, 248), or a 12th century relief in Alba Fucense (Hans von der Gabelentz, *Mittelalterliche Plastik in Venedig*, Leipzig 1903, p. 173). These two representations show that it is not always possible to distinguish clearly between the sinner and the vice.

[2] E. g. on the octagon of Montmorillon (Vienne); cf. *Congrès archéologique* LXX, 1903, illustration facing p. 64; or on the Benedictine Abbey of St. Jouin-de-Marnes (Deux-Sèvres).

[3] I. The wanton: In the priory church of La Charité-sur-Loire (Nièvre); in St. Trophime, Arles (Bouches-du-Rhône); in Vienne (Isère) Cathedral where she is distorted into a horned demon; on a capital of St. Maria zur Höh, Soest. Further examples are given by Mâle I, pp. 375, 376.

II. The miser: In the churches of Ennezat (Puy-de-Dôme) with the inscription: "Cando usuram acepisti, opera mea fecisti"; St. Julien-de-Brioude (Haute-Loire); Chanteuges (Haute-Loire); Orcival (Puy-de-Dôme) with the inscription: "Fol dives" (H. du Ranquet, "Orcival"; *Congrès archéologique* LXXXVII, 1924, fig. 394); Cunault (Maine-et-Loire); St. Nectaire (Puy-de-Dôme); Notre-Dame-du-Port, Clermont-Ferrand, with the inscription: "Mile artifex scripsit: Tu periisti usura" (Marcel Aubert, "Notre-Dame-du-Port"; *Congrès archéologique* LXXXVII, 1924, pp. 47, 48).

III. Wanton, miser and glutton: On the porch of the church of Beaulieu (Corrèze). Cf. E. Lefèvre-Pontalis, "Beaulieu" *(Congrès archéologique* LXXXIV, 1921, p. 380).

IV. Pairs in discord and in concord, one pair quarreling and the other engaged in reconciliation: In St. Hilaire, Poitiers (E. Lefèvre-Pontalis, "Saint-Hilaire-le-Grand"; *Congrès archéologique* LXXIX, 1912, vol. I, p. 307); in St. Pierre-le-Moutier (Nièvre), cf. Deschamps, pl. 63 A; in the priory church of Anzy-le-Duc (Saône-et-Loire), cf. Kingsley Porter, fig. 17.

On a capital in Ste. Madeleine at Vézelay (Yonne), however, not the sinners but two demons of vice with flaming hair are represented. Desperatio commits suicide and Luxuria, in the coils of a snake, tears her breast (Kingsley Porter, fig. 34a). There are similar demons, difficult to identify, on the façade of Angoulême Cathedral (Kingsley Porter, figs. 931, 932).

[4] Amiens, Bibliothèque Municipale, MS. 19, fol. 12 v, end of the 11th century, Northern French. The same theme on the tympanum of the west porch of St. Lazare at Autun, circa 1120 (Kingsley Porter, fig. 81) or on the tympanum of St. Yved-de-Braisne (Soissons, Musée Municipal); cf. Vitry, pl. 5.

See also the punishing of the sinful, the miser among them, on the Last Judgment tympanum of the church at Conques (Aveyron), second quarter of the 12th century, where angels placed above the blessed hold scrolls on which are the names of virtues (Kingsley Porter, figs. 392 ff.).

[5] Following the system of vices established by Cassianus *(De institutis coenobiorum et de octo principalium vitiorum remediis libri XII*; Migne *P. L.* 49, 201 ff.), eight male and female caryatid-like figures on the blind arcades of the porch of St. James in Ratisbon, second half of the 12th century, represent Gastrimargia, Fornicatio, Philargyria, Ira, Tristitia, Akedia, Kenodoxia and Superbia. Once again the woman with the snake and the miser holding a box on his lap are easily distinguished (Goldschmidt, *Albanipsalter*, pp. 85, 86).

sense a counterpart to the figures of sinners (Fig. 59)[1], as do those virtuous persons who perform deeds of mercy by feeding the hungry, giving drink to the thirsty, extending hospitality to strangers, clothing the naked and visiting the sick and those in prison (Matth. XXV, 35 sq.)[2]. On the back-cover of the Melisenda Psalter it is King David, who looks after the toilers[3], while on the Hildesheim Font, Mercy herself tends them[4].

It is difficult and frequently quite impossible to decide whether the representations of animals have a particular moral significance. Animals or monsters, above all in Romanesque sculpture, are very often the creation of pure phantasy or illustrate in a mere general sense the realm of the baser instincts, and also perhaps incidentally represent one particular quality or another. In the midst of this rather vague general field, a special type of illustration stands out clearly, that of an animal world regarded purely from a moral standpoint and associated with definite conceptions. (There is no intention here of going into detail concerning each of the many scattered impulses imparted by the *Physiologus*, the expositions of the fathers of the church and the illustrated bestiaries.)

Thus certain animals are ascribed to virtues (e. g. the snake or dove to Prudentia) as distinguishing characteristics in the same way as they were associated with the gods of classical mythology. Up to the early 13th century attributes were only used as stereotyped formulae. It was only in the Paris cycle that a general expansion took place and once the spell of the rigid and narrow tradition was thus broken, nothing stood in the way of a generous elaboration of the motives.

[1] In the prayer-book of St. Hildegard, c. 1170, there are eight miniatures in which the virtuous who are assured of eternal bliss appear in an upper region as harmonious couples pardoned by the hand of God, while below them are shown the damned, quarreling violently (Munich, Bayerische Staatsbibliothek, Cod. lat. 935, fols. 32 v ff.).

[2] As, for instance, in the Floreffe Bible miniature described on p. 38. The representation of deeds of mercy is associated with the Last Judgment in an Italian picture, second half of the 11th century (Deoclecio Redig de Campos, "Eine unbekannte Darstellung des jüngsten Gerichts aus dem elften Jahrhundert"; *Zeitschrift für Kunstgeschichte* V, 1936, pp. 124 ff.), on the Gallus Door of Basle Cathedral or on the jambs of the door of the Baptistry at Parma.

Herrad of Landsberg surrounds Misericordia's chariot with the heads of six women embodying deeds of mercy (cf. p. 61).

Cf. further Otto Schmitt, "Barmherzigkeit, Werke der Barmherzigkeit" (*Reallexikon zur deutschen Kunstgeschichte* I, cols. 1457 ff.).

[3] Cf. p. 9, note 2. St. Elizabeth as a merciful benefactress in six reliefs on the Shrine of St. Elizabeth in the Elisabethkirche at Marburg and on medallions of a window in the same church (Richard Hamann and Kurt Wilhelm-Kästner, *Die Elisabethkirche zu Marburg und ihre künstlerische Nachfolge* II, Marburg 1929, figs. 35, 46, 48, 49, 54, 55, 58, 59, 65).

[4] Cf. p. 49, note 1. This method of representation was for a long time frequently adopted in a simpler form for illustrating psalters. In the Chludoff Psalter, 9th century, Mercy bestows money on clergy and monks (Ps. XXXVI, 26 (37, 26)). A shrub grows out of her diadem. Cf. Tikkanen. *Psalter*, fig. 57.

Certain animals embody particular vices or virtues in themselves, and not as attributes, the he-goat, for instance, representing Luxuria, who, following Venus' example, is herself wont to ride on this animal[1]. The lion represents Crudelitas, the ape Curiositas[2] and seven doves the gifts of the Holy Ghost[3]. In this connexion the remarkable talent of Herrad of Landsberg once again becomes evident; she always achieves her aim with unusual boldness and opens up avenues for fresh developments. On each of two miniatures she depicts a chariot in which Avaritia and Misericordia are seated respectively. For the vehicle of evil she appoints a fox (Fraus) and a lion (Ambitio) as draught animals (Fig. 60), for that of good, a lamb and a dove[4]. In the upper and lower parts of the picture of the vice, moreover, there are six heads of animals symbolising Philargyria (eagle), Sorditas (pig), Tenacitas (dog), Violentia (bear), Rapacitas (wolf) and Fames acquirendi (ox)[5]. This theme is reminiscent of the illustration to a vision of St. Hildegard. Five wild beasts — in their carnal lusts they signify the five ages before the appearance of the Antichrist — are bound by ropes to the five peaks of a mountain symbolising the culminating points of earthly might: a fiery dog, a red glowing lion, a dun horse, a black pig and a wolf[6]. The literary sources go back to very early times; even Boethius speaks of the covetousness of the wolf and of the "sordida sus"[7].

Mediaeval allegorization did not content itself with equating the animal

[1] Richard Hamann, "The Girl and the Ram" *(Burlington Magazine* LX, 1932, pp. 91 ff.). In the porch of Freiburg Minster Voluptas is clothed with a goat's skin.

[2] Both vices in animal form defeated by Fortitudo and Justitia on two consoles of the north porch of Chartres Cathedral, first half of the 13th century (Houvet, *Portail Nord* I, p. 3).

[3] Particularly on representations of the Tree of Jesse. Watson, *Tree*, gives numerous examples. Cf. further Wilhelm Molsdorf, "Zur Darstellung der Gaben des hl. Geistes" *(Die christliche Kunst* XXVI, 1929–30, pp. 112 ff.).

[4] Fols. 203 v, 204 r (Straub-Keller, pls. LI bis, LII bis).
Similar thoughts also occur in literature, in Hugo de Folieto for instance: "Quattuor enim sunt, qui trahunt currum elationis, id est amor dominandi, amor propriae laudis, contemptus et inoboedientia" *(De claustro animae* I, cap. 6; Migne *P. L.* 176, 1029).
The opposed conception, that of the cardinal virtues moving a chariot, is brought out by a miniature illustrating the *Carolinus* of Aegidius Parisiensis, between 1216 and 1223. Each of the crowned virtues holds a wheel of the chariot in which Prince Louis, emulating Charlemagne, is about to set forth on the right road in his journey through life. Surviving copies in Paris, Bibliothèque Nationale, MS. lat. 6191, fol. VII v and London, British Museum, Add. MS. 22399, fol. 3 r. Cf. H. François Delaborde, "Note sur le Carolinus de Gilles de Paris" *(Mélanges Emile Chatelain,* Paris 1910, pp. 195 ff. with illustration).

[5] On a liturgical bowl of the late 12th century (Xanten, St. Victor) Sapientia, enthroned between Sts. John and Paul, is surrounded by six trinities (Doves symbolical of the Holy Ghost—Old Testament figures—Animals): Sapientia—Adam—snake, Intellectus—Abraham—cock, Consilium—Moses—ant, Fortitudo—Elijah—lion, Scientia—Solomon—dog, Pietas—Samuel—dove. Cf. Witte, pl. 14 and p. 31.

[6] *Liber Scivias,* pars III vis. 11, fol. 214 v of the Wiesbaden Codex. Cf. Keller, pl. 29 and pp. 112 ff. — Baillet, pl. X and p. 115.

[7] *De consolatione Philosophiae,* lib. IV, 3.

with virtue or the vice. The various qualities and parts of an animal are also given moral interpretation.

A 12th century miniature gives an early example of the practice of adding to various limbs inscriptions with moral precepts. Two monsters illustrated are subjected to a thorough exposition of their evil qualities (Fig. 61)[1].

The dove was given an allegorical exposition by Hugo de Folieto (d. c. 1174) writing of it in conjunction with Psalm LXVII, 14 [68, 13]: "Si dormiatis inter medios cleros, pennae columbae deargentatae et posteriora dorsi eius in pallore auri". It is now represented in the centre of a "medallion" design which is covered with explanatory inscriptions bearing especially on the colours of the bird's plumage (Fig. 62)[2].

A similar instance: Alanus ab Insulis (d. 1202) attached the interpretation of definite forms of virtuous behaviour to the plumage of the winged cherubim. In the miniature illustrating this the appropriate names are inscribed on the wings and the larger feathers (Fig. 63)[3].

[1] Munich, Bayerische Staatsbibliothek, Cod. lat. 18158, fol. 63 r. — An identical representation of the 12th century: Cod. Reichenau LX, fol. 2 r of the Landesbibliothek Karlsruhe. The author is indebted to Dr. Hanns Swarzenski for drawing his attention to this miniature.

In an English miniature of the late 13th century a horse is ridden by a knight whose armour is interpreted in the same way (Ephes. VI, 11 ff.). The knight is shown riding into battle against a host of flying devils (principal vices) and smaller monsters (minor vices). British Museum, Add. MS. 3244, fols. 27 v, 28 r.

[2] E. g. Frankfort, Stadtbibliothek, MS. Batt. 167, fol. 66 r, second half of the 12th century, Eastern French. Cf. Swarzenski-Schilling, pp. 33, 34.

Heiligenkreuz, Stiftbibliothek, Cod. 226, fol. 130 r, late 12th century, Lower Austrian.

St. Omer, Bibliothèque Municipale, MS. 94, fol. 13v, first half of the 13th century, from the Cistercian Abbey of Clairmarais (Pas-de-Calais).

Brussels, Bibliothèque Royale, MS. 1491, fol. 124 v, early 13th century, from the Abbey of Aulne-sur-Sambre (Hainaut).

Cambrai, Bibliothèque Municipale, MS. 259, fol. 192 r, mid-13th century.

Douai, Bibliothèque Municipale, MS. 370, fol. 105 r, mid-13th century, from the Abbey of Anchin (Nord).

Paris, Bibliothèque Nationale, MS. lat. 2495, fol. 2 r, mid-13th century.

London, British Museum, Royal MS. 10. A. vii, fol. 150 v, late 13th century, from Bardney Abbey.

Bordeaux, Bibliothèque Municipale, MS. 995, fol. 62 v, late 13th century.

The text of the tract is printed among the works of Hugo of St. Victor (Migne P. L. 177, 15 ff.).

[3] The two inner wings, which the angel lowers and crosses, signify Confessio and Satisfactio, the outer ones, which are shown hanging vertically and are unfolded stiffly, Carnis Munditia and Puritas Mentis. The last pair of wings, which are crossed above the angel's head, represent Dilectio proximi and Dilectio Dei. Since each of these general conceptions is divided into five special qualities, the feathers of the mighty projecting wings bear the names of the various forms of virtuous behaviour. The tract of Alanus, De sex alis Cherubim (Migne P. L. 210, 266 ff.) is also ascribed to St. Augustine and Bonaventura. Some 12th and 13th century manuscripts still preserved are:

Frankfort, Stadtbibliothek, MS. Batt. 167, fol. 88 r, second half of the 12th century, Eastern French. Cf. Swarzenski-Schilling, pl. IX B.

Cambridge, Corpus Christi College, MS. 66, fol. 100 r, late 12th century.

Thus the subject of tract illustration calls for consideration. Since the text provides a reliable key to the content of the pictures, the understanding of their meaning presents no difficulties. This type of illustration provided a new field for the miniaturists of the first half of the 12th century, because certain figurative conceptions of the authors called for clear visual representation, that the reader in the midst of a complicated world of abstractions might see and grasp the essentials.

The tract illustrations were important above all in the depiction of parables drawn from the vegetable world, which, with its great variety of fruits, its strongly marked types and highly articulated forms, provided a wealth of ideas and fresh conceptions for the minds of the writers.

Thus the difference between good and evil has, for ages past, been illustrated by the parable of two contrasted trees. The fruits of the spirit are already enumerated in the New Testament (Galat. V, 22 sq.) and the good tree with its fruits contrasted with the bad (Matth. VII, 17 sq.). This striking conception was extended more and more later on. Two trees are usually employed; their roots are Humilitas and Superbia, their branches virtues and vices respectively, for they are always productive either of good or of evil[1]. In this way visible expression is given to the endeavours on the part of the theologians and philosophers to convey genealogies of main and subsidiary abstractions[2].

Manchester, John Rylands Library, MS. 6, fol. 197 v, late 12th century, from the Cistercian Abbey of Hunnerode. Cf. James, p. 13.

Vienna, Nationalbibliothek, MS. 1548 (Theol. 333), fol. 17 v, mid-13th century, French. Cf. Hermann, fig. 40.

Paris, Bibliothèque Nationale, MS. lat. 17251, fol. 128 r, mid-13th century, from Notre-Dame, Paris.

Ib., MS. lat. 14500, fol. 150 r, late 13th century, from St. Victor, Paris.

Ib., MS. lat. 15988, fol. 95 r, late 13th century.

London, British Museum, Arundel MS. 83, fol. 130 v, late 13th century.

Ib., Add. MS. 18325, fol. 113 v, late 13th century.

St. Francis' vision of a crucified seraph of all the virtues (= Stigmatization) was drawn by Matthew Paris (Cambridge, Corpus Christi College, MS. 16, fol. 66 r). Cf. M. R. James, *The drawings of Matthew Paris (The Walpole Society* XIV, 1925–26), pl. XI, no. 51.

[1] Cf. Rabanus Maurus, *De clericorum institutione* III (Migne *P. L.* 107, 415 sq.). A poem of Bonifatius describes the Tree of Life with its apples, and contrasts it with the deadly Plague Tree and its bitter fruits *(Monumenta Germaniae Historica, Poetae latini* I, pp. 3, 4).

[2] The dependence of the various disciplines is frequently elucidated by simple linear diagrams of abstract genealogies (e. g. Chartres, Bibliothèque Municipale, MS. 77, Alcuin, *Dialogus de rhetorica et virtutibus,* 10th century).

About 1250 an Austrian miniaturist replaced the inscriptions of such a diagram by figures. In the branching system of lines he shows Fortitudo as a knight, Temperantia with two vessels, Sapientia with a book and Justitia with the balance (Benedictine Abbey of Admont, MS. 73 (128), fol. 13 r). Cf. Buberl, fig. 92 and p. 88.

Complicated circular diagrams illustrate the moral tract of Hugo of St. Victor *De quinque septenis seu septenariis* which comprises the principal vices, the requests of the Lord's Prayer, the gifts of the Holy Ghost, the virtues referred to in the Sermon on the Mount and the Beatitudes (Migne

The artists treated this widely applicable parable, both in its general outlines and with subtle refinement, simply by contenting themselves with representing two contrasting trees, e. g. a withered and a fruitful tree[1] or the Tree of Sin and the Tree of the Cross[2], or, in a more complicated manner, by imposing, mainly with the aid of inscriptions, whole systems of virtues and vices on the trees. Only in the 12th century did the parable come to be represented in its strongly characteristic form[3].

P. L. 175, 405 ff.). In a late 12th century miniature from Cîteaux, Superbia, decorated with crown and cloak, is enthroned above five concentric circles. The outside ring has circular pictures of seven vices distinguished by typical behaviour. Invidia, for example, points spitefully at Avaritia, who feverishly clasps her treasures. In the smaller circular medallions, the subsidiary vices are only mentioned by name and are grouped around their respective "mothers". The four remaining rings contain the name-medallions of the forces working for good and of their subsidiary concepts. Christ, a central spiritual opposition to the powers of the outer darkness, is seated enthroned in the middle of the diagram. Explanatory text runs through the various sectors and fills the corners outside the circles thus extending the whole into a rectangle. Pictorial representations in five corner medallions of the outer frame denote the epochs of Salvation which correspond with the divisions of the church year. The five medallions contain pictures of Adam, Moses, the Nativity, the Resurrection and the Divine Judge.

Such a diagram clearly reflects the graduated mode of thought of the Middle Ages. The man who is inwardly prepared is shown the way towards the overcoming of evil through steadily intensified powers of grace. He must turn away from the region of vicious deeds and thoughts so that, steadfastly ascending through prayers, he may attain first the virtues, then heavenly blessedness, in order to emerge at last triumphant before the Judge, Christ. The miniature is reproduced in *La settimana del libro antico e raro* (4. Fiera internazionale del libro, Florence, Istituto Italiano del Libro, 1932), pl. 2. Concerning another, 13th century copy, cf. *Bibliotheca medii aevi manuscripta* I, Catalogue 83, Jacques Rosenthal, Munich, pl. XIX and pp. 91 ff. — also Salomon, p. 100.

The same diagram without representations of figures: Lyons, Bibliothèque Municipale, MS. 863, 13th century. Simpler linear ring-diagrams of virtues and vices in the Cod. lat. 9564 of the Bayerische Staatsbibliothek, Munich, fols. 127 v, 128 r, 13th century; one of the vices only in the MS. lat. 11615, fol. 293 r from St. Germain-des-Prés in the Bibliothèque Nationale in Paris; one of the virtues only in MS. 2468 (Univ. 345), fol. 100 v, in the Nationalbibliothek in Vienna (Hermann, p. 391).

A peculiar and unique instance: In two 11th century Italian miniatures (Florence, Biblioteca Laurentiana, Cod. Plut. XVI. 21, fols. 2 v and 3 r) two heads, "Humilitas bona" and "Superbia mala" are opposed to one another. The eyebrows of each are extended into luxuriant tendrils which have heads in the middle and, at the end, human faces for the virtues and animal masks for the vices. Two similar tendrils proceed from above the mouth and a third from beneath.

[1] On the central porch of Amiens Cathedral for instance, below the Wise and the Foolish Virgins (Durand, pls. XXVIII, XXIX).

[2] E. g. in the Ratisbon Cod. lat. 14159, fol. 1 r, in the Bayerische Staatsbibliothek, Munich, between 1170 and 1185 (Boeckler, *Regensburg*, pl. XXVI).

[3] Already in Carolingian times, however, Theodulf of Orleans describes a picture of the Tree of the World, in which the cardinal virtues, as the daughters of Ethics, are displayed besides the seven liberal arts etc. (*Monumenta Germaniae Historica, Poetae latini* I, pp. 544 ff.). If the writer had an actual work in mind, then the attributes of some of the virtues in this picture must have departed considerably from those of the usual representations. For he states that Justitia bears a sword, palm-branch and balance, Moderatio head-harness and scourge.

Less frequently the filial character of certain virtues is indicated by making the main virtue bear discs with head-and-shoulder representations of her "daughter" virtues. Caritas, for example, bears discs of Fides and Spes in a Salzburg miniature of about 1150 (Vienna, Nationalbibliothek, MS. 1367 (Salisb. 251), fol. 92 v). Cf. Hermann, fig. 79. — On the porches of the Baptistry of

The original of the *Liber floridus Lamberti,* the illustrated encyclopaedia written about 1120 by the prebendary of St. Omer, shows the reader the "Arbor bona" as a symbol of the "Ecclesia fidelium" (Fig. 64)[1]. An explanatory inscription runs: "Arbor bona, quae est regina a dextris Dei, varietate circumdata, id est fidelium ecclesia, virtutum diversitate amicta". The miniature strikes one as an allegorical illustration of the words of the Apostle Paul: "Fructus autem Spiritus est caritas, gaudium, pax, patientia, benignitas, bonitas, longanimitas, mansuetudo, fides, modestia, continentia, castitas" (Galat. V, 22 sq.). Benignitas is replaced, however, by Sobrietas, and Spes is added to complete the Pauline trinity.

Branching roots enclose the half-figure of Caritas, the mother of all virtues (Inscription: "Sicut ex una arboris radice multi rami prodeunt, sic multae virtutes ex una karitate generantur"), and join to merge into a short stout trunk the branches of which bear two kinds of fruit, first twelve circles with representations of the virtues, and then, springing from these, young shrubs. The figures representing moral forces are closely attached to the shrubs, which resemble a herbarium[2]. In a lively manner the virtues are turned facing in every direction as if to exhort the observer emphatically to follow the good. Only Fides, crowned and stretching out her hands, solemnly faces the reader.

Beside all these fruits and blossoms the "Arbor mala" (Fig. 65), also named "Synagoga", gives an impression of deadness and coldness ("Haec arbor autumnalis est infructuosa, bis mortua, eradicata, cui procella tenebrarum conservata est in aeternum"). Cupiditas is the root, and twelve vices, some of which were enumerated by St. Paul as the works of the flesh (Galat. V, 19 ff.), are the evil fruits. Only their names are given in the circles[3] and the

Parma, circa 1200, Castitas is holding two flowers out of the cups of which busts of Patientia and Humilitas emerge (Inscription: "Ponitur in medio virtus, que casta tuetur. Cuius ad ornatum resident paciencia dextra et faciens humilem cognoscitur altera leva"). In the same way Pax and Justitia are associated with Oboedientia ("Ac Habraam Christo placuit virtute probatus. Leve justicia, pax dextre consociatur"), and Prudentia and Modestia with Spes ("Spes est quam cernis, prudencia dextra sodalis signatur lapide et parte modestia leva"). A fourth group is no longer recognisable. Cf. Camille Martin, pl. 14.

[1] Ghent, Bibliothèque de l'Université et de la Ville, MS. 16, fol. 231 v. Cf. Boeckler, *Abendl. Min.,* pp. 121, 122 with bibliography. — 12th and 13th century copies:
Wolfenbüttel, Herzog-August-Bibliothek, MS. I Gud. lat. 2⁰, late 12th century, St. Omer?
Paris, Bibliothèque Nationale, MS. lat. 8865, circa 1260.
Leyden, University Library, Cod. Voss. lat. F. 31, late 13th century.

[2] They are paired as follows: Continentia-rose, Fides-pine, Longanimitas-terebinth, Mansuetudo-box, Patientia-cedar, Castitas-olive, Gaudium-cypress, Sobrietas-fir, Pax-plane,Bonitas-amomum, Modestia-balsam.

[3] Desperatio, Ira, Dissensio, Luxuria, Immunditia, Injustitia, Homicidium, Simulatio, Fornicatio, Rixa, Invidia, Contentio.

growths springing from each of these are without exception withered fig-trees (Matth. XXI, 18 ff.).

While the virtues of the "Arbor bona" are not divided into groups of associated types of virtuous conduct, each vice is subdivided into various species, the names of which are inscribed in the circles. The more highly articulated organism is thus contrasted with the more general one of the virtues.

The tract of the Pseudo-Hugo, *De fructibus carnis et spiritus*, obviates this difference in degree of articulation by using for the purpose of contrasting virtues and vices the allegory of two similarly subdivided trees — in addition to the stereotyped image of two hostile armies, which was of such importance for the Herrad of Landsberg cycle[1].

The author of the tract wishes to convince humanity that it must seek its spiritual salvation in humility and avoid the evil of pride. He thus thinks fit to place before the reader's eyes two trees different in growth and fruits, so that he and others may be able to decide between the two. Superbia with the seven principal vices and their subsidiary aspects dominates the one structure, Humilitas, the theological virtues and the cardinal virtues, together with their sub-species, the other. Since both genealogies originally developed independently of one another, there is no exact parallelism in the contrast between the two. The establishment of more subtly differentiated conceptions and the didactic purpose result in the trees assuming a more rigid form than in the *Liber floridus*.

One of the oldest copies of the tract (second quarter of the 12th century) contrasts on two of its leaves the "Arbor vitiorum" (Fig. 66) and the "Arbor virtutum" (Fig. 67)[2]. Numerous inscriptions interpret in full detail the meaning of the two pictures. The growth of destruction, designated as "sinistra", is given the place befitting all depravity, the left ("Stirps, flos, fructus, odor sanctis fuga, sontibus error — Mortis ab hac stirpe vicii genus effluit omne"). The trunk grows out of Superbia, the root of all evil, and the branches of the tree drop to the ground for they look for the base and turn away from the divine ("His socium viciis anime mors certa fit ex his — Fructibus et ramis cognoscitur aspera radix"). Medallions, the "fructus carnis", which enclose busts of the vitia principalia, are attached to the branches — and in this the illustration resembles the representations of the tree of Jesse[3]. Each of the

[1] Migne *P. L.* 176, 997 ff.
[2] Salzburg, Studienbibliothek, MS. Sign. V. 1. H. 162, fols. 75 v, 76 r. Cf. Frisch, pls. XIV, fig. 1; XV, fig. 2 and pp. 67 ff.
[3] Cf. for instance the corresponding illustrations in the *Speculum Virginum* (v. p. 16, note 2), the author of which also symbolizes the three classes of married women, widows and virgins by means of a tree.

principal vices holds the stalks of seven leaves which hang down and on which are given the names of the appropriate subsidiary vices ("Fructus in hac hominem si farserit interiorem, omne necat, solidos quicquid reminiscitur annos"). Towards the top the trunk broadens to include a bust of Luxuria and from this swelling two more luxuriant tendrils go forth. Twelve leaves, the symbols of particular sensual desires, hang from them. They exceed in number the other groups of leaves, for voluptuousness threatens man in many guises and in a more dangerous way than other impulses. At the very top of the picture Adam crosses his arms over his breast as if out of a chilling sense of shame ("Culpa peracta palam veterem nudaverat Adam"). Thus Superbia, the worst of all vices, gives rise at definite intervals to the four vices of the mind, Invidia, Vana Gloria, Tristitia and Ira and to the other company of evil impulses confined to material pleasures, Ventris Ingluvies, Avaritia and Luxuria. What is begun with Superbia is completed with Adam, for it was the seed of pride which produced in the first man the fruit of original sin which was to weigh upon mankind ever afterwards.

Beside the tree of corruption with its evil fruits stands the tree of virtues, rooted in Humilitas ("O decus, o morum stirps, flos fructusque bonorum! — Noris ab hac stirpe redolentia germina vite, ex quorum flore mens pasta sacroque sapore"). Its branches twist upwards, to the salvation which comes of the spirit. The busts of the cardinal virtues, as a lower type of "fructus spiritus", fill the medallions of the lower branches and hold stalks of leaves which strain upwards ("Vernant virginei fructu florente manipli"). The theological virtues are arranged nearer heaven, nearer perfection, Fides and Spes on either side, and Caritas in the middle of the trunk sending forth in the fullness of her goodness ten leaves ("Quis sit amor pensat, qui dona perennia monstrat"). Christ, the "novus Adam", raises his hand above her in benediction ("Presidet his floris species sacra plena decoris—Summa petens stabilem capit ergo quisque decorem").

Thus the parable of the two trees is used during the 12th century to the point of threadbareness, the reason being that the highly articulated structure of the growths of nature could lodge complicated systems of abstractions and their upward development could be interpreted step by step—or rather, branch by branch[1].

[1] In other manuscripts which are less closely related to the original, the well thought-out and balanced design becomes either weak or too free.

The picture-medallions are replaced by small name shields and only the two radical principles are still represented as figures, e. g. Leipzig, University Library, MS. 148, fols. 113 v, 114 r, illustrated in 1133, from Pegau Monastery (Rudolf Helssig, *Katalog der Handschriften der Uni-*

In the *Liber floridus* there is also a picture of a palm-tree (Ecclesia) the leaves of which are inscribed with the names of virtues, opposite which are arranged the designations of vices[1]. The Beatitudes and the gifts of the Holy Ghost, joined by Perfectio, are also attributed to certain plants (Ecclesiasticus XXIV, 17 [13] ff.)[2].

Apart from all these parables which are faithfully translated into the language of pictures, the artists also make some of the more general allusions on the part of the authors serve as a basis for their representations.

versitätsbibliothek zu Leipzig IV. 1, Leipzig 1926–35, pp. 161, 162). The inscriptions correspond roughly those of the Salzburg MS.

Leipzig, University Library, MS. 305, fols 151 r and v, late 12th century, from Altzelle Monastery (Frisch, pl. XVI, figs. 3 and 4. — Bruck, figs. 72, 73).

Melk, Stiftsbibliothek, MS. 199, fols. 149 v, 150 r, second half of the 13th century *(Österreichische Kunsttopographie* III, Vienna 1909, fig. 348).

Paris, Bibliothèque Nationale, MS. lat. 10630, fols. 65 r and v, late 13th century.

Occasionally the trees grow out of the heads and shoulders of Humilitas and Superbia (e. g. Leipzig, MS. 148; Paris. lat. 10630) or a snake winds itself around the trunk of the tree of vice (Leipzig, MS. 305).

Other copyists completely dispense with figures and botanical elements with the result that only plain tabulated lists remain, e. g.

Brussels, Bibliothèque Royale, MS. 1453, fols. 194 v, 195 r.

Paris, Bibliothèque Mazarine, MS. 981, fols. 20 v, 21 r, from St. Victor, Paris.

Lyons, Bibliothèque Municipale, MS. 445, fols 1 v, 8 r. All these manuscripts are of the 13th century.

A portion of the tract was also taken over into the *Speculum Virginum* (cf. p. 16, note 2). Only certain details vary from the normal. Superbia for example holds the "calix aurea Babilon" (Jerem. LI, 7), for she is, after all, a citizen of that notorious city. Two snakes writhe around the trunk and their bared fangs drip venom. Winged dragons menace Adam and emphasize the terrors and corruptness of the vicious life. Humilitas, however, is accompanied by two "Angeli pacis", harbingers of the blessed happiness to which the virtuous man may attain. Cf. Watson, *Speculum*, pp. 449, 450.

A representation of the theme in enamel remains an exception. A semi-circular 12th century plaque, Saxon (Brussels, Musées Royaux du Cinquantenaire), displays beneath a medallion with the head and shoulders of Humilitas a circular picture of Caritas, from which tendrils proceed to twine around the medallions of other virtues — the cardinal virtues and Castitas, Concordia, Oboedientia, Patientia as well as Fides and Spes on either side of Caritas. Cf. Swarzenski, *Kunstkreis*, p. 335.

[1] "... et folia ligni ad sanitatem gentium" (Rev. XXII, 2) — Ghent, Bibliothèque de l'Université et de la Ville, MS. 16, fol. 76 v. Cf. p. 65, note 1.

[2] *Ib.*, fols. 139 v, 140 r. Cedar-Humilitas, cypress-Pietas, palm-Scientia, rose-Fortitudo, olive-Consilium, plane-Intelligentia, terebinth-Sapientia, vine-Perfectio. This series of virtues corresponds with that of the Alexander Reliquary (cf. p. 48).

Six 13th century enamel plaques are similar (Darmstadt, Landesmuseum): Rose-Fortitudo, vine-Temperantia, cedar-Humilitas, cypress-Pietas, terebinth-Sapientia, palm-Scientia.

In the Tree of Jesse as illustrated in the *Speculum Virginum*, there are seven leaves which radiate from Christ and on these are inscribed the gifts of the Holy Ghost and their qualities (Wisdom of Solomon VII, 22), on another seven leaves the openings of the Beatitudes, the requests of the Lord's Prayer, the "Voces Domini" (Ps. XXVIII, 3 [29, 3] ff.), the prophecies of the Book of Revelations (Rev. II and III), the articles of the Creed, the sources of Christian Salvation and the virtues. This complicated mode of correlation reminds one of the Septenary of Hugo of St. Victor (cf. p. 63, note 2). Cf. Watson, *Tree*, pl. XXX. — Watson, *Speculum*, pl. I and pp. 459 ff.

The "mystical paradise", of which it is said in the *Speculum Virginum* that it flourishes in a mysterious way, is depicted as a rose which, in close adherence to the text, includes the cardinal virtues and other theological groups of four (Fig. 68). In the course of the dialogue of this widely circulated book of devotions the presbyter Peregrinus says to the nun Theodora: Just as the source of four rivers welled up in the middle of paradise, so did Christ, the fount of all wisdom, pour forth the Evangelists and the Doctores ecclesiastici that they might irrigate the world with their teaching and cause the hearts of the faithful to blossom and bear fruit. Peregrinus wishes to give his companion a picture of this mystical paradise so that fount and rivers may serve as a balm to the consecrated virgins. "They should drink from the springs of the Gospels or the teachings of the Church in order to imitate the eight Beatitudes together with the cardinal virtues, in the emulation of which lies embodied the true sense of every devotional exercise."

All the spiritual forces enumerated by the author (he extends the well-known exposition of Ambrose[1] by adducing other groups of four to those of the rivers and virtues) have been represented by the miniaturist. In the centre of one of the oldest copies, of the second quarter of the 12th century, there is the crouching figure of a youth signifying paradise and holding a medallion on which the head and shoulders of Christ are portrayed[2]. From this centre the springs flow into all parts of the world. The figures representing the rivers of paradise resemble classical nature gods and they are arranged in the form of a cross. Streams of the Water of Life connect them with the Origin of all being. Each of them holds two discs with the symbols of the Evangelists and the busts of the Doctores ecclesiastici. Four shrubs bear the cardinal virtues as fruit. On either side of these plants stand four sisterly pairs of virgins, the Beatitudes.

The readers of the *Speculum Virginum* were thus given a complete picture of the Church with its strength-giving foundation (Christ), its scriptures of revelation (Evangelists), its teachings (Church fathers) and its effects of saving grace (Virtues and Beatitudes). At the same time the rivers of paradise (historical) correspond with the Evangelists (typological) and the cardinal virtues (moral).

The miniaturist, who had to create such a comprehensive picture of the world, returned, as did the artist of the "virtue-medallion" picture, to a design which may be traced back to classical times. This time it is the quatre-

[1] *Liber de paradiso* III (Migne *P. L.* 14, 296 ff.).
[2] London, British Museum, Arundel MS. 44, fol. 13 r. — Cf. Watson, *Speculum*, pl. II and pp. 448, 449. — Bruck, fig. 148.

foil which radiates from its centre a cross formed by the figures of the four principal winds, who hold pictures of the lesser winds[1]. Not only is the general composition taken over, but the wild appearance as of creatures or spirits of nature, the horns and crouching attitudes of the figures representing the rivers of paradise are also to be explained by the model.

While other copies in the main preserve much the same appearance in spite of variations in form or increasing rigidity, in spite of luxuriant growth or conventionalisation of the rose, a Ratisbon miniaturist (circa 1170–85), when he treated the theme, simplified it thoroughly and with almost mathematical exactitude. His work is still distinguished by the same characteristics as that of his predecessors of the 11th century—sure treatment of an intricate design, and a capacity for noting wider associations (Fig. 69)[2]. He places the representation within the limits of a circle and the round medallion-pictures of the virtues are joined to Paradise in the centre by a number of spokes, as it were. In order to render the composition clearer, he omits the Beatitudes and the plant-motives but he adds two further groups to the allegorical sets of fours. The additions, which are given by means of inscriptions, are the four stages of the life of Christ and the four points of the compass. He also adds the figure of Christ at the top of the picture and shows him as he appears at the Last Judgment, between the instruments of torture and an angel bearing the cross; it is as if the illustration were intended to comprise the whole course of world history — the beginning (earthly paradise), middle (Evangelists, Church fathers, the forces of salvation, i. e. the Church) and the end (Last Judgment as the gate to the heavenly paradise)[3].

Common objects also play an important part in allegorical representations. The wheel is particularly significant in this respect. Hugo de Folieto in his tract *De rota verae et falsae religionis* had placed a moral interpretation on the old metaphor of Boethius, that of the wheel of fate into the spokes of

[1] E. g. Vienna, Nationalbibliothek, MS. 395 (Hist. eccl. 50), fol. 34 v, mid-12th century. Cf. Hermann, fig. 171 and pp. 284, 285.

[2] Munich, Bayerische Staatsbibliothek, Cod. lat. 14159, fol. 5 v (Boeckler, *Regensburg*, fig. 39 and pp. 40, 41).

[3] Three groups of four (rivers of paradise, Evangelists and their symbols, cardinal virtues) are arranged in and around a cross in a miniature of a lectionary from Zwiefalten, mid-12th century (Stuttgart, Landesbibliothek, Cod. Brev. 128, fol. 10 r). The ends of the cross are extended to form T-shapes, and from these ends the figures of the rivers of paradise pour out the contents of their pitchers in the direction of the Agnus Dei in the centre. In the corners formed by the arms of the cross sit the four Evangelists looking away towards their symbols. The circular medallions at the corners of the frame contain head-and-shoulder portrayals of the cardinal virtues. The attributes as on p. 33, note 1, but Prudentia's book is missing. Cf. Löffler, pl. 20 and p. 38. The groups of four on the Hildesheim font are also reminiscent of the mystical paradise (cf. p. 49).

which are woven all living creatures[1], and had applied it to the narrower sphere of monastic life. He who strives to attain higher rank by bribery admittedly holds his lofty office for a time by reason of his lordliness. But then because he is so heedless he is caught up by the movement of the wheel and it casts him down so that, lying in the dust of lowliness, he may repent of his turpitude. This law is explained by means of four representatives of the monastic calling and represented pictorially, the illustrations visibly following the usual pictures of the wheel of Fortuna, who controls the four phases of human fortune and misfortune, rise and decline[2].

The goddess of blind fate is missing. The "Rota falsae religionis" turns of itself and in the end always metes out to the guilty man the lot he deserves (Fig. 70)[3]. The bribing prior greedily clasps the rim of the wheel that it may draw him up. On the top of the wheel the proud abbot sits enthroned with arms outstretched holding the insignia of his office. The falling sub-prior tries to gain a firm hold on the irrevocably descending wheel, but in vain. The fallen "discipulus" is, however, seen lamenting at the foot of the picture. There is an essential difference between the tract illustration and the image of Fortuna's wheel. Since the systematically thinking mediaeval writer attributes moral significance to every detail of his work, it follows in the illustration that the sections of the rim of the wheel are inscribed with the names of six particularly monastic vices (Astutia, Avaritia, Superbia, Negligentia, Desidia, Inopia), the spokes with those of sinful desires; and the hub is the wayward mind. The observer consequently not only regards the vices as abstractions, but he sees their effects presented all the more strikingly in the monks' ruinous "pas de quatre".

With this the possibilities of compositions of this kind are by no means exhausted. The "Rota falsae religionis" constructed on the model of the wheel of Fortuna is extended in a logical manner to the representation of the "Rota verae religionis" (Fig. 71)[4]. Once again four monks are arranged around a wheel, but this time they are not compelled to follow its turning as a result of their sinfulness. At the points where the wicked prior was striving upwards and the deposed sub-prior was being carried down, two model representatives of their respective positions are shown. While the one rises to high office really against his will, the other renounces it out of true

[1] Boethius, *De consolatione Philosophiae*, lib. II. 2. 9 ff. Cf. Gustav Heider, "Das Glücksrad und dessen Anwendung in der christlichen Kunst" *(Mitteilungen der k. k. Central-Commission zur Erforschung und Erhaltung der Baudenkmale* IV, 1859, pp. 113 ff.), pp. 122 ff.

[2] E. g. Heiligenkreuz, Stiftsbibliothek, Cod. 130, fol. 1 v, late 12th century, Lower Austrian.

[3] E. g. Heiligenkreuz, Stiftsbibliothek, Cod. 226, fol. 149 v, late 12th century, Lower Austrian. Cf. Winkler, fig. 38.

[4] *Ib.*, fol. 146 r, Cf. Salomon, fig. 73 and pp. 309, 310.

humility. With the movement of the wheel, the rim of the virtues (Puritas, Voluntas, Caritas, Humilitas, Sobrietas, Paupertas) and the spokes of heavenly thoughts revolve. The abbot sits at the top and gives the benediction, a model abbot. With becoming modesty he has inclined his crozier. At the bottom of the wheel, the monk who has voluntarily humbled himself is reading. If the vicious monks are involved in the vagaries of reprehensible deeds and thoughts without being able to extricate themselves, the virtuous ones mould their lives so that all the forces of goodness gain expression.

The tract was often copied in the mediaeval scriptoria. The strong dramatic qualities of the two pictures, however, begin to decline, either because the miniaturist makes the representation of the "Rota falsae religionis" approximate to that of the wheel of virtue since the sub-prior no longer crashes down[1], or because the monastic figures disappear completely leaving a bare circular design — the usual shrinking-process, such as may frequently be observed[2].

The allegorical representations of the Cherubim, the Trees of the Virtues and the Vices, of the wheel and of linear diagrams were collected from the latter part of the 13th century onwards into a series of manuscripts which strike one as handbooks for clergy[3]. (The best of these is Arundel MS. 83 II in the British Museum.)

[1] Brussels, Bibliothèque Royale, MS. 1491, fols. 82 r, 87 r, early 13th century, from the Abbey of Aulne-sur-Sambre (Hainaut).

St. Omer, Bibliothèque Municipale, MS. 94, fols. 37 v, 42 v, first half of the 13th century, from the Cistercian Abbey of Clairmarais (Pas-de-Calais).

Cambridge, Corpus Christi College, MS. 164, fols. 9 r, 10 v, late 13th century.

[2] Cambrai, Bibliothèque Municipale, MS. 211, fol. 129 r, mid-13th century, perhaps from Ste. Marie-de-Ourscamps (Oise).

Paris, Bibliothèque Nationale, MS. lat. 17468, fols. 99 r, 102 v, second half of the 13th century, from St. Martin-des-Champs, Paris.

[3] Thus the "sevens" design for instance, which is inscribed in a number of concentric circles, comprises the requests of the Lord's Prayer, the sacraments, the gifts of the Holy Ghost, the spiritual weapons of the virtues, deeds of mercy, virtues, vices. In Arundel MS. 83 the cardinal virtues stand beside the Arbor virtutum. Prudentia holds a dove and snake, Justitia a rod and balance, Fortitudo sword and shield, Temperantia torch and vessel. (Cf. Saunders, pl. 105 and p. 103).

A fresh type of illustration: The "Turris Sapientiae", a building of the same kind as those in miniature-illustrations of the temple in the vision of Ezekiel (Ezek. XLI, 1 ff.; cf. Paris, Bibliothèque Nationale, MS. lat. 3848, fol. 87 r). In a miniature of Arundel MS. 83, fol. 135 r, the various parts of the building are inscribed with moral precepts. The base represents Humilitas, the breadth Caritas, the height Perseverantia. On the steps and columns, doors and windows, and the stones of the masonry stand the names of virtues and exhortations to virtuous conduct. Between the supporting columns appear the figures of their respective cardinal virtues, above them virtuous clercs. Model representatives of the rulers of the world emerge from the towers.

Other MSS. of the same sequence of a purely diagramatic character: Paris, Bibliothèque de l'Arsénal, MSS. 937, 1037, late 13th century. Already in a 10th century miniature from St. Bertin there is a "Turris Philosophiae", a step-like erection constructed out of the seven liberal arts (Boulogne, Bibliothèque Municipale, MS. 40, fol. 98 r).

Starting from the words of the Epistle to the Ephesians (III, 18): "ut possitis comprehendere cum omnibus sanctis, quae sit latitudo et longitudo et sublimitas et profundum", the theologians place a moral interpretation upon the points of the cross. Corresponding inscriptions are to be found on miniatures[1]. The rungs of the ladder are also regarded as virtues or vices[2]. It may finally be mentioned incidentally that the names of the gifts of the Holy Ghost are recorded on the seven-armed candlestick of Solomon's Temple (Exod. XXV, 31 ff.)[3].

All these allegorical representations show the close combination and interweaving of thought, mental images and actual forms. Based on general or subtly developed views, they make a wealth of outward shapes convey an inner, spiritual message. The almost inexhaustible theme of virtues and vices is consequently broached again and again in early mediaeval art in fresh ways and with steadily increasing emphasis.

The *Psychomachia* cycle had first given a visual picture of the invisible conflict between the spiritual forces of good and evil. After a highly ramified development in the 9th and 10th centuries, it declined in the latter part of the 11th, to give place to triumphal psychomachy, the more rigid and direct treatment of the same motive, so preparing the way for a fuller development in 12th century French sculpture. And the illustrations of the ladder of virtue finally showed the various steps in the subjection of evil and the ascent to the good.

The virtues, however, were not only portrayed dynamically in the excitement of battle or of triumph but also in peaceful representations of a static nature. From the 9th century onwards whole groups of moral personifications were enclosed in "medallion" designs, the clear and systematic arrangement

[1] E. g. in the Uota Book of the Gospels, fol. 3 v (cf. p. 35, note 2). Cf. Swarzenski, *Regensburg*, pl. XIII, no. 30.

[2] In a late 12th century South German miniature the old theme of the two paths is illustrated by means of a forking ladder. At the foot the new born babe climbs up the rungs of the five senses. Higher up, the good man laboriously ascends the steps of the cardinal virtues towards Christ who sheds upon him the seven rays of the Holy Ghost — "Ibunt de virtute in virtutem, videbitur Deus deorum in Sion" says Ps. LXXXIII, 8 [84, 7] —, while the wicked man, ridden by a devil, stumbles down the rungs of the vices into hell (Erlangen, Universitätsbibliothek, MS. 8, fol. 130 v). Cf. *Katalog der Handschriften der Universitätsbibliothek Erlangen* VI. Eberhard Lutze, *Die Bilderhandschriften*, Erlangen 1936, fig. 4. — The conception of a ladder with rungs of increasing value towards the top is of classical origin. In the Mithras mysteries a ladder of various metals was regarded as a symbol of the soul's ascent through the spheres of the planets. Cf. Franz Cumont, "Disques ou miroirs magiques de Tarente" *(Revue archéologique* 1927, p. 15, note 1).

[3] E. g. in a 12th century Northern French psalter-miniature (Amiens, Bibliothèque Municipale, Fonds Lescalopier, MS. 2, fol. 19 bis r): "Lucernae septem sunt dona spiritus sancti", as the Venerable Bede has it, for instance *(De tabernaculo et vasis eius ac vestibus sacerdotum*, lib. I, cap. 9; Migne, *P. L.* 91, 419).

of which suited the complicated thought structure which the picture sought to convey.

These "virtue-medallion" representations achieved in Germany and in the Meuse region during the 11th and 12th centuries—at first in miniatures, then on church furniture—a remarkably high pitch of refinement. Also belonging to the static cycle of illustrations are the representations of virtues and vices as human examples, animals, trees or objects, and, particularly in 12th century tract illustrations, as genealogical systems.

All these various elements of the attempt to inculcate morals by representational means are fused into a self-contained unity in the virtue and vice cycle of Notre-Dame.

CHAPTER III. THE VIRTUE AND VICE CYCLE OF NOTRE-DAME.

At the end of the first decade of the 13th century the central porch of the façade of Notre-Dame received as decoration for the plinths of its jambs a complete cycle of virtues and vices, a sort of ethical Summa (Figs. 72, 73)[1]. This moment was one of singular importance for the intellectual development of the Middle Ages, for it was then that the "Universitas magistrorum et scholarium Parisiis studentium", particularly favoured by the Popes, took the lead over all other places of education, and by its direct exposition of the reviving Aristotelianism overshadowed in effect and influence the most famous cathedral schools such as Chartres. The immediate neighbourhood of such living learning provided the best possible soil for the evolution of the comprehensive plan on which was built up this bold new treatment and final summing up of a theme which had exercised the hearts and minds of the faithful for centuries.

The virtues and vices belong to the cycle of the Last Judgment, to the Judge Christ in the tympanum, to the hierarchy of angels and saints, to the blessed and the damned in the archivolts, to the twelve assessors of the verdict and to the Wise and Foolish Virgins on the pillars at the entrance. These all strike one as a warning in stone for the churchgoer, enjoining him to look to the judgment of the last day. As if locked together by an invisible band, the twelve virtues sit, peaceful and self sufficient, below the Apostles, as though they sought to embody in a large, harmonious company the purity and tranquillity of the soul. The series begins on the left with Humilitas, the root of all good, who is followed by Prudentia and Castitas, and reaches its climax, at the entrance, in the theological virtues (Caritas, Spes, Fides). The cycle is continued on the right with Fortitudo, Patientia, Mansuetudo, Concordia, Oboedientia and ends with Perseverantia. Each virtue holds a circular disc with a symbolical device which serves as a characteristic enabling

[1] Marcel Aubert, *Notre-Dame de Paris*, pls. 41, 45 and p. 17. — Mâle II, figs. 70, 71, 75. Several reliefs were heavily restored in the 18th century and the "restorations" betray a large number of misconceptions. The extremely faithful copies on the Cathedrals of Amiens and Chartres, however, serve to give us an accurate impression of the originals.

75

one to establish the identity of each of these otherwise practically indistinguishable figures[1].

The diversity of the lower series stands in effective contrast to the unity of the upper zone. The lower series presents a number of scenes illustrative of vicious conduct and is based entirely on the horrifying transitoriness of wicked joys and impulses. Beside the falling rider.(Superbia)[2] can be seen the fool (Stultitia), the wanton regarding herself in a mirror, wrongly restored as a woman engaged in weighing (Luxuria)[3], the miserly woman (Avaritia), the suicide (Desperatio) and the idolater (Idolatria). The right jamb shows a knight fleeing from a hare (Ignavia), a monk being threatened (Ira), the maltreatment of a servant (Malignitas), a domestic quarrel (Discordia), an altercation between a bishop and a layman (Contumacia) and a monk running away from his monastery (Inconstantia)[4].

Virtues and vices had already been introduced into the sphere of representation of the Last Judgment on Romanesque church-façades in South-West France. But that the virtues should now serve as bases for the twelve Apostles and the bases should stress the imposing size and united appearance of the virtues and show them exalted above all petty strife, all the hurly-burly of sinful activity, has its origin in another source from which it grew and developed rapidly.

[1] Humilitas with a dove; Prudentia with a snake; Castitas with the bird Charista, which hovers unharmed above a burning mountain; Caritas with a lamb, giving clothing to a freezing person; Spes with a banner, reaching for a crown; Fides with cross and chalice; Fortitudo armed, with a lion; Patientia with an ox; Mansuetudo with a sheep; Concordia with an olive-branch; Oboedientia with a camel; Perseverantia with the crown of life. A lion's tail is represented on the disc, and the head belonging to it is held in Perseverantia's right hand (symbols of the beginning and the end). Cf. Mâle II, pp. 110 ff.

 True creative power in the invention of attributes is thus seen for the first time since Carolingian days. The usual distinguishing marks are chosen from the range of animals or objects possessing a moral significance (e. g. Prudentia's snake), or fresh ones selected (e. g. Oboedientia's camel).

 Individual enthroned virtues frequently occur in book-illuminations, Sapientia in particular in the initial of Ecclesiasticus. The enthroned Sapientia of the *Psychomachia* may originally have served as a model. A 9th century example: Bamberg, Staatliche Bibliothek, Cod. A. I. 5, fol. 260 v (Köhler, pl. 58 c); some 12th century instances: Paris, Bibliothèque Nationale, MSS. lat. 116, fol. 13 v; lat. 104, fol. 29 v.

[2] Villard de Honnecourt sketched the Humilitas and the Superbia scene about 1235 (Hans R. Hahnloser, *Villard de Honnecourt*, Vienna 1935, pl. 6). The "falling horseman" type was also applied to representations of a similar nature, the falling Paul for instance.

[3] In Amiens and Chartres Luxuria is represented by a pair of lovers.

[4] In conjunction with this cycle two scenes, one above the other, are done in relief on the buttresses on each side of the porch. They are obviously examples of virtuous and sinful conduct. On the left, Job on his bed of sickness (Patientia) — a man armed with a spear standing by a stream (?). On the right, the sacrifice of Abraham (Oboedientia) — Nimrod raises his spear against the sun (Contumacia); cf. "Nemrod gigas diaboli typum expressit, qui superbo appetitu culmen divinae celsitudinis appetivit dicens: Ascendam super altitudinem nubium et ero similis Altissimo" (Isidorus Hisp., *Allegoriae quaedam sacrae scripturae ;* Migne *P. L.* 83, 103).

In the jambs of the central porch of the Cathedral of Senlis (circa 1180) not far from Paris, there are eight Old Testament figures and on their pedestals which form a series of blocks at right-angles is a sequence of sixteen reliefs mainly representing occupations characteristic of each of the months; the theological sequence thus rests upon the secular base of the cycle of the months[1].

The single relief-sequence was already doubled in the Cathedral of Sens (circa 1200), the emphasis on form and content being so distributed that the upper series predominates over the lower one. On the left side of the plinth the seven liberal arts are shown enthroned above monsters and animals (Fig. 74)[2]. The various branches of philosophy thus rise above the rude and ill-formed realm of nature into a purer sphere. The master craftsman of Paris adopted the idea of dividing the ornamentation of the plinth for the kindred theme of virtues and vices[3].

There are other elements in the Paris cycle, besides this, which point back to Sens where the contrast between good and evil is recorded by a particularly important example on two plinth reliefs in the left side-porch (late 12th century). On the left, Avaritia tries to press down the lid of a chest with the weight of her body, so that none of her ill-gotten possessions may get lost. Facing her, Largitas, wearing a crown, generously opens two small boxes of treasures[4].

Even symbolical discs[5] are already borne by the sixteen virtues who stand on the outside archivolt of the central porch at Sens. But the discs only designate the figures in quite a general fashion as virtues comparable with plants and birds, without distinguishing them any more closely than that.

[1] Aubert, pls. 55, 58.

[2] Bégule, fig. 40 and pp. 35, 36.

[3] Since the jambs are no longer stepped, the artist doubles, nay, trebles the dividing columns in order to articulate the jambs and consequently the unbroken frieze in a more pronounced manner. For the virtues he retains the sitting position and the arrangement in pairs of the liberal arts. Only Fortitudo looks to the front, for her square facing attitude indicates courage and resolution. The representations of the frieze beneath that of the virtues, being in lower relief, are less conspicuous. Though they are executed on a rectangular field, they are confined to circular frames considerably smaller.

[4] Aubert, pl. 4, no. 2. — Bégule, figs. 42, 43 and pp. 37, 38. — Related representations on the porch of the church of Villeneuve-l'Archevêque (Yonne). Cf. Bégule, fig. 44.

[5] Discs with symbols were already common in Early Christian times. John the Baptist usually bears such a disc with the picture of the Agnus Dei. On a late 12th century portable altar from Cologne the apostles hold circular discs showing their allotted missionary districts (Goldschmidt, *Elfenbeine* III, pl. XXXV, nos. 87 a ff.). Job bears a head-and-shoulder portrayal of Patientia on the portable altar from the former Benedictine Abbey at München-Gladbach (Hans Graeven, "Fragmente eines Siegburger Tragaltars im Kestnermuseum zu Hannover"; *Jahrbuch der kgl. preussischen Kunstsammlungen* XXI, 1900, pp. 75 ff.). Cf. also the Prudentia with a disc bearing the picture of a dove (see p. 45, note 2).

Shrubs decorate the plates as a rule, but doves are used twice, for the two topmost figures[1].

Thus the scattered motives which appear without any real coherence on the Cathedral of Sens and are rendered in an inchoate manner, embodying, as they do, the initial stage of a rapid development (a symbolically graduated plinth, virtues and vices arranged to oppose one another, discs with symbols) only achieve a living unity in the work of the Paris master, who, to all appearance, seems to have come from the workshop active at some distance to the south. Conceived afresh and combined with other forces, these motives gain in meaning, clarity and strength.

The artist carried out the plan of the cycle with such skill that the subtlety of the content achieved full and perfect expression in the outward form, for that which can be seen reveals the thought behind it as plainly as if it were written down for us at the present day.

A fundamental change in outlook is shown by the fact that all the vices are now illustrated by examples in the form of sinners in everyday life; these have an immediate deterring effect on the observer, since they are men like himself and not remote personifications. The originator of the scheme for the cycle seems to have gathered ideas for a large number of scenes from codes of punishment, since he regarded a "Poenitentiale Pauperum" as the best means of warning those who have wandered from the path of righteousness. From very early times onward the law of the church has condemned suicide commited out of despair: "Si quis homo vexatus est a diabolo et nescit quid facit et venans se ipsum occidit, licet ut oretur pro eo. Si vero pro desperatione... occidit, non oretur pro eo"[2]. One punishment is appoint-

[1] Aubert, pl. 9. — Bégule, fig. 38.

More clearly defined is the representation of the fourteen joys of the body and the soul in heaven executed on the outer archivolt of the left side of the arcade in the north porch of Chartres Cathedral, circa 1215. The virgins hold not only lances but shields with symbolical signs: Pulchritudo—four roses, Libertas—two crowns, Honor—two mitres, Gaudium—an angel, Voluptas—an angel, Velocitas—three arrows, Fortitudo—a lion, Concordia—two doves, Amicitia—four doves, Longaevitas—an eagle, Potestas—three sceptres, Sanitas—three fishes, Securitas—a castle, Scientia—a griffin. Cf. Houvet, *Portail Nord* I, p. 3; II, pls. 1–6, 11, 13–16.

Honorius Augustodunensis says of them: "Qui per septiformum spiritum in his virtutibus florebunt, per ipsum VII munera in corpore, VII dona in anima obtinebunt, quando in terra sua duplicia possidebunt, cum in corpore sicut sol fulgebunt et in anima aequales angelis erunt" (*Speculum Ecclesiae, In pentecostem*; Migne *P. L.* 172, 961). According to an account of Eadmer of Canterbury, St. Anselm preached to the monks of Cluny on the same subject: "Quattuordecim igitur sunt beatitudinis partes, quas finito generali examine perfectius omnes electi habebunt..." (Migne *P. L.* 159, 627 sq.).

[2] *Poenitentiale Valicellanum* I, 6 (Herm. Jos. Schmitz, *Die Bussbücher und die Bussdisciplin der Kirche* I, Mainz 1883, p. 259).

ed for the idolater[1], another for the miser[2]. The menacing attack of the woman filled with unrighteous wrath reminds one of the regulation: "Si quis ministros ecclesiae, subdiaconum, lectorem, exorcistam, acolytum injuriaverit aut percusserit vel plagiaverit, componat hoc tripliciter Diaconi vero, presbyteri atque episcopi injuria in quadruplum componatur"[3] or the order that: "Si quis alium per iram percusserit et sanguinem effuderit, si laicus est, XX dies poeniteat: clericus XXX ..."[4]. The maltreatment of servants must be punished[5], and special provision is made to protect the bishop against insubordination: "Si autem vobis episcopis non oboedierint... reliqui populi, non solum infames, sed et extorres a regno Dei et consortio fidelium ac a liminibus sanctae Dei ecclesiae alieni erunt"[6]. The deserting monk also appears liable to punishment: "Fugitivum vero clericum aut monachum deserentem disciplinam velut contemptorem placuit revocare"[7].

Not only does the content of many of the vice scenes offer a parallel to penal rules, but their form is related to the miniatures illustrating legal books. In late 12th century Northern French manuscripts of the *Decretum Gratiani* one may find at the openings of various "Causae" figured initials with little scenes, a quarrel between a bishop and a layman for instance, very similar to that represented in the Contumacia relief (Fig. 75)[8].

The various scenes are neither loosely nor arbitrarily arranged but are bound together in a graduated symmetry. On the left jamb the examples all consist of single figures. The medallions at each end, pride and idolatry, illustrate two related kinds of false faith, both resting on insecure foundations. The wild movement of the galloping horse on the first medallion leads, like the movement of the idolater[9], on to the neighbouring pair of reliefs, which show again two related subjects. Foolishness and despair are spiritual conditions in which man permanently or temporarily lacks the insight given him by God and is driven to taking ill-considered steps. The four types of obfusc-

[1] "Nam de his, qui daemonibus immolant, Theodori episcopi constitutiones habemus, in quibus scriptum est: Qui immolant daemoniis in minimis, anno uno poeniteant, qui vero in magnis, decem annos poeniteant" (Ivo of Chartres, *Decretum* XI cap. 39; Migne *P. L.* 161, 755). Cf. also *Decretum Gratiani* II c. 10 C. 26 q. 5 (Migne *P. L.* 187, 1348 sq.).

[2] *Decretum Gratiani* I c. 8 D. 47 (Migne *P. L.* 187, 247 sq.).

[3] Ivo of Chartres, *Decretum* VI cap. 401 (Migne *P. L.* 161, 531).

[4] Burchard of Worms, *Decretum* XIX, 119 (Migne *P. L.* 140, 1007).

[5] *Decretum Gratiani* I c. 43 D. 50 (Migne *P. L.* 187, 277).

[6] *Ib.*, II c. 11 C. 11 q. 3 (Migne, *P. L.* 187, 843 sq.).

[7] Ivo of Chartres, *Decretum* VII cap. 46 (Migne *P. L.* 161, 555).

[8] Berlin, Preussische Staatsbibliothek, MS. lat. Fol. 1, fol. 108 v, at the beginning of *Decretum* II C. 10; circa 1170.

[9] This is a widespread motive in book-illumination, e. g. Paris, Bibliothèque Ste. Geneviève, MS. 9, fol. 209 r. Cf. p. 8, note 1.

ation and perversity of the human mind enclose the two most dangerous material desires, lechery and avarice, the human representatives of which are accorded places in the centre. Each anxiously guards the treasure which she deems most precious, the wanton her ephemeral beauty, the avaricious woman her ill-gotten gains. The one bows towards her mirror and the other over her treasure-chest.

The right jamb-plinth is decorated on the same lines except that here, as a rule, two figures are represented. The medallions at each end have the allied weaknesses of cowardice and vacillation as their theme illustrated by the flight of a knight and a monk, who both cast glances behind them. Then there are two examples of the way lack of self-control occasions injustice. The angry woman threatens violence, while the refractory man contents himself with abuse. In each case it is a clerc who is the victim of these evil practices. Moreover these reliefs occupy the same position on each side. The central reliefs finally show still worse manifestations of injustice, namely one-sided and reciprocal violence. On the left the mistress kicks her servant and on the right a man and his wife fight a domestic battle. Thus the six reliefs on the right proceeding from lack of courage (knight) and lack of perseverance (monk) turn to steadily worse forms of wrong-doing extending in logical sequence from threats of word (layman and bishop) and deed (woman and monk) to one-sided violence (mistress and servant) and the exchange of blows (married couple).

One may discern the nucleus of this finely devised virtue and vice cycle in the pattern finally established by Hugo of St. Victor, which comprises Humilitas, the theological trinity and the cardinal virtues. The series, of such importance for the illustration of morals[1], is increased to twelve corresponding with the number of the Apostles, and this is done by treating more fully the figures of two virtues (Fortitudo, Justitia) which exercise a stronger

[1] Cf. the Initials in the Book of the Gospels of Hitda of Meschede (see p. 34), the introductory miniature of the psychomachy cycle of the *Hortus Deliciarum* (see p. 10) or the trees of the virtues (see p. 67). The same series is combined with eight vices to form opposing pairs on an archivolt of the north porch of Chartres Cathedral. The composition, as far as content is concerned, occupies a position between those of the triumphal psychomachy representations and the Paris relief sequence although chronologically somewhat later. The virtues are admittedly larger and tower over the vices whom they press downwards, but the essential characteristics, those of standing triumphant over the vanquished or of the bitter final struggle, are missing. The majority of the virtues, moreover, hold attributes. The following are represented: Prudentia with book — Stultitia biting a stone. Justitia with a pair of scales, the equilibrum of which is upset by Injustitia. Fortitudo armed — Ignavia, a fallen soldier who throws away his sword. Temperantia with a dove—Intemperantia tearing her garment. Fides catching the blood of a lamb in a chalice—Idolatria blindfold. Spes looking up to heaven—Desperatio stabing herself to death. Caritas giving away her garment—Avaritia guarding her treasures. Humilitas with a dove—Superbia falling. The artist thus treats motives of the Paris cycle. Cf. Mâle II, pp. 105, 106.

influence on their surroundings than the others do. The virtues which primarily concern the individual are placed on the left — Humilitas, Prudentia, Castitas as the most important aspect of Temperantia, Caritas, Spes, Fides— and on the right, the social virtues—Fortitudo with Perseverantia and the four subsidiary conceptions of Justitia, as a contrast to types of unjust behaviour.

Thus all the currents in the range of art concerned with representations of morality seem to have contributed their share to this supreme example, just as a burning glass receives scattered rays and concentrates them into a powerful brilliance. Various motives are derived from the *Psychomachia* illustrations (the arrogant man, the miserly woman); triumphal psychomachy has supplied the principle of arrangement above and below, as well as the difference in size between the upper and lower spheres; some characteristics are adopted from the "virtue-medallion" type of representation, for instance the spacial separation of moral forces and their designation by means of attributes. Allegorical representations (human examples, animal symbolism) contribute their share, as does theological literature. But the man who used his great selective and arranging capacity in formulating the thought, and the sculptor with his clear formative powers succeeded in setting before the observer the whole theme in two strata—an absolute world comparable to the realm of the blessed, and a series of episodes characteristic of the transient everyday world.

And so this single work, a kind of "Summa virtutum et vitiorum", comprises once and for all the highly ramified development of virtue and vice representation through the centuries.

APPENDIX. THE INFLUENCE OF THE VIRTUE AND VICE CYCLE OF NOTRE-DAME.

For many succeeding decades all artists of note, in whatever medium they tried to treat the theme of virtues and vices, stood under the spell of the Paris master.

Yet the repetitions on the Cathedrals of Amiens (Plinths of the jambs of the central west porch, circa 1230; Fig. 76) and Chartres (Central piers of the south porch, circa 1240) already show that only slight alterations are necessary to break up the finely constructed unity. In Amiens the reliefs of the virtues and those of the examples of vices are rendered of equal size and strength and both series are fitted into similar quatrefoils. The telling formal preponderance of the upper frieze disappears because of this unification[1]. And since the artist of Chartres places three pairs of virtue and vice reliefs above one another, the impressive contrast between spheres of blessedness and abomination is completely lost[2].

[1] Durand, pls. XXVIII, XXIX. — Mâle II, figs. 52, 53, 55, 57, 60, 63, 66, 68, 69, 72 ff. and pp. 110 ff — Vitry, pl. 33.

Other departures from the original worthy of mention are these: The virgins bear pointed shields instead of discs. Is this a relapse into the ideas of psychomachy? Beside Humilitas a shrub is to be seen. This is perhaps added as an allusion to the highly ramified tree of the virtues of which Humilitas is the root. In order to illustrate the situation more effectually, the sensual woman who looks at herself in the glass, is also given a lover who embraces her with passionate desire. And so the old motive of the pair of lovers, which is capable of many an interpretation in both good and evil senses, is introduced once again. Christ clasps Ecclesia, the "sponsa", with both hands (e. g. Benedictine Abbey of Admont, MS. 37 (255), fol. 12 r, circa 1180; Buberl, fig. 70). Solomon and the Queen of Sheba (or Sapientia? e. g. in the Heisterbach Bible, circa 1240, Berlin, Preussische Staatsbibliothek, MS. theol. lat. Fol. 379, fol. 264 v; Hanns Swarzenski, fig. 80), or Hosea and the whore whom he took at God's command, correspond the heavenly pair (Hos. I, 2 ff.; cf. Paris, Bibliothèque Nationale, MS. lat. 11534, fol. 324 r, circa 1180). The unnamed example of base desire is presented in the same way as in the initial of the *Decretum Gratiani* which illustrates the regulation concerning adultery (e. g. Benedictine Abbey of Admont, MS. 72 (35), fol. 255 r, first half of the 13 th century; Buberl, fig. 89). The variations of the Amiens artist thus keep within the bounds of church law.

[2] Houvet, *Portail Sud* II, pls. 44–66. — Mâle II, fig. 51 and pp. 110 ff.

Certain motives recur again and again. Thus, on the jambs of the right porch in the west front of Rheims Cathedral (circa 1265), virtues and vices are arranged above one another, Superbia, for instance, as a falling rider, whose horse is frightened by three dragons, Fortitudo-Ignavia, Castitas-Luxuria, Largitas-Avaritia, Prudentia-Stultitia, Spes-Desperatio. Cf. L. Demaison, "Les figures des vices et des vertus au portail occidental de la Cathédrale de Reims" (*Bulletin monumental* LXXXII, 1923, pp. 130 ff.). — Paul Vitry, *La Cathédrale de Reims* I, Paris, pl. LXV, nos. 3, 4 and fig. 22.

Besides these instances mention may be made of Avaritia and Superbia on the choir-stall of Poitiers Cathedral (Amédée Boinet, "Les stalles de la Cathédrale de Poitiers"; *Congrès archéologique* LXXIX, 1912, vol. II, pp. 332 ff.) and the Osnabrück Imperial Goblet, first half of the 14th century (Chr. Dolfen, *Der Kaiserpokal der Stadt Osnabrück*, Osnabrück 1927).

Two other copies also depart from the symmetry of the original, one because it enriches the content with new features, the other because it allows the content to degenerate. The artist who repeats the ornamentation of the plinths in the glass of the great rose-window in the west front of Notre-Dame places spears, as well as symbolical discs, in the hands of the virtues. He considered it necessary to express the superiority of the forces of righteousness, which the master-sculptor of the reliefs had shown as being based on the real inner character, by external means of power as well[1].

The symbolic value of the discs was clearly lost, however, on the German sculptor who copied the Paris cycle around 1230 for a porch planned for Magdeburg Cathedral. He therefore omits to reproduce them and only records the rough impression which the row of the virgins succeeded in making on him[2].

[1] The virtues fill the twelve upper quatrefoils against the periphery. A smaller circular field, rather nearer to the centre and showing an example of a vice is subordinated to each of these. Cf. Ferdinand de Lasteyrie, *Histoire de la peinture sur verre d'après ses monuments en France*, Text I, Paris 1857, pp. 138 ff. — Mâle II, figs. 58, 59, 61, 62, 64, 65 and pp. 110 ff.

Two other 13th century glass windows show the influence of the Paris relief sequence, but to a lesser degree.

I. Window of the choir apse of Lyons Cathedral, circa 1220. Virtues and vices are opposed to one another thus:

Superbia, a falling monarch.	Humilitas crossing her hands over her breast.
Ira, a youth piercing himself with a spear.	Patientia holding a chalice.
Dolor, a man crossing his hands.	Laetitia as a praying female figure.
Luxuria regards herself in a mirror.	Castrimargia (Sobrietas) holding a cross.
Avaritia, a man collecting treasures.	Largitas giving away valuables.
Cupiditas holding tightly on to her property.	Caritas clothing the naked.
Ebrietas with a vessel.	Castitas with a sceptre and a spray of blossom.

Cf. Lucien Bégule, *Les vitraux du moyen-âge et de la renaissance et spécialement dans l'ancien diocèse de Lyon*, Lyons 1911, pp. 45 ff. — Lucien Bégule, *La Cathédrale de Lyon*, Paris, figs. 30 ff. and pp. 79, 80.

II. Choir window of Auxerre Cathedral, circa 1230. Eight virtues are enthroned in the sectors formed by the eight radii of the rose. The virtues are near the centre, while the vices are placed close to the circumference:

Superbia, a knight falling off a horse.	Humilitas holding a disc with a dove on it.
Desperatio piercing herself with a spear.	Patientia holding the picture of a lamb.
Dolor tearing her hair.	Laetitia with book and sceptre.
Discordia, two people fighting.	Concordia with cross.
Stultitia, a fool with a club.	Sapientia with book.
Ebrietas with a goblet.	Sobrietas drinking out of a small cup.
Avaritia holding treasures.	Largitas clothing the poor.
Luxuria with a mirror.	Castitas with a book and a palm-branch.

Cf. Charles Porée, *La Cathédrale d'Auxerre*, Paris 1926, pp. 79, 80. — Mâle II, pp. 110 ff.

[2] The reliefs, in as far as they were completed, were later placed high up on the walls of the choir. The vice scenes are apprehended with great faithfulness, but in place of the virtues the artist renders

The influence of the Paris reliefs had not died out even by the end of the 13th century when a comprehensive cycle of virtues and vices was created for the *Somme le Roi*, written by a Dominican friar named Laurent of Orleans at the command of King Philip III, the Bold, in the year 1279. Here all known thought and imagery is elaborated with great care and, where possible, eagerly developed. But the accumulation of a large number of dissociated elements and the departure from the principle of closely-knit composition seen in the Notre-Dame cycle are signs that a new phase is beginning in the representations of virtues and vices.

male and female figures and moreover, for formal reasons, two as a rule instead of one. They strike one as ladies and gentlemen of this world, especially those holding musical instruments.

Cf. Adolph Goldschmidt, "Französische Einflüsse in der frühgotischen Skulptur Sachsens" (*Jahrbuch der kgl. preussischen Kunstsammlungen* XX, 1899, pp. 285 ff.), pl. I and pp. 291 ff. — Greischel, pl. 65.

LIST OF ILLUSTRATIONS

Plate Figure

I 1 Concordia commanding. *Psychomachia* MS., late 10th century. Paris, Bibliothèque Nationale, MS. lat. 8318, fol. 62 r.

 2 Marcus Aurelius commanding. Column of Marcus Aurelius, Rome.

 3 The March of.the Virtues. *Psychomachia* MS., late 10th century. Paris,Bibliothèque Nationale, Ms. lat. 8318, fol. 62 v.

 4 The March of the Romans. Column of Trajan, Rome.

II 5 Patientia in the midst of the Vices. *Psychomachia* MS., 9th century. Leyden, University Library, Cod. Burmanni Q 3, fol. 125 v.

 6 Operatio (Largitas) and Avaritia — Operatio and the Poor. *Psychomachia* MS., 1298. Paris, Bibliothèque Nationale, MS. lat. 15158, fol. 53 v.

III 7 Psychomachy. Book-Cover of the Melisenda Psalter, c.1131—44. London, British Museum, Egerton MS. 1139.

IV 8a Psychomachy. *Hortus Deliciarum*, fol. 199 v, late 12th century.

 9 The Band of Vices, Moissac MS., late 11th century. Paris, Bibliothèque Nationale, MS. 2077, fol. 163 r.

V 8b Psychomachy. *Hortus Deliciarum*, fol. 200 r, late 12th century.

 10 Joseph before Pharaoh. English MS., 11th century. London, British Museum, Cotton MS. Claudius B iv, fol. 65 v.

 11 Humilitas before Exultatio. Moissac MS., late 11th century. Paris, Bibliothèque Nationale, Ms. 2077, fol. 164 v.

 12 Ira and Patientia. *Ib.*, fol. 168 r.

VI 13 Virtues triumphant. Ivory, 9th century. Florence, Museo Nazionale, Carrand Collection.

 14 Virtues triumphant and human Examples. Bamberg Apocalypse, 1001—2. Bamberg, Staatliche Bibliothek, Cod. A. II. 42, fol. 60 r.

VII 15 Humilitas triumphant and virtuous Women. *Speculum Virginum*, second quarter of the 12th century. London, British Museum, Arundel MS. 44, fol. 34 v.

 16 The Triumph of Christ and of Humilitas. Ratisbon MS., c. 1170—85. Munich, Bayer. Staatsbibliothek, Cod. lat. 14159, fol. 5 r.

VIII 17 Virtues triumphant, c. 1130. Aulnay (Charente-Inférieure), St. Pierre.

IX 18 Last Judgment Cycle, c. 1135. Argenton-Château (Deux-Sèvres), St. Gilles.

X 19 Virtues triumphant, c. 1280. Strasbourg Cathedral.

 20 Virtues triumphant. Church-Door, 1152—54. Novgorod.

XI 21 Virtues triumphant. Reliquary, c. 1200. Troyes Cathedral.

 22 Virtues triumphant. French MS., late 12th century. Paris, Bibliothèque Nationale, MS. lat. 11629, fol. 3 r.

XII 23 The Ladder of Virtue. Klimax MS., 11th century. Rome, Biblioteca Vaticana, Cod. gr. 394, fol. f v.

 24 The Ladder of Virtue. *Ib.*, fol. 94 r.

XIII 25 The Ladder of Virtue. *Hortus Deliciarum*, fol. 215 v, late 12th century.

 26 The Ladder of Virtue. *Speculum Virginum*, second quarter of the 12th century. London, British Museum, Arundel MS. 44, fol. 93 v.

XIV 27 Virgil and two Muses. Roman Mosaic. Tunis, Museo del Bardo.

 28 Bacchus and the Seasons. Roman Mosaic (from an old drawing). Algiers, Museum.

XV 29 Anicia Juliana and two Virtues. Vienna Dioscurides, c. 500—510. Vienna, Nationalbibliothek, Cod. Med. gr. 1, fol. 6 v.

 30 Hope. Fresco at Bawît, 5th century.

XVI 31 Christ and two Virtues. Gospels of John II Komnenos, c. 1118—43. Rome, Biblioteca Vaticana, Cod. Urb. gr. 2, fol. 19 v.

XVII	32	Unknown Ruler and the cardinal Virtues. Cambrai Gospels, second half of the 9th century. Cambrai, Bibliothèque Municipale, MS. 327, fol. 16 v.
XVIII	33	Archbishop Frederick and the cardinal Virtues, Rhenish Lectionary, c. 1130. Cologne, Dombibliothek, Ms. Fol. 59, fol. 1 r.
XIX	34	Liturgical Scene with the cardinal Virtues. Rhenish Sacramentary, early 11th century. Paris, Bibliothèque Nationale, MS. lat. 9436, fol. 106 v.
	35	Initial-Page with Virtues. Gospels of Hitda of Meschede, c. 1030. Darmstadt, Landesbibliothek, MS. 1640, fol. 173 r.
XX	36	Romualdus and Virtues. Codex Aureus of St. Emmeram, late 10th century. Munich, Bayer. Staatsbibliothek, Cod. lat. 14000 (Cim. 55), fol. 1 r.
	37	The Creation and Virtues. Gospels of Uota, c. 1002—25. Munich, Bayer. Staatsbibliothek, Cod. lat. 13601 (Cim. 54), fol. 1 v.
XXI	38	Henry II and Virtues. Gospels, c. 1014—24. Rome, Biblioteca Vaticana, Cod. Ottob. lat. 74, fol. 193 v.
XXII	39	Pictorial Exegesis of the Book of Job. Floreffe Bible, c. 1155. London, British Museum, Add. MS. 17738, fol. 3 v.
XXIII	40	Virtues crucifying Christ. Rhenish MS., c. 1250—60. Cologne, Stadtarchiv, MS. W. f. 255.
	41	Virtues crucifying Christ. South German MS., c. 1260. Besançon, Bibliothèque Municipale, MS. 54, fol. 15 v.
XXIV	42	The Ascension of St. Amandus. St. Amand MS., late 11th century. Valenciennes, Bibliothèque Municipale, MS. 502, fol. 119 r.
	43	The Ascension of St. Amandus. St. Amand MS., c. 1160. Valenciennes, Bibliothèque Municipale, MS. 501, fol. 31 r.
XXV	44	Psalm LXXXIV. Utrecht Psalter, 9th century. Utrecht, University Library, Cod. 32, fol. 49 v.
	45	Psalm LXXXIV and the Visitation. Peterborough Psalter, mid-13th century. Brussels, Bibliothèque Royale, MS. 593, fol. 10 r.
XXVI	46	Virtues in the Tower. Liber Scivias, c. 1175. Wiesbaden, Landesbibliothek, Cod. 1, fol. 138 v.
	47	Virtues in the Tower. Ib., fol. 139 r.
XXVII	48	Virtues on the Ladder. Ib., fol. 178 r.
XXVIII	49	Portable Altar with the cardinal Virtues. South German, early 11th century. Munich, Bayer. Nationalmuseum.
XXIX	50	St. Heribert and two Virtues. Heribert Shrine, c. 1165—75. Deutz, Parish church.
XXX	51,52	The Gifts of the Holy Ghost on the Reliquary of Pope Alexander, c. 1145. Brussels, Musées Royaux du Cinquantenaire.
XXXI	53	Virtues on the Reliquary of St. Gondulf, c. 1160—70. Brussels, Musées Royaux du Cinquantenaire.
XXXII	54	Vices and human Examples. Ratisbon MS., 1165. Munich, Bayer. Staatsbibliothek, Cod. lat. 13002, fol. 3 v.
XXXIII	55	Virtues and human Examples. Ib., fol. 4 r.
XXXIV	56	The Wanton, c. 1120. Bordeaux, Ste. Croix.
	57	The Miser, c. 1120. Bordeaux. Ste. Croix.
XXXV	58	The Sinners in the Last Judgment. French Psalter, late 11th century. Amiens, Bibliothèque Municipale, MS. 19, fol. 12 v.
	59	The Blessed and the Damned. Prayer-Book of St. Hildegard, c. 1170. Munich, Bayer. Staatsbibliothek, Cod. lat. 935, fol. 33 v.
XXXVI	60	The Chariot of Avaritia. Hortus Deliciarum, fol. 203 v, late 12th century.
	61	Moral Exposition of two Monsters, German MS., 12th century. Munich, Bayer. Staatsbibliothek, Cod. lat. 18158, fol. 63 r.
XXXVII	62	Moral Exposition of the Dove. French MS., second half of the 12th century. Frankfort, Stadtbibliothek, MS. Batt. 167, fol. 66 r.
	63	Moral Exposition of the Cherubim. Ib., fol. 88 r.
XXXVIII	64	The "Arbor bona". Liber floridus, c. 1120. Ghent, Bibliothèque de l'Université et de la Ville, MS. 16, fol. 231 v.

XXXIX	65	The "Arbor mala". *Ib.*, fol. 231 v.
XL	66	The Tree of Vices. *De fructibus carnis et spiritus*, second quarter of the 12th century. Salzburg, Studienbibliothek, MS. Sign. V. 1. H. 162, fol. 75 v.
XLI	67	The Tree of Virtues. *Ib.*, fol. 76 r.
XLII	68	The Mystical Paradise. *Speculum Virginum*, second quarter of the 12th century. London, British Museum, Arundel MS. 44, fol. 13 r.
XLIII	69	The Mystical Paradise. Ratisbon MS., c. 1170—85. Munich, Bayer. Staatsbibliothek, Cod. lat. 14159, fol. 5 v.
XLIV	70	The "Rota falsae religionis". Austrian MS., late 12th century. Heiligenkreuz, Stiftsbibliothek, Cod. 226, fol. 149 v.
XLV	71	The "Rota verae religionis". *Ib.*, fol. 146 r.
XLVI	72a	The Virtue and Vice Cycle of Notre-Dame, c. 1210. Left side I.
	73a	The Virtue and Vice Cycle of Notre-Dame, Right Side I.
XLVII	72b	The Virtue and Vice Cycle of Notre-Dame. Left Side II.
	73b	The Virtue and Vice Cycle of Notre-Dame, Right Side II.
XLVIII	74	The Liberal Arts, c. 1200. Sens Cathedral.
	75	Initial of the *Decretum Gratiani*. French MS., c. 1170. Berlin, Preussische Staatsbibliothek, MS. lat. Fol. 1, fol. 108 v.
	76	The Virtue and Vice Cycle of Amiens Cathedral, c. 1230.

Figs. 9, 11, 12, 16, 17, 19, 20, 36, 37, 50, 54—57, 59, 69, 74: "Marburger Fotos".
Figs. 33, 46—48, 70, 71: Photographs of the Rheinisches Bildarchiv, Cologne.

LIST OF ABBREVIATIONS

d'Ancona = Paolo d'Ancona, *L'uomo e le sue opere nelle figurazioni italiane del medioevo,* Florence 1923.

Aubert = Marcel Aubert, *French Sculpture at the Beginning of the Gothic Period.* 1140—1225, Florence 1931.

aus'm Weerth = Ernst aus'm Weerth, *Der Mosaikboden in St. Gereon zu Cöln,* Bonn 1873.

Baillet = Dom Louis Baillet, "Les miniatures du "Scivias" de Sainte Hildegarde conservé à la Bibliothèque de Wiesbaden" *(Fondation Eugène Piot, Monuments et Mémoires* XIX, 1911, pp. 49ff.).

Bassermann-Schmid = E. Bassermann-Jordan and Wolfgang M. Schmid, *Der Bamberger Domschatz,* Munich 1914.

Bégule = Lucien Bégule, *La Cathédrale de Sens,* Lyons 1929.

Benedicti Regula = Sancti Benedicti Regula monasteriorum ed. D. Cuthbertus Butler, Freiburg 1927 (2nd ed.).

Boeckler, *Abendl. Min.* = Albert Boeckler, *Abendländische Miniaturen bis zum Ausgang der romanischen Zeit,* Berlin-Leipzig 1930.

Boeckler, *Evangelienbuch* = Albert Boeckler, *Das goldene Evangelienbuch Heinrichs III.,* Berlin 1933.

Boeckler, *Regensburg* = Albert Boeckler, *Die Regenburg-Prüfeninger Buchmalerei des XII. und XIII. Jahrhunderts (Miniaturen aus Handschriften der Bayerischen Staatsbibliothek in München* VIII), Munich 1924.

Borchgrave d'Altena = Comte J. de Borchgrave d'Altena, "Des figures de vertus dans l'art mosan au XIIe siècle" *(Bulletin des Musées royaux d'art et d'histoire* V, 1933, pp. 14ff.*).*

Borenius-Tristram = Tancred Borenius and E. W. Tristram, *English Mediaeval Painting,* Florence-Paris 1927.

Braun, *Altargerät* = Joseph Braun, *Das christliche Altargerät in seinem Sein und seiner Entwicklung,* Munich 1932.

Braun, *Heribertusschrein* = Joseph Braun, "Der Heribertusschrein zu Deutz, seine Datierung und seine Herkunft" *(Münchner Jahrbuch der bildenden Kunst,* new series VI, 1929, pp. 109ff.).

Braun, *Meisterwerke* I, II = Joseph Braun, *Meisterwerke der deutschen Goldschmiedekunst der vorgotischen Zeit* I, II, Munich 1922.

Bruck = Robert Bruck, *Die Malereien in den Handschriften des Königreichs Sachsen,* Dresden 1906.

Buberl = Paul Buberl, *Die illuminierten Handschriften in Steiermark* I *(Beschreibendes Verzeichnis der illuminierten Handschriften in Österreich* IV), Leipzig 1911.

Chamot = M. Chamot, *English Mediaeval Enamels,* London 1930.

Clemen = Paul Clemen, *Die romanische Monumentalmalerei in den Rheinlanden,* Düsseldorf 1916.

Cornell = Henrik Cornell, *Biblia Pauperum,* Stockholm 1925.

Creutz = Max Creutz, "Rheinische Goldschmiedeschulen des X. und XI. Jahrhunderts" *(Zeitschrift für christliche Kunst* XXI, 1908, cols. 163ff., 201ff., 229ff.).

Demus = Otto Demus, *Die Mosaiken von San Marco in Venedig 1100—1300,* Baden (near Vienna) 1935.

Deschamps = Paul Deschamps, *French Sculpture of the Romanesque Period,* Florence 1930.

De Wald = E. T. De Wald, *The Illustrations of the Utrecht Psalter,* Princeton.

Durand = Georges Durand, *Monographie de l'église Notre-Dame, Cathedrale d'Amiens.* Amiens—Paris 1903.

Falke-Frauberger = Otto v. Falke and Heinrich Frauberger, *Deutsche Schmelzarbeiten des Mittelalters und andere Kunstwerke der kunsthistorischen Ausstellung zu Düsseldorf 1902,* Frankfort 1904.

Falke-Meyer = Otto v. Falke and Erich Meyer, *Romanische Leuchter und Gefässe. Giessgefässe der Gotik (Bronzegeräte des Mittelalters* I), Berlin 1935.

Frisch = Ernst v. Frisch, "Über die Salzburger Handschrift von Hugo von St. Victors Opusculum De Fructu Carnis et Spiritus" *(Leidinger-Festschrift,* Munich 1930, pp. 67ff.).

Gardner = Arthur Gardner, *A Handbook of English Mediaeval Figure-Sculpture,* Cambridge 1935.

Goldschmidt, *Albanipsalter* = Adolph Goldschmidt, *Der Albanipsalter in Hildesheim und seine Beziehung zur symbolischen Kirchenskulptur des XII. Jahrhunderts,* Berlin 1895.

Goldschmidt, *Elfenbeine* I ff. = Adolph Goldschmidt, *Die Elfenbeinskulpturen* I ff., Berlin 1914ff.
Goldschmidt, *Illumination* II = Adolph Goldschmidt, *German Illumination* II, Florence-Paris 1928.
Greischel = Walther Greischel, *Der Magdeburger Dom*, Berlin 1929.
Hauttmann = Max Hauttmann, *Die Kunst des frühen Mittelalters*, Berlin 1929.
Hermann = Hermann Julius Hermann, *Die deutschen romanischen Handschriften (Beschreibendes Verzeichnis der illuminierten Handschriften in Österreich*, new series II), Leipzig 1926.
Houvet, *Portail Nord, Portail Sud* = Et. Houvet, *Cathédrale de Chartres*, Chelles (S. et M.).
James = Montague Rhodes James, *A descriptive Catalogue of the Latin Manuscripts in the John Rylands Library at Manchester*, Manchester-London 1921.
Jansen = Franz Jansen, *Die Helmarshausener Buchmalerei zur Zeit Heinrichs des Löwen*, Hildesheim-Leipzig 1933.
Keller = Hiltgart L. Keller, *Mittelrheinische Buchmalereien in Handschriften aus dem Kreise der Hiltgart von Bingen*, Stuttgart 1933.
Kleinschmidt = Beda Kleinschmidt, "Der mittelalterliche Tragaltar" *(Zeitschrift für christliche Kunst* XVI, 1903; XVII, 1904).
Köhler = Wilhelm Köhler, *Die karolingischen Miniaturen I. Die Schule von Tours*, Berlin 1930-33.
Lehmann-Hartleben = Karl Lehmann-Hartleben, *Die Trajanssäule*, Berlin-Leipzig 1926.
Liebeschütz = Hans Liebeschütz, *Das allegorische Weltbild der heiligen Hildegard von Bingen (Studien der Bibliothek Warburg)*, Leipzig-Berlin 1930.
Löffler = Karl Löffler, *Schwäbische Buchmalerei in romanischer Zeit*, Augsburg 1928.
Mâle I = Émile Mâle, *L'art religieux du XIIᵉ siècle en France*, Paris 1924 (2nd ed.).
Mâle II = Émile Mâle, *L'art religieux du XIIIᵉ siècle en France*, Paris 1925 (6th ed.).
van Marle = Raimond van Marle, *Iconographie de l'art profane au moyen-âge et à la renaissance* II, Hague 1932.
Martin = Camille Martin, *L'art roman en Italie. L'architecture et la décoration* I, Paris 1912.
Mattingly-Sydenham = Harold Mattingly and Edward Sydenham, *The Roman Imperial Coinage*, London 1923ff.
Metz = Peter Metz, "Das Kunstgewerbe von der Karolingerzeit bis zum Beginn der Gotik" (Bossert, *Geschichte des Kunstgewerbes* V, Berlin 1932, pp. 197ff.).
Michel II. 1 = André Michel, *Histoire de l'art* II. 1, Paris 1922 (2nd ed.).
Millar = Eric G. Millar, *English Illuminated Manuscripts from the Xth to the XIIIth Century*, Paris-Brussels 1926.
Mosaïques = *Inventaire des mosaïques de la Gaule et de l'Afrique*, Paris 1909ff.
Omont = Henry Omont, *Miniatures des plus anciens manuscrits grecs de la Bibliothèque Nationale du VIᵉ au XIVᵉ siècle*, Paris 1929.
Oursel = C. Oursel, *La miniature du XIIᵉ siècle à l'abbaye de Cîteaux d'après les manuscrits de la Bibliothèque de Dijon*, Dijon 1926.
Petersen = E. Petersen, A. v. Domaszewski, G. Calderini, *Die Marcussäule*, Munich 1896.
Kingsley Porter = A. Kingsley Porter, *Romanesque Sculpture of the Pilgrimage Roads*, Boston 1923.
Prior-Gardner = Edward S. Prior and Arthur Gardner, *An Account of Mediaeval Figure-Sculpture in England*, Cambridge 1912.
Quibell = J. E. Quibell, *Excavations at Saqqara* II ff. *(Service des antiquités de l'Egypte)*, Cairo 1908ff.
Reitzenstein = Alexander Frh. von Reitzenstein, "Das Clemensgrab im Dom zu Bamberg" *(Münchner Jahrbuch der bildenden Kunst*, new series VI, 1929, pp. 216ff.).
Rey = Raymond Rey, *La sculpture romane languedocienne*, Toulouse-Paris 1936.
Salomon = Richard Salomon, *Opicinus de Canistris (Studies of the Warburg Institute)*, London 1936.
Saunders = O. Elfrida Saunders, *English Illumination* I, Florence-Paris 1928.
Saxl = Fritz Saxl, *Mithras*, Berlin 1931.
Schramm, *Herrscherbild* = Percy Ernst Schramm, "Das Herrscherbild in der Kunst des frühen Mittelalters" *(Vorträge der Bibliothek Warburg* II. 1, 1922—23, pp. 145ff.).
Schramm, *Kaiser und Könige* = Percy Ernst Schramm, *Die deutschen Kaiser und Könige in Bildern ihrer Zeit* I, Leipzig-Berlin 1928.
Smith = E. Baldwin Smith, *Early Christian Iconography and a School of Ivory Carvers in Provence*, Princeton 1918.
Stettiner = Richard Stettiner, *Die illustrierten Prudentius-Handschriften*, Berlin 1895—1905.

Straub-Keller = A. Straub and G. Keller, *Herrade de Landsberg, Hortus Deliciarum*, Strasbourg 1879—99.

Hanns Swarzenski = Hanns Swarzenski, *Die lateinischen illuminierten Handschriften des XIII. Jahrhunderts in den Ländern an Rhein, Main und Donau*, Berlin 1936.

Swarzenski, *Kunstkreis* = Georg Swarzenski, "Aus dem Kunstkreis Heinrich des Löwen" (*Städel-Jahrbuch* VII-VIII, 1932, pp. 241 ff.).

Swarzenski, *Regensburg* = Georg Swarzenski, *Die Regensburger Buchmalerei des X. und XI. Jahrhunderts*, Leipzig 1901.

Swarzenski, *Salzburg* = Georg Swarzenski, *Die Salzburger Malerei von den ersten Anfängen bis zur Blütezeit des romanischen Stils*, Leipzig 1913.

Swarzenski-Schilling = Georg Swarzenski und Rosy Schilling, *Die illuminierten Handschriften und Einzelminiaturen des Mittelalters und der Renaissance in Frankfurter Besitz*, Frankfort 1929.

Tikkanen, *Klimax-Hs.* = J. J. Tikkanen, *Eine illustrierte Klimax-Handschrift der vatikanischen Bibliothek (Acta Societatis Scientiarum Fennicae* XIX, no. 2), Helsingfors 1893.

Tikkanen, *Psalter* = J. J. Tikkanen, *Die Psalterillustration im Mittelalter (Acta Societatis Scientiarum Fennicae* XXXI, no. 5) Helsingfors 1903.

Toesca, *Pittura* = Pietro Toesca, *La pittura e la miniatura nella Lombardia*, Milan 1912.

Toesca, *Storia* = Pietro Toesca, *Storia dell'arte italiana* I. 2, Turin 1927.

Vitry = Paul Vitry, *French Sculpture during the Reign of Saint Louis.* 1226—1270, Florence 1930.

Watson, *Speculum* = Arthur Watson, "The Speculum Virginum with special Reference to the Tree of Jesse" (*Speculum* III, 1928, pp. 445 ff.).

Watson, *Tree* = Arthur Watson, *The early Iconography of the Tree of Jesse*, Oxford 1934.

Welfenschatz = O. v. Falke, R. Schmidt and Georg Swarzenski, *Der Welfenschatz des Braunschweiger Doms*, Frankfort 1930.

Wilpert = Giuseppe Wilpert, *I sarcofagi cristiani antichi* I, Rome 1929.

Winkler = Erich Winkler, *Die Buchmalerei in Niederösterreich von 1150—1250*, Vienna 1923.

Witte = Fritz Witte, *Tausend Jahre deutscher Kunst am Rhein* I, Berlin 1932.

Woodruff = Helen Woodruff, "The Illustrated Manuscripts of Prudentius" (*Art Studies* 1929, pp. 33 ff.).

ERRATUM

Plate II, fig. 5. For: Ira, read: Patientia.

INDEX OF PLACES

The numbers in large type refer to the pages and figures, those in small type to the notes, which are designated thus "⁰" when they begin on the preceding page.

Admont,Benedictine Abbey:
 MS. 37 (255): 82¹.
 MS. 72 (35): 82¹.
 MS. 73 (128): 63².
Aix-la-Chapelle, Minster:
 Chandelier. 51⁷.
 Shrine of Charlemagne. 48⁰.
Alba Fucense. Relief. 59¹.
Alexandria. Fresco. 14³.
Algiers, Museum. Mosaic. 28³. Fig. 28.
Amiens:
 Bibl. Municipale:
 MS. 19: 59⁴. Fig. 58.
 Fonds Lescalopier, MS. 2: 73³.
 Cathedral. Socle frieze etc. 64¹. 75¹. 76³. 82.
 82¹. Fig. 76.
Angers, St. Aubin. Archivolt. 19¹.
Angoulême, Cathedral. Façade. 59³.
Anzy-le-Duc, Priory Church. Capital. 59³.
Argenton-Château, St. Gilles. Archivolts. 17 ff.
 Fig. 18.
Arles, St. Trophime. Capital. 59³.
Arras, Bibl. Municipale. MS. 943—282: 16².
Augsburg, Cathedral Treasure. Altar. 45².
Aulnay, St. Pierre. Archivolts. 17ff. Fig. 17.
Autun:
 Bibl. Municipale. MS. 19, Sacramentary.
 33. 33³.
 St. Lazare. Tympanum. 59⁴.
Auxerre, Cathedral. Window. 83¹.
Bamberg:
 Cathedral. Tomb of Clement. 52⁰.
 Staatl. Bibl.:
 Cod. A. I. 5: 76¹.
 Cod. A. II. 25: 50¹.
 Cod. A. II. 42. Apocalypse. 15. 15³. 17.
 57. Fig. 14.
Basle:
 R. von Hirsch Collection. Enamel plaque. 45².
 Minster. Gallus Door. 60².
Bawît. Frescoes. 29. Fig. 30.
Bayeux, Cathedral. Chandelier. 51⁷.
Beaulieu, Church. Porch. 59³.

Berlin:
 Preuss. Staatsbibl.:
 MS. lat. Fol. 1: 34³. 79⁸. Fig. 75.
 MS. Phill. 1701: 16².
 MS. theol. lat. Fol. 2: 50.¹
 MS. theol. lat. Fol. 379: 82¹.
 Schlossmuseum:
 Altar cross. 49².
 Eilbertus Altar. 45².
 Enamel plaque. 45².
Berne, Stadtbibl.:
 MS. 120: 30².
 MS. 264: 4⁰. 15¹.
Besançon, Bibl. Municipale. MS. 54: 39².
 Fig. 41.
Blasimont, St. Maurice. Archivolt. 19¹.
Bonn, Provincial Museum. *Speculum Virginum.*
 16².
Bordeaux:
 Bibl. Municipale. MS. 995: 62².
 Ste. Croix. Archivolts. 58. Figs. 56. 57.
Boulogne, Bibl. Municipale:
 MS. 40: 72³.
 MS. 46: 40⁴.
Brixen, Church of the Baptism. Fresco. 42⁰.
Brussels:
 Bibl. Royale:
 MS. 465: 50¹.
 MS. 593. Peterborough Psalter. 41⁴. Fig. 45.
 MS. 974: 4⁰. 7.
 MS. 975: 4⁰.
 MS. 977: 4⁰. 15¹.
 MS. 1453: 68⁰.
 MS. 1491: 62². 72¹.
 Musées Royaux du Cinquantenaire:
 Alexander Reliquary. 48. 48¹. 53⁰. 68².
 Figs. 51. 52.
 Enamel plaque. 68⁰.
 Gondulf Reliquary. 48. 48². 54. Fig. 53.
 Stoclet Collection. Enamel plaque. 49⁰.
Budapest, National Museum:
 Aquamanile. 51³.
 Crown of King Andrew. 51⁵.

Cambrai, Bibl. Municipale:
MS. 211: 72².
MS. 259: 62².
MS. 327: Gospels. 31. 31³. 32. Fig. 32.
Cambridge:
Corpus Christi College:
MS. 16: 63⁰.
MS. 23: 4⁰. 7.
MS. 66: 62³.
MS. 164: 72¹.
Fitzwilliam Museum. MS. 12: 41⁵.
Trinity College. MS. R. 17. 1: 41¹.
Carthage. Mosaic. 28³.
Castelvieil, Church. Archivolt. 19¹.
Chadenac, Church. Archivolt. 19¹.
Chaldon, Church. Fresco. 25¹.
Chalgrove, Church. Fresco. 20².
Chanteuges, Church. Capital. 59³.
Charlieu, Church. Relief. 59¹.
Chartres:
Bibl. Municipale. MS. 77: 63².
Cathedral. Archivolts etc. 61². 75¹. 76³. 78¹. 80¹. 82.
Civray, St. Nicolas. Archivolt. 19¹.
Clermont-Ferrand, Notre-Dame-du-Port. Capitals. 8¹. 17². 59³.
Cleveland, Museum. Bernward Patens. 51². 51⁴.
Cluny, Musée Ochier. Capitals. 53. 53¹.
Cologne:
Cathedral. Shrine of the three Kings. 47. 47⁶.
Dombibl. MS. Fol. 59. Lectionary of Archbishop Frederick I. 32. 33. 33¹. Fig. 33.
St. Maria Lyskirchen. Fresco. 53⁰.
St. Pantaleon:
Albinus Shrine. 47.
Maurinus Shrine. 47.
Stadtarchiv:
MS. W. f. 255: 39³. Fig. 40.
MS. W. f. 276a: 16².
Deutz, Parish-church. Heribert Shrine. 8¹. 47. 47². Fig. 50.
Conques, Church. Tympanum. 59⁴.
Copenhagen:
Gl. kongl. Bibl. MS. 6. 2⁰: 29⁰.
National Museet. Antependium. 45².
Ny Carlsberg Glyptothek. Sarcophagus. 6¹¹.
Corme-Royal, Church. Archivolt. 19¹.
Cremona, Cathedral. Mosaic. 8¹.
Cunault, Church. Capital. 59³.
Darmstadt:
Landesbibl. MS. 1640. Gospels of Hitda of Meschede. 33. 34. 34¹. 54. 80¹. Fig. 35.
Landesmuseum:
Book-cover. 50¹.
Enamel plaques. 68².
Dijon, Bibl. Municipale. MS. 641: 16¹.

Donaueschingen, Library of Prince Fürstenberg. MS. 185: 39².
Douai, Bibl. Municipale. MS. 370: 62².
Düsseldorf, Landesbibl. MS. B. 31: 39².
El Bagawat. Fresco. 28.
El Djem. Mosaic. 28³.
El Escorial. Cod. Real. Bibl., Vitr. 17. Codex Aureus. 32. 32¹. 34³.
Engelberg, Stiftsbibl. MS. 61: 39².
Ennezat, Church. Capital. 59³.
Erlangen, Univ. Bibl. MS. 8: 73².
Eton College. MS. 177: 46².
Fenioux, Church. Archivolt. 19¹.
Florence:
Bibl. Laurenziana. Cod. Plut. XVI. 21: 64⁰.
Museo Nazionale, Carrand Collection:
Bishop's crozier. 21³.
Ivory. 15. 15². 17. Fig. 13.
Fontaines-d'Ozillac, Church. Archivolt. 19¹.
Frankfort:
Museum of Arts and Crafts. Enamel plaque. 45².
Stadtbibl. MS. Batt. 167: 62². 62³. Figs. 62.63.
Freiburg, Minster. Porch. 61¹.
Fritzlar, St. Peter. Altar cross. 49².
Gaza, Winter baths. Painting. 29⁰.
Ghent, Bibl. de l'Univ. et de la Ville. MS. 16. Liber floridus. 65. 65¹. 66. 68. 68¹. 68². Figs. 64. 65.
Gmunden, Kgl. Ernst-August Fideikommissbibl. Gospels of Henry the Lion. 9. 9³. 33². 34³. 41⁴.
Gotha, Landesbibl. MS. I. 19: 34².
Gurk, Cathedral. Fresco. 53⁰.
Hannover, Kestnermuseum. Altar. 77⁵.
Heddernheim. Mithras Relief. 28. 29.
Heidelberg. Univ. Libr. MS. Sal. X. 16: 44².
Heiligenkreuz, Stiftsbibl.:
Cod. 130: 71².
Cod. 226: 62². 71³. 71⁴. Figs. 70. 71.
Hildesheim:
Cathedral:
Chandelier. 51⁷.
Floor. 52¹.
Font. 20³. 49. 49¹. 60. 70³.
MS. 37: 33⁵.
St. Godehard. Albani Psalter. 10⁴.
St. Michael:
Ceiling. 52¹.
Reliefs. 54⁰.
Ivry-la-Bataille, Church. Archivolt. 19¹.
Karlsruhe, Landesbibl. Cod. Reichenau LX. 62¹.
Klosterneuburg. Ambo. 46. 46². 47.
La Charité-sur-Loire, Priory church. Capital. 59³.

La Graulière, Church. Sculptures. 58[4].
Langres, Museum. Enamel plaques. 8[1].
Laon, Cathedral. Archivolt. 19.
Laval, St. Martin. Frescoes. 20[2].
Leipzig, Univ. Libr.:
 MS. 148: 67[1]. 68[0].
 MS. 305: 68[0].
 MS. 665: 16[2].
Leyden, Univ. Libr.:
 Cod. Burmanni Q 3: 4[0]. 7. 7[4]. Fig. 5.
 Cod. Voss. lat. F. 31: 65[1].
 Cod. Voss. lat. oct. 15: 3[2]. 4. 5[2]. 6[7]. 6[13]. 7.
Liége:
 Ste. Croix. Reliquary. 49[0].
 Univ. Libr. Book-cover. 50[1].
London:
 British Museum:
 Enamel plaques. 49[0].
 ~~Add.~~ MS. 3244: 62[1].
 Add. MS. 11695: 58[3].
 Add. MS. 17738. Floreffe Bible. 37. 37[1]. 52. 60[2]. Fig. 39.
 Add. MS. 18325: 63[0].
 Add. MS. 22399: 61[4].
 Add. MS. 24199: 4[0]. 7.
 Arundel MS. 44: 16[2]. 16[3]. 25[2]. 69[2]. Figs. 15. 26. 68.
 Arundel MS. 83: 63[0]. 72. 72[3].
 Cotton MS. Claudius B iv. 12[2]. Fig. 10.
 Cotton MS. Cleopatra C viii. 4[0]. 7.
 Cotton MS. Titus D. xvi. 4[0]. 7.
 Egerton MS. 1139. Melisenda Psalter. 9[2]. 60. Fig. 7.
 Harl. MS. 2799. Arnstein Bible. 33. 33[2].
 Royal MS. 10 A vii. 62[2].
 Chester Beatty Library. W. de Brailes Psalter. 34[3].
 Lambeth Palace. MS. 3: 41[3].
 Victoria and Albert Museum:
 Alton Towers Triptych. 45[2].
 Gloucester Candlestick. 8[1].
 Reliquary. 49[0].
 Westminster Palace, Frescoes. 20[2].
Lucca, Bibl. governativa. Cod. 1942: 44[2].
Lyons:
 Bibl. du Palais des Arts. MS. 22: 4[0]. 7[8]. 15[1].
 Bibl. Municipale:
 MS. 445: 68[0].
 MS. 863: 64[0].
 Cathedral. Window. 83[1].
 St. Irenée. Mosaic. 52[1].
Magdeburg, Cathedral. Reliefs. 54[0]. 83. 83[2].
Mainz, Cathedral. Key-stone. 54[0].
Manchester, John Rylands Libr.:
 MS. 6: 63[0].
 MS. 11: 50[1].

Marburg, St. Elizabeth. Shrine, windows. 60[3].
Melk, Stiftsbibl. MS. 199: 68[0].
Melle, St. Hilaire. Archivolt. 19[1].
Meuse School. 8[1]. 45[2]. 48[0] ff. 50[1]. 74.
Milan:
 Bibl. Ambrosiana. Iliad. 5[4].
 Cathedral. Candlestick. 20.
Modena, Cathedral. Relief. 8[1].
Moissac, St. Pierre. Sculptures. 54[0]. 58[4].
Montecassino, Rabanus Maurus. MS. 12[2].
Montmorillon, Octogon. Sculptures. 59[2].
Montoire, St. Gilles. Frescoes. 20[2].
Moscou. Chludoff Psalter. 60[4].
Munich:
 Bayer. Nationalmuseum. Altar. 45[2]. Fig. 49.
 Bayer. Staatsbibl.:
 Cod. lat. 935: 60[1]. Fig. 59.
 Cod. lat. 4452 (Cim. 57). 50[1].
 Cod. lat. 9564: 64[0].
 Cod. lat. 13002: 57[2]. Figs. 54. 55.
 Cod. lat. 13601 (Cim. 54). Gospels of Uota. 35. 35[2]. 73[1]. Fig. 37.
 Cod. lat. 14000 (Cim. 55). Codex Aureus of St. Emmeram. 35. 35[1]. Fig. 36.
 Cod. lat. 14159: 17[1]. 64[2]. 70[2]. Figs. 16. 69.
 Cod. lat. 17403: 58[0].
 Cod. lat. 18158: 62[1]. Fig. 61.
 Reiche Kapelle. Reliquary. 45[2].
Murano, S. Donato. Mosaic. 8[1].
Naples, S. Gennaro. Fresco. 5[3].
Naumburg, Cathedral. Window. 20[2].
New York, Pierpont Morgan Libr. Book-cover. 50[1].
Nordkirchen, Arenberg Collection. Reliquary. 49[0].
Novgorod. Church-door. 21. 21[2]. Fig. 20.
Orcival, Church. Capital. 59[3].
Osnabrück, Town hall. Goblet. 82[2].
Oxford, Keble College. Legendary. 39[2].
Palermo, Cappella Palatina. Mosaics. 53[0].
Paris:
 Bibl. de l'Arsenal:
 MS. lat. 937: 72[3].
 MS. lat. 1037: 72[3].
 Bibl. Mazarine. MS. 981: 68[0].
 Bibl. Nationale:
 MS. Coislin 79: 30[1].
 MS. Coislin 88: 24.[1]
 MS. gr. 139: 24[0].
 MS. gr. 1158: 24[1].
 MS. lat. 1. First Bible of Charles the Bald. 31. 31[2]. 32.
 MS. lat. 104: 76[1].
 MS. lat. 116: 76[1].
 MS. lat. 817: 33[5].
 MS. lat. 2077: 11[3] ff. Figs. 9. 11. 12.

MS. lat. 2495: 62².
MS. lat. 3848: 72³.
MS. lat. 6191: 61⁴.
MS. lat. 8085: 4⁰. 7.
MS. lat. 8318: 3².4. 4¹ff. 5⁶ff.7.8. Figs. 1.3.
MS. lat. 8851: 33⁵.
MS. lat. 8865: 65¹.
MS. lat. 9436: 33⁴. Fig. 34.
MS. lat. 10501: 34³.
MS. lat. 10630: 68⁰.
MS. lat. 11534: 82¹.
MS. lat. 11615: 64⁰.
MS. lat. 11629: 21⁴. Fig. 22.
MS. lat. 14500: 63⁰.
MS. lat. 15158: 4⁰. 7. Fig. 6.
MS. lat. 15988: 63⁰.
MS. lat. 17251: 63⁰.
MS. lat. 17468: 72².
Bibl. Ste. Geneviève, MSS. 9—10: 8¹. 79⁹.
Musée de Cluny:
Antependium. 45. 46. 46¹.
Portatile. 45².
Notre-Dame. Socle frieze, window. 27. 54.
56. 59. 60. 75 ff. 83. 83¹. Figs. 72. 73.
Parma, Baptistery. Porches. 60². 65⁰.
Partenay, Notre-Dame-de-la-Couldre. Archivolt. 19¹.
Pavia, Museo Civico. Mosaic. 8¹.
Pesaro. Mosaic. 28³.
Peterborough, Cathedral. Frescoes. 41⁴.
Piacenza, Cathedral. Sculptures. 54⁰.
Poitiers:
Cathedral. Choir-Stalls. 82².
St. Hilaire. Capital. 59³.
Polirone, S. Benedetto. Mosaic. 52¹.
Pont-l'Abbé-d'Arnoult, Church. Archivolt. 19¹.
Quedlinburg, Church. Carpet. 42⁰.
Ratisbon:
All Saints Chapel. Frescoes. 53⁰.
Book illumination. 16. 34 ff. 52. 57. 64². 70.
Cathedral Treasure. Miniature. 39².
St. James. Porch. 59⁵.
Ravenna:
Baptisteries. Mosaics. 53⁰.
S. Croce. Mosaic. 14⁴.
Rheims:
Cathedral. Porch. 82².
St. Remi. Mosaic. 52¹.
Rome:
Bibl. Vaticana:
Cod. gr. 394: 22²ff. Figs. 23. 24.
Cod. gr. 1754: 24¹.
Cod. gr. 1927: 41¹.
Cod. Ottob. lat. 74. Gospels of Henry II.
36. 36². Fig. 38.
Cod. Pal. lat. 565: 16².

Cod. Urb. gr. 2. Gospels of John II Komnenos. 30. 30². Fig. 31.
Column of Marcus Aurelius. 5. 5⁷ff. 6. Fig. 2.
Column of Trajan. 5. 6. 6²ff. Fig. 4.
Lateran Museum. Sarcophagus. 46³.
S. Maria Maggiore. Mosaics. 3¹. 5⁴.
S. Paolo fuori le mura. Bible of S. Callisto.
31. 31¹.
S. Sabina. Door. 29.
Vatican, Museo Cristiano. Book-cover. 14³.
Rossano: Codex Rossanensis. 29⁰.
St. Gall, Stiftsbibl. MS. 135: 4⁰. 7. 7⁸.
St. Ghislain, Church. Shrine of St. Gislenus.
48⁰.
St. Gilles, Church. Tomb of St. Gilles. 51⁸.
St. Jacques-des-Guérets, Church. Fresco. 20².
St. Jouin-de-Marnes, Benedictine Abbey. Sculptures. 59².
St. Julien-de-Brioude, Church. Capital. 59³.
St. Junien, Church. Tomb of St. Junianus. 51⁸.
St. Nectaire, Church. Capital. 59³.
St. Omer, Bibl. Municipale:
MS. 34: 34³.
MS. 94: 62². 72¹.
St. Pierre-le-Moutier, Church. Capital. 59³.
St. Pompain, Church. Archivolt. 19¹.
St. Romain-en-Gal. Mosaic. 28³.
St. Symphorien, Church. Archivolt. 19¹.
St. Symphorien near Mons, Church. Shrine of
St. Symphorianus. 48⁰.
Sakkara, Jeremiah Monastery. Frescoes. 29. 29¹.
Salisbury, Chapter House. Archivolt. 19².
Salzburg, Studienbibl. MS. Sign. V. 1. H. 162:
66². Figs. 66. 67.
S. Cugat del Valles, Cloister. Capital. 19².
Schwarzrheindorf, Lower church. Frescoes.
20².
Senlis, Cathedral. Socle frieze. 77.
Sens, Cathedral. Socle frieze. 77. 78. Fig. 74.
Sinai Monastery. Cod. 418: 24⁰.
Soest, St. Maria zur Höh. Capital. 59³.
Soissons, Musée Municipal. Tympanum. 59⁴.
Southrop. Font. 20. 20⁵.
Stammheim, Library of Count Fürstenberg.
Missal. 34⁰.
Stanton-Fitzwarren. Font. 20. 20⁵.
Strasbourg, Cathedral. Porch. 19. Fig. 19.
Stuttgart, Landesbibl.:
Cod. Bibl. Fol. 20: 41¹.
Cod. Bibl. Fol. 23: 41¹.
Cod. Brev. 128: 70³.
Cod. hist. Fol. 415: 25³.
Susteren, Church. Amalaberga Shrine. 48⁰.
Tavant, Church. Fresco. 8¹.
Tongres, Notre-Dame. Reliquary. 49⁰.
Toulouse, Cathedral. Capitals. 58.

Tournai, Cathedral. Porte Mantile. 19^2.
Tremessen, Chalice. 51^1.
Trier:
 Dombibl. MS. Fol. 132: 16^2.
 St. Maximin, Folcardus Font. 20.
Troyes:
 Bibl. de la Ville:
 MS. 252: 16^2.
 MS. 413: 16^2.
 Cathedral Treasure:
 Reliquary. 21. 21^3. Fig. 21.
 Shrine of St. Bernard. 48^0.
Tunis, Museo del Bardo. Mosaic. 28^1. Fig. 27.
Utrecht, Univ. Libr. Cod. 32. Psalter. 14^4. 41. 41^1. Fig. 44.
Valenciennes, Bibl. Municipale:
 MS. 500: 40^4.
 MS. 501: 40^3. Fig. 43.
 MS. 502: 40^1. Fig. 42.
 MS. 512: 32^2.
 MS. 563: 4^0.
Varaize, Church. Archivolt. 19^1.
Venice, St. Mark. Mosaic. 53^0.
Vercelli, Museo Leone. Mosaic. 8^1.
Verona:
 Cathedral. Porch. 54^0.
 S. Zeno. Door. 51^6.

Vézelay, Ste. Madeleine. Capital. 59^3.
Vic, Church. Fresco. 20^2.
Vienna:
 former Figdor Collection. Candlestick. 8^1.
 Kunsthist. Museum. Chalice of Wilten Monastery. 51^1.
 Nat.-Bibl.:
 MS. Med. gr. 1. Dioscurides MS. 28. 28^6. Fig. 29.
 MS. 395 (Hist. eccl. 50). 70^1.
 MS. 1367 (Salisb. 251). 64^3.
 MS. 1548 (Theol. 333). 63^0.
 MS. 2468 (Univ. 345). 64^0.
 St. Stephen. Enamel plaques. 49^0.
Vienne, Cathedral. Capital. 59^3.
Villeneuve-l'Archevêque, Church. Reliefs. 77^4.
Volvic, Church. Capital. 54^0.
Westphalia, Private collection. Miniature. 41^5.
Wiesbaden, Landesbibl. Cod. 1. *Liber Scivias.* 42 ff. 42^2. 61^6. Figs. 46 ff.
Wolfenbüttel, Herzog-August-Bibl.:
 MS. I. Gud. lat. 2^0: 65^1.
 MS. Helmstedt 65: 34^0.
Xanten:
 Chapel of St. Michael. Reliefs. 17^2.
 St. Victor. Bowl. 61^5.
Zwettl, Cistercian Abbey. Cod. 180: 16^2.

Aaron. 49⁰.
Abraham. 15. 15³. 49⁰. 57. 61⁵. 76⁴. Fig. 14.
Abstinentia. 9¹. 37². 43². 46. 53⁰.
Adam. 61⁵. 64⁰. 67. 68⁰. Fig. 66.
Adelgundis, St. 39.
Aegidius Parisiensis. 61⁴.
Agape. 22. 23. 23². 24⁰. 29. 29¹.
Agnes, Empress 32.
Agnes, St. 16¹.
Ahab. 57². Fig. 54.
Akakia. 24⁰.
Akedia. 9¹. 23². 59⁵.
Alanus ab Insulis. 39¹. 62. 62³.
Alazoneia. 24⁰.
Alcuin. 30. 30⁴. 63².
Aletheia. 29.
Alexander the Great. 58⁰.
Alexios, Prince. 30. Fig. 31.
Amandus, St. 39. 40. 45². Figs. 42. 43.
Ambitio. 61.
Ambrose, St. 30³. 49¹. 69.
Amicitia. 78¹.
Amor coelestis. 43. Figs. 46. 47.
Anaisthesia. 23².
Angel. 12. 18². 22. 24. 24⁰. 25¹. 29¹. 32². 34².
 43². 46. 48⁰. 51⁷. 59⁴. 68⁰. 70. 75.
Anicia Juliana. 28. Fig. 29.
Animals:
 Ant. 61⁵.
 Ape. 61.
 Aspis. 14. 26. Fig. 16.
 Basilisk. 14. 26. Fig. 16.
 Bear. 61. Fig. 60.
 Bird Charista, see Attributes.
 Camel, see Attributes.
 Cock. 61⁵.
 Dog. 61. 61⁵. Fig. 60.
 Dove. 36. 38. 43². 44. 61. 61⁵. 62. Fig. 62;
 see also Attributes.
 Dragon. 13¹. 14. 16. 16¹. 17. 17². 26. 43³.
 54⁰. 68⁰. 82². Fig. 16.
 Eagle. 61. Fig. 60; see also Attributes.
 Fish, see Attributes.
 Fox. 61. Fig. 60.
 Griffin, see Attributes.
 He-goat. 61. 61¹.
 Horse. 61. 62¹.
 Lamb. 61; see also Attributes.
 of God. 18. 45. 50¹. 70³. 77⁵. 80¹.

Lion. 14. 24⁰. 26. 32². 34³. 43. 46². 48⁰. 50¹.
 51⁶. 52⁰. 53⁰. 54⁰. 56. 61. 61⁵. Figs. 16. 47.
 60; see also Attributes.
Monsters. 10⁴. 13. 13¹. 60. 62. 62¹. 77. Fig. 61.
Ox. 61. Fig. 60.
Pig. 61. Fig. 60.
Sheep, see Attributes.
Snake. 58. 58³. 59³. 59⁵. 61⁵. 68⁰; see also
 Attributes.
Stag, see Attributes.
Toad. 58. 58³.
Wolf. 61. Fig. 60.
Anselm, St. 78¹.
Antichrist. 30².
Aorgesia. 23².
Apatheia. 23². 24⁰.
Apistia. 24⁰.
Apostles. 13¹. 18. 20². 29⁰. 32. 37. 38. 46.
 47. 50¹. 51⁸. 53⁰. 75. 76. 77⁵. 80. Figs. 18.
 33. 39.
Aprospatheia. 23².
Arete. 29⁰.
Arts, the seven liberal. 52¹. 64³. 72³. 77. 77³.
 Fig. 74.
Ascension. 53⁰.
Astutia. 71.
Atlas. 29⁰.
Attributes:
 Angel. 43². 78¹.
 Armour. 31¹. 31³. 33¹ff. 35³. 43³. 45². 49¹.
 49². 55. 63². 70³. 72³. 76¹. 80¹.
 Arrow. 78¹.
 Balance. 28⁵. 30. 30². 31¹. 31³. 32²ff. 34³.
 35³. 45². 46². 48⁰. 49⁰ff. 51⁶. 52⁰. 53⁰. 54⁰.
 55. 63². 64³. 70³. 72³. 80¹.
 Banner. 76¹.
 Bird Charista. 76¹.
 Blossom. 28². 33². 34³. 49². 50⁰. 53⁰. 53¹.
 56. 83¹.
 Book. 13¹. 19³. 31¹. 31³. 32²ff. 34³. 35³.
 46². 48⁰. 49⁰. 49¹. 55. 63². 80¹. 83¹.
 Book-casket. 49⁰.
 Branch. 44¹.
 Camel. 76¹.
 Candle. 29.
 Castle. 78¹.
 Chalice. 76¹. 80¹. 83¹.
 Cornocupia. 28⁵.
 Cross. 48². 49⁰. 50⁰. 76¹. 83¹.

Cross-staff. 33³.
Crown. 48⁰. 49⁰. 76¹. 78¹.
Crucifix. 43. 43².
Disc. 29. 50¹. 53⁰.
Dove. 34⁰. 45². 48⁰. 56. 60. 72³. 76¹. 77⁵. 78.
 78¹. 80¹. 83¹.
Eagle. 78¹.
Fan. 43².
Fish. 78¹.
Flower 43.
Font. 45². 48². 56.
Griffin. 78¹.
Head-harness. 64³.
Jewels. 43².
Jug. 31³. 33³. 54⁰. 55; see also Vessel.
Lamb. 76¹. 83¹.
Lion. 43². 76¹. 78¹.
Loaf. 46². 48². 49⁰. 53⁰. 56.
Measuring-rod. 34³. 55.
Mitre. 78¹.
Olive-branch. 30². 48⁰. 48². 49⁰. 56. 76¹.
Ox. 76¹.
Palm-branch. 12. 13¹. 31². 43. 52¹. 64³. 83¹.
Plumb-level. 45². 55.
Rod. 72³.
Rose. 78¹.
Sceptre. 3. 28⁵. 53⁰. 78¹. 83¹.
Scourge. 64³.
Set-square. 12. 45². 49². 55.
Sheep. 76¹.
Shrub. 78.
Snake. 33¹. 33². 34⁰. 34³. 43². 45². 46². 48⁰.
 49⁰ff. 52⁰. 53⁰. 56. 60. 70³. 72³. 76¹.
Stag. 44¹.
Strong-box. 53⁰. 53¹. 56.
Sword. 30². 34³. 40⁴. 52⁰. 54⁰. 56. 64³.
Symbol of life. 28⁵.
Torch. 31³. 33³. 55. 72³.
Vessel. 32²ff. 34³. 35³. 43². 45². 46². 48⁰ff.
 51⁶. 52⁰ff. 55. 56. 63². 70³. 72³. 83¹.
Aurelian. 28².
Avaritia. 2. 3. 6. 7⁸. 8¹. 9¹. 10ff. 11¹. 13¹. 18⁰.
 20⁵. 21³. 34³. 54⁰. 58. 58². 61. 64⁰. 67. 71.
 76. 77. 80. 80¹. 82². 83¹. Figs. 6. 7. 8a.
 9. 18. 21. 60. 66. 72b. 76.
Babylon, the daughter of. 57. 57². Fig. 54.
Bacchus. 28. 28³. Fig. 28.
Baptism. 46².
Bearing of the Cross. 46².
Beatified, the. 59. Fig. 59.
Beatitudes. 34³. 48. 51¹. 51⁷. 53⁰. 54⁰. 63². 68ff.
 68². Fig. 68.
Beatitudo. 9. 43². Fig. 7.
Bede, the Venerable. 45¹. 73³.
Benedict, St. 25. 25³. 35. 35⁶ff. 46.
Benignitas. 9. 20². 38. 47⁶. 53⁰. 65. Figs. 7. 39.

Bible, books and parts of:
 Genesis. 22. 49⁰. 57².
 Exodus. 45. 49⁰. 57². 73.
 Numbers. 49⁰.
 Judges. 16.
 Samuel. 57².
 Kings. 57².
 Judith. 16.
 Esther. 57².
 Job. 37. 38.
 Psalms. 14. 16. 18. 40ff. 41¹. 60⁴. 62. 68². 73².
 Proverbs. 33. 36. 49¹. 50¹.
 Wisdom of Solomon 49¹. 68².
 Ecclesiasticus. 58³. 68.
 Isaiah. 37. 58³.
 Jeremiah. 68⁰.
 Ezekiel. 58³. 72³.
 Hosea. 82¹.
 Matthew, Gospel of St. 13. 34³. 49¹. 56. 58.
 60. 63. 66.
 Luke, Gospel of St. 53⁰.
 Romans. 58³.
 Corinthians. 54.
 Galatians. 47. 48. 63. 65.
 Ephesians. 1. 45². 62¹. 73.
 Revelation of St. John. 57². 68¹. 68².
Bios. 23².
Blasphemia. 11¹. 24⁰.
Boethius. 61. 70. 71¹.
Boniface, St. 63¹.
Bonitas. 9. 47. 47⁶. 65. 65². Figs. 7. 64.
Burchard of Worms. 79⁴.
Carausius. 28².
Caritas. 10. 11¹. 17². 19³. 21³. 34³. 38. 39. 44.
 44². 45². 46ff. 46². 47². 48⁰. 48². 49⁰. 50⁰.
 50¹. 53⁰. 53¹. 54ff. 57². 64³. 65. 67. 68⁰.
 72. 72³. 75. 76¹. 80¹. 81. 83¹. Figs. 8b. 35.
 39. 41. 48. 50. 53. 55. 64. 67. 72b. 76;
 see also Virtues, the theological.
Cassianus. 59⁵.
Castitas. 9¹. 13¹. 18⁰. 19². 19³. 20². 21³. 34².
 37². 44. 46.² 47. 47⁶. 53⁰. 65. 65⁰. 65². 68⁰.
 75. 76¹. 81. 82². 83¹. Figs. 18. 21. 48. 64.
 72a. 76.
Charlemagne. 61⁴.
Charles the Bald, Emperor. 15³.
Charles III, the Fat, Emperor. 31.
Cherubim. 62. 72. Fig. 63.
Christ. 3¹. 13¹. 14. 14⁴. 16. 17. 22. 24⁰. 25¹. 26.
 29. 29⁰. 30. 30³. 32. 33. 35. 37². 38. 39.
 40⁴. 41. 41⁵. 42⁰. 43ff. 43². 45². 50. 50¹. 51².
 52¹. 64⁰. 67. 68². 69. 70. 73². 75. 82¹.
 Figs. 16. 18. 31. 33. 34. 39ff. 49. 67ff.
Cicero. 30³.
Column of the Redeemer. 43.
Commandments, the ten. 48⁰. 49⁰.

Compassio. 37^2.
Compunctio cordis. 44^1. 53^0.
Concordia. 3. 6. 9. 18^0. 19^3. 21^3. 28^2. 44^1. 46.
 46^2. 47^6. 59^3. 68^0. 75. 76^1. 78^1. 83^1. Figs. 1.
 7. 18. 73b.
Confessio. 37^2. 62^3.
Congratulatio fraterna. 13^1.
Conrad of Hirsau, *Speculum Virginum* 16. 25.
 57. 66^3. 68^0. 68^2. 69.
Conrad of Scheyern. 58^0.
Consilium. 37. 61^5. 68^2. Fig. 51; see also Gifts
 of the Holy Ghost.
Constantia. 44^1. 53^0.
Constantius. 15^3.
Contemptus mundi. 44^1.
Contentio. 65^3.
Continentia. 34^2. 47. 65. 65^2. Fig. 64.
Contumacia. 76. 76^4. 79. 80. Fig. 73b.
Covotise. 20^2.
Creation. 35. 37. Fig. 37.
Croesus. 57^2. Fig. 54.
Crucifixion. 16. 38. 39. 45^2. 46^2. 50^1. Figs. 16.
 40. 41.
Crudelitas. 8^1. 61.
Cupiditas. 57^2. 65. 83^1. Fig. 54.
Curiositas. 61.
David. 9. 15. 15^3. 21^3. 23^2. 24^0. 29^0. 31. 32. 38.
 56. 57^2. 60. Figs. 7. 14. 39. 55.
Death. 13^1.
Debilitas. 8^1.
Debonerete. 20^2.
Deilia. 24^0.
Demon. 13^1. 17 ff. 17^2. 24^0. 59. 59^3.
Desiderium coeleste. 44^1.
Desidia. 71.
Desperatio. 13^1. 20^2. 59^3. 65^3. 76. 78. 79. 80^1.
 82^2. 83^1. Figs. 72b. 76.
Detractio. 12. Fig. 11.
Devil. 8^1. 16. 22. 24. 24^0. 25^1. 58. 62^1. 73^2.
Diagrams of moral genealogies, linear. 63^2. 72.
 72^3.
Dikaiosyne. 28. 30. Fig. 31.
Dilectio. 13^1.
 Dei. 40. 44. 62^3. Fig. 43.
 proximi. 40. 44. 62^3. Fig. 43.
Dionysius, St. 33. Fig. 34.
Disciplina. 43. 46. 50^1. Figs. 46. 47.
Discordia. 2. 3. 8^1. 18^0. 19^3. 20^5. 21^3. 59^3. 76.
 80. 83^1. Figs. 7. 18. 73b.
Discretio. 43^2.
Discretionis temperamentum. 36.
Dissensio. 65^3.
Districtionis rigor. 36.
Doctores ecclesiastici. 69. 70. Figs. 68. 69.
Dolor. 83^1.
Domitian. 28^2.

Dynamis. 24^0.
Eadmer of Canterbury. 78^1.
Ebrietas. 20^5. 21^3. 83^1.
Ecclesia. 30^2. 39. 65. 68. 82^1. Figs. 40. 41.
Eilbertus, Master. 45^2.
Eirene. 28.
Eleemosina. 40^4.
Eleemosyne. 30. Fig. 31.
Elijah. 57^2. 61^5. Fig. 55.
Elizabeth, St. 60^3.
Elpis. 22. 23. 24^0. 29. 29^1. Fig. 30.
Erhard, St. 35.
Evagrios of Pontos. 9^1.
Evangelists. 31. 50. 50^1. 53^0. 70. 70^3.
 Symbols of. 26. 35. 45^2. 49. 50. 50^1. 51^2. 53^0.
 69. 70^3. Figs. 36. 68. 69.
Exultatio. 12 . Fig. 11.
Fall of the angels. 34^3.
Fallacia. 11^1. 21^3.
Falsitudo. 19^2.
Fames acquirendi. 61.
Fel. 8^1.
Felonia. 8^1.
Fides. 2. 2^1. 3. 9. 9^1. 10. 11^1. 18^0. 19^2. 21^3. 28^2.
 34^3. 38. 39. 44. 45^2. 46. 46^2. 48. 48^0. 48^2.
 49^0. 50^1. 53^0. 53^1. 54 ff. 64^3. 65. 65^2. 67. 68^0.
 75. 76^1. 80^1. 81. Figs. 7. 8b. 18. 21. 35. 39.
 48. 53. 64. 67. 72b. 76; see also Virtues,
 the theological.
Flagellation of Christ. 47.
Fol. 8^1.
Fornicatio. 9^1. 59^5. 65^3.
Fortitudo. 8^1. 10. 11^1. 20^2. 21^2. 29^1. 30. 31^1.
 31^3 ff. 33. 34^3. 37. 43^3. 45^2. 46^2. 48^0. 49^1 ff.
 51^6. 52^0 ff. 54 ff. 61^2. 61^5. 63^2. 68^2. 72^3. 75.
 76. 77^3. 78^1. 80. 80^1. 81. 82^2. Figs. 8b. 20.
 32 ff. 37. 49. 51. 67 ff. 73a; see also Gifts of
 the Holy Ghost and Virtues, the cardinal.
Fortuna, the wheel of. 70. 71.
Francis, St. 63^0.
Fraus. 2. 3. 11^1. 61.
Frederick I, Archbishop of Cologne. 32. Fig. 33.
Fruits of the flesh. 65 ff.
 of the Spirit. 63. 65 ff.
Furibundia. 23^1. 23^2. 59^5. Fig. 24.
Gastrimargia. 23^1. 23^2. 59^5. Fig. 24.
Gaudium. 9^1. 13^1. 46^2. 48^0. 52^1. 65. 65^2. 78^1.
 Fig. 64.
Gemitus. 43. Fig. 46.
Geneviève, St. 46.
Gereon, St. 17^2.
Gifts of the Holy Ghost. 37. 43. 48. 48^1. 57^1.
 61. 61^5. 63^2. 68. 68^2. 72^3. 73; see also Con-
 silium, Fortitudo, Intellectus, Pietas,
 Sapientia, Scientia, Timor Domini.
Glaucus. 28^3.

Gloria. 57². Fig. 54.
 inanis. 11. 12.
 vana. 9¹. 10. 11¹. 12. 67. Figs. 8a. 9. 66.
Glutton, the. 59³.
Godefroid, Master. 45².
Goliath. 9. 24⁰.
Gondulf, St. 48. Fig. 53.
Gratia Dei. 44. Fig. 48.
Gratian. 79. 79¹. 79². 79⁵. 82¹.
Gregory the Great, St. 10. 11. 32. 32². 37. 58³.
Gregory of Nyssa. 29⁰.
Gregory Thaumatourgos, St. 29⁰.
Gula. 9¹. 12. 13¹. 21³. Fig. 9; see also Ventris
 Ingluvies.
Haeresis. 30².
Halitgarius of Cambrai. 11. 11⁴.
Haman. 57². Fig. 54.
Haplotes. 24⁰.
Hebetatio. 19³.
Hell. 22. 73².
Henry II, Emperor. 36. Fig. 38.
Henry III, Emperor. 32.
Henry VI, Emperor. 30².
Hercules. 56.
Heribert, St. 47. Fig. 50.
Hermann of Helmarshausen 9.
Hermann of Lerbecke. 50¹.
Hermas, Shepherd of. 5³.
Herrad of Landsberg, *Hortus Deliciarum*. 10. 11.
 13. 24. 37². 60². 61. 66. 80¹. Figs. 8. 25. 60.
Hildegard, St. 42 ff. 44². 61.
Holofernes. 16. Fig. 15.
Homicidium. 12. 65³. Fig. 9.
Honor. 78¹.
Honoris Appetentia. 57². Fig. 54.
Honorius Augustodunensis. 24². 47. 50. 58². 78¹.
Horace. 49¹.
Hortus Deliciarum, see Herrad of Landsberg.
Hosea 82¹.
Hugo de Folieto 61⁴. 62. 70.
Hugo of St. Victor. 10. 37. 41². 62². 63². 66.
 68². 80.
Humilitas. 2. 7. 8¹. 9¹. 10. 10⁴. 12. 16. 17. 18⁰.
 19². 20⁵. 21³. 25. 34. 34³. 37 ff. 42. 43. 44².
 46². 47. 47². 47⁶. 48⁰. 49⁰. 50¹. 53⁰. 54. 54⁰.
 57. 57². 63. 64⁰. 65⁰. 66. 67. 68⁰. 68². 72.
 72³. 75. 76¹. 76². 80. 80¹. 81. 82¹. 83¹.
 Figs. 7. 8b. 9. 11. 15. 16. 18. 21. 35. 39.
 41. 48. 50. 52. 55. 67. 72a. 76.
Hypakoe. 23².
Hyperephania. 23¹. 24⁰. Fig. 24.
Hypnos. 23¹. 23². Fig. 24.
Hypocrisis. 30².
Idolatria. 8¹. 11¹. 18⁰. 21³. 76. 79. 80¹. Figs. 7.
 18. 21. 72b. 76.
Ignavia. 76. 80. 80¹. 82². Fig. 73a.

Immunditia. 65³.
Impatientia. 12. Fig. 9.
Impietas. 8¹. 21³.
Inconstantia. 76. 79. 80. Fig. 73b.
Infidelitas. 19².
Injustitia. 8¹. 65³. 80¹.
Innocentia. 46.
Inopia. 71.
Intellectus. 37. 50¹. 61⁵; see also Gifts of the
 Holy Ghost.
Intelligentia. 68².
Intemperantia. 8¹. 80¹.
Invidia. 10 ff. 11¹. 13¹. 18¹. 20². 20⁵. 21³. 64⁰.
 65³. 67. Figs. 8a. 9. 66.
Ira. 2. 6. 8¹. 9¹. 10 ff. 11¹. 18⁰. 18¹. 20². 20⁵. 21³.
 34³. 59⁵. 65³. 67. 76. 79. 80. 83¹. Figs. 7.
 8a. 9. 12. 18. 66. 73a.
Iracundia. 21³.
Ischys. 24⁰.
Isidorus Hispalensis. 15³. 36³. 36⁴. 55². 76⁴.
Ivo of Chartres. 79¹. 79³. 79⁷.
Jacob. 49⁰.
Jael. 16. 57. Fig. 15.
Jerusalem, the heavenly. 57².
Jesse, Tree of. 37. 41. 53⁰. 61³. 66. 68².
Jesus Sirach. 34⁰.
Jezebel. 57². Fig. 54.
Job. 2. 15. 15³. 37. 38. 57. 76⁴. 77⁵. Figs. 14. 39.
John the Baptist, St. 77⁵.
John the Evangelist, St. 33². 39. 61⁵. Fig. 40.
John of Gaza. 29⁰.
John Klimakos. 22.
John II Komnenos. 30. Fig. 31.
Joseph. 12. 57². Figs. 10. 55.
Joshua. 5⁴.
Judgement, the last. 17. 53⁰. 59. 59⁴. 60². 70.
 75. 76. Figs. 18. 58.
Judicium. 49⁰.
Judith. 16. 57. Fig. 15.
Julianus Pomerius. 55. 55⁵.
Jus. 36. 36⁴. Fig. 38.
Justitia. 8¹. 10. 11¹. 15³. 30. 30². 31¹. 31³ ff.
 33. 34³. 35. 36. 36³. 37². 40. 41. 41¹ ff. 43³.
 45². 46². 47⁶. 48. 48⁰. 49⁰ ff. 51⁶. 52⁰ ff. 55.
 56. 61². 63². 64³. 65⁰. 72³. 80. 80¹. 81.
 Figs. 8b. 32 ff. 36 ff. 44. 45. 49. 53. 67 ff.;
 see also Virtues, the cardinal.
Juventus. 52¹.
Katalalia. 23².
Kenodoxia. 23¹. 24⁰. 59⁵. Fig. 24.
Koros. 23¹. Fig. 24.
Labor. 3. 6.
Ladder of Virtue. 22 ff. 43. 73. 73². Figs. 23 ff. 48.
Laetitia. 9. 83¹. Fig. 7.
Lambertus, Prebendary of St. Omer. 65. 66. 68.
Lambertus, Abbot. 40⁴.

Largesce. 20².
Largitas. 8¹. 9. 9¹. 11¹. 17². 18⁰. 20⁵. 21³. 37².
 43². 46². 47. 47⁶. 77. 82². 83¹. Figs. 7. 18. 21.
Laurent of Orleans. 84.
Lazarus. 18. 58. Fig. 18.
Leda. 28³.
Lex. 36. 36⁴. Fig. 38.
Liberalitas. 28².
Liber floridus, see Lambertus, Prebendary.
Libertas. 78¹.
Libido. 2. 6. 8¹. 18⁰. 18¹. 20⁵. 21³. Figs. 7. 18.
Longaevitas. 78¹.
Longanimitas 57². 65. 65². Figs. 55. 64.
Lorsch Chronicle. 36³.
Louis, Prince. 61⁴.
Ludus de Antichristo 30².
Luxuria. 2. 3. 5. 6. 8¹. 10. 11. 13¹. 18⁰. 19². 20².
 20⁵. 21³. 58. 58². 58³. 59¹. 59³. 61. 65³.
 67. 76. 76³. 80. 82². 83¹. Figs. 7. 8a. 21.
 66. 72a. 76.
Magnanimitas. 46.
Majestas Domini. 29. 31. 50¹. 51⁸.
Malignitas. 76. 79. 80. Fig. 73a.
Mansuetudo. 19³. 21³. 47⁶. 57². 65. 65². 75. 76¹.
 Figs. 55. 64. 73a.
Marcus Aurelius. 6. Fig. 2.
Mark, St. 29⁰.
Martin, St. 40⁴.
Matthew Paris. 63⁰.
Megalopsychia. 29. Fig. 29.
Mendacitas. 8¹.
Mens Humilis, see Humilitas.
Mercy, deeds of. 38. 60. 60². 60³. 72³. Fig. 39;
 see also Misericordia.
Metus. 3.
Milo of St. Amand. 40.
Miser, the. 58. 58³. 59. 59³. 76. 79. 80. 83¹.
 Figs. 57. 58. 72b. 76.
Misericordia. 13¹. 15³. 20⁵. 21³. 30². 35. 38 ff.
 39¹. 40 ff. 43. 46². 47⁶. 49⁰. 53⁰. 60. 60². 60⁴.
 61. Figs. 36. 44 ff.; see also Mercy, deeds of.
Mithras. 28. 29.
Mnesikakia. 23².
Moderatio. 64³.
Modestia. 20⁵. 45². 51⁵. 53⁰. 65. 65⁰. 65². Fig. 64.
Monarchy, moral significance of. 15³. 28. 28².
 30 ff. 36. 42⁰.
Monastic life, virtues and vices of. 22 ff. 35. 36.
 70 ff. 76. 79. 80.
Months. 17. 52¹. 77. Fig. 18.
Mordecai. 57². Fig. 55.
Moses. 12. 15. 57. 57². 61⁵. 64⁰. Figs. 14. 55.
Mount Athos, Handbook of Painting 22².
Munditia. 15. 57. 62³. Fig. 14.
Muses. 28. 29⁰. Fig. 27.
Nativity. 41. 41⁵. 46². 64⁰.

Negligentia. 71.
Nicholas of Verdun 46. 47.
Nikephoros Botaniates. 30.
Nimrod. 76⁴.
Oboedientia. 15. 15³. 37 ff. 37². 44. 46². 47⁶.
 53⁰. 57. 65⁰. 68⁰. 75. 76¹. 76⁴. Figs. 14. 39.
 41. 48. 73b.
Odium. 18¹. 21³.
Operatio. 2. 3. 6. 45². Fig. 6.
Opulentia. 57². Fig. 54.
Otto III, Emperor. 15³.
Oxythymia. 23¹. Fig. 24.
Paradise, the mystical. 69. 70. Figs. 68. 69.
 rivers of. 45². 49. 49¹. 51¹. 52¹. 53⁰. 69. 70.
 70³. Figs. 68. 69.
Parastasis. 24⁰.
Parcitas. 47⁶.
Parsimonia. 13¹. 21³.
Patientia. 2. 8¹. 9¹. 11¹. 12. 15. 15³. 18⁰. 20².
 20⁵. 21³. 29. 29¹. 34³. 37. 38. 40⁴. 43. 45².
 46. 46². 47. 48⁰. 53⁰. 54⁰. 57. 65. 65⁰. 65².
 68⁰. 75. 76¹. 76⁴. 77⁵. 83¹. Figs. 5. 7. 12.
 14. 18. 39. 46. 64. 73a.
Paul, St. 38. 61⁵. 76².
Paulus Diaconus. 32².
Paupertas. 19³. 21². 37². 72. Fig. 20.
Pax. 3. 18¹. 40. 41. 41¹ ff. 43². 44². 45². 46². 47.
 48⁰. 65. 65⁰. 65². Figs. 44. 45. 64.
Perfectio. 48¹. 68. 68².
Perpetua, St. 2.
Perseverantia. 72³. 75. 76¹. 81. Fig. 73 b.
Petrus Ansolinus de Ebulo. 30².
Petrus Cellensis. 18¹.
Petrus Damiani. 42⁰.
Phaeton. 6.
Pharaoh. 12. 57². Figs. 10. 54.
Philargyria. 23². 59⁵. 61.
Phronesis. 29. Fig. 29.
Physiologus. 60.
Pietas. 20⁵. 28². 35 ff. 36³. 42⁰. 43². 46². 49⁰.
 50¹. 61⁵. 68². Figs. 38. 52; see also Gifts
 of the Holy Ghost.
Pistis. 22. 23. 24⁰. 29. 29¹.
Plants:
 Amomum. 65².
 Balsam. 65².
 Box. 65².
 Cedar. 65². 68².
 Cypress. 65². 68².
 Fig-tree. 66.
 Fir. 65².
 Olive. 65². 68².
 Palm-tree. 68. 68².
 Pine. 65².
 Plane. 65². 68².
 Rose. 65². 68².

Terebinth. 65². 68².
Vine. 68².
Poenitentia. 15. 15³. 37². Fig. 14.
Poenitentiale Valicellanum. 78².
Polylogia. 23².
Poneria. 24⁰.
Potentia. 57². Fig. 54.
Potestas. 78¹.
Praotes. 23². 24⁰.
Prophetia. 29⁰.
Prophets. 26. 31. 32. 39. 46. 49. Figs. 33. 40.
Proseuche. 23². 24⁰.
Providentia. 15³. 28². 38. Fig. 39.
Prudentia. 10. 11¹. 29¹. 30. 31¹. 31³. 32¹. 33.
 33¹ff. 34³. 35 ff. 45². 46. 46². 47⁶. 48⁰.
 49⁰ff. 52⁰ff. 55. 56. 57². 60. 65⁰. 72³. 75.
 76¹. 77⁵. 80¹. 81. 82². Figs. 8b. 32 ff. 36 ff.
 49. 55. 67 ff. 72a. 76; see also Virtues,
 the cardinal.
Prudentius, *Psychomachia*: 1 ff. 15. 18⁰. 19³.
 21³. 58.
 archetype. 4 ff.
 classical models of. 5. 6.
 illustrations of. 3 ff. 13¹. 15. 19. 22. 25. 26.
 73. 76¹. 81. Figs. 1. 3. 5. 6.
Pseudeulabeia. 23¹. Fig. 24.
Pudicitia. 2. 2¹. 20⁵. 21³. 42⁰. 48⁰. Fig. 7.
Pulchritudo. 78¹.
Puritas mentis. 62³. 72.
Rabanus Maurus. 30⁴. 63¹.
Raganaldus, Abbot. 33.
Rapacitas. 61.
Rapina. 11¹. 12. Fig. 9.
Religio. 49⁰. 50¹.
Requests of the Lord's Prayer. 63². 68². 72³.
Resurrection. 64⁰.
Rixa. 65³.
Romualdus, Abbot. 35. Fig. 36.
Rota falsae religionis. 70 ff. Fig. 70.
Rota verae religionis. 70 ff. Fig. 71.
Rupert of Deutz. 41². 47².
Salvatio animarum. 43².
Samson. 56.
Samuel. 61⁵.
Sanctitas. 43³.
Sanitas. 78¹.
Sapientia. 3. 9. 32². 33. 35 ff. 43³. 44². 46².
 47⁶. 48¹. 50¹. 52¹. 61⁵. 63². 68². 72³. 76¹.
 83¹. Figs. 36. 38. 51; see also Gifts of the
 Holy Ghost.
Satisfactio. 62³.
Saul. 57². Fig. 54.
Scelus. 3.
Scientia. 37. 50¹. 61⁵. 68². 78¹. Fig. 52; see also
 Gifts of the Holy Ghost.
Seasons. 28. 28³. 29. 31. 52¹. 53¹. Fig. 28.

Securitas. 78¹.
Sedes Sapientiae. 42⁰. 53⁰.
Senses, the five. 73².
Sheba, Queen of. 82¹.
Simplicitas. 46.
Simulatio. 65³.
Sion, daughter of. 57. 57². Fig. 55.
Siope. 23².
Sisera. 16. Fig. 15.
Sobrietas. 2. 9. 9¹. 11¹. 18⁰. 19³. 21³. 34². 37². 46².
 47⁶. 57². 65. 65². 72. 83¹. Figs. 7. 55. 64.
Socrates. 30³.
Solitudo. 53⁰.
Solomon. 29⁰. 33. 42⁰. 61⁵. 82¹.
Sophia. 29⁰.
Sophrosyne. 23².
Sorditas. 61.
Speculum Virginum, see Conrad of Hirsau.
Spes. 2. 7. 9. 10. 11¹. 20². 28². 34³. 38. 44. 45².
 46². 48. 48⁰. 48². 49⁰. 50¹. 52¹ff. 54 ff. 64³.
 65. 65⁰. 67. 68⁰. 75. 76¹. 80¹. 81. 82².
 Figs. 8b. 35. 39. 48. 53. 64. 67. 72b. 76;
 see also Virtues, the theological.
Stultitia. 76. 79. 80¹. 82². 83¹. Figs. 72a. 76.
Superbia. 2. 4. 5. 8¹. 9¹. 10 ff. 10⁴. 16. 17. 18⁰.
 19². 20⁵. 21³. 34³. 58⁰. 59⁵. 63. 64⁰. 66.
 67. 68⁰. 71. 76. 76². 79. 80¹. 82². 83¹.
 Figs. 7. 8a. 9. 15. 16. 18. 21. 66. 72a. 76.
Symbolism:
 architectural. 72³.
 colour. 8¹.
 cross. 38. 73.
 hierarchical. 54. 55.
 numerical. 31. 37. 49. 63². 68². 72³.
Synagogue. 39. 65. Fig. 41.
Synetheia ponera. 23¹. Fig. 24.
Tapeinophrosyne. 23². 24⁰.
Temperantia. 8¹. 10. 20⁵. 30. 31¹. 31³ff. 34³.
 37. 45². 46². 47⁶. 48⁰. 49⁰ff. 51⁶. 52⁰. 53⁰.
 54⁰. 55. 56. 63². 68². 72³. 80¹. 81. Figs. 8b.
 32 ff. 37. 39. 49. 67 ff.; see also Virtues,
 the cardinal.
Tenacitas. 61.
Tertullian. 1.
Theodulf of Orleans. 64³.
Theophilus. 50.
Thiofridus of Echternach. 47.
Thymos. 23¹. Fig. 24.
Timor Domini. 12. 37. 42. 44. 46². Fig. 48;
 see also Gifts of the Holy Ghost.
Titus. 28².
Tower:
 of the Church. 5³. 43. 43³.
 of Philosophy. 72³.
 of the preparing divine will. 42.
 of Wisdom. 72³.

Trees of virtues and vices. 63 ff. 72. 72³. 80¹.
 82¹. Figs. 64 ff.
Tristitia. 9¹. 10 ff. 13¹. 59⁵. 67. Figs. 8 a. 9. 66.
Uota, Abbess. 35.
Usura. 54⁰.
Velocitas. 78¹.
Ventris Ingluvies. 10. 11. 11¹. 13¹. 67. Figs. 8 a.
 66; see also Gula.
Venus. 28³. 61.
Verecundia. 43. 53⁰. Figs. 46. 47.
Veritas. 19². 21³. 40. 41. 41¹ ff. 43². 46. 46².
 48. 49⁰. 51⁵. Figs. 44. 45. 53.
Vespasian. 28².
Veterum Cultura Deorum. 2; see also Idolatria.
Victor, St. 17².
Victoria. 43. Figs. 46. 47.
Villard de Honnecourt. 76².
Violentia. 11¹. 19³. 61.
Virgil. 28. 29⁰. Fig. 27.
Virgin Mary. 29. 32. 34². 35. 39. 40⁴. 41. 42⁰.
 48⁰. 50¹. 53⁰. Fig. 40.
Virginitas. 34². 50¹. 53⁰.
Virgins, the Wise and the Foolish. 18. 58. 64¹.
 75. Fig. 18.

Virtues, the cardinal. 10. 30 ff. 30² ff. 34³. 35. 35³.
 42⁰. 45. 45¹. 45². 46². 47. 49. 50. 50¹. 51¹ ff.
 51⁷ ff. 52. 54⁰. 55. 57². 61⁴. 64³. 66. 67. 68⁰. 69.
 70. 70³. 72³. Figs. 8 b. 32 ff. 37. 49. 55. 67 ff;
 see also Fortitudo, Justitia, Prudentia,
 Temperantia.
Virtues, the theological. 10. 22. 24⁰. 30². 34.
 38. 47. 48⁰. 51⁷. 51⁸. 53⁰. 54⁰. 56. 65 ff.
 75. 80. Figs. 35. 39. 53. 67. 72 b; see also
 Caritas, Fides, Spes.
Virtus. 46².
Vis. 3.
Visitation. 41. 41⁴. Fig. 45.
Vita S. Genovefae. 46.
Voluntas. 72.
Voluptas. 57². 61¹. 78¹. Fig. 54.
Walafrid Strabo. 18¹.
Wanton, the. 58. 59. 59³. 59⁵. 76. 80. 82¹.
 Figs. 56. 58. 72 a. 76.
William de Brailes. 34³.
Wind-gods. 28. 28³. 70.
Xeniteia. 23².
Xenophon. 30³.
Zodiac, signs of the. 17. 52¹. Fig. 18.

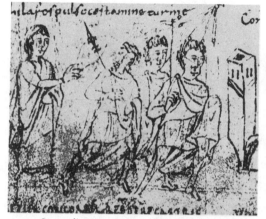

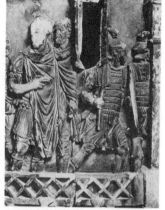

1. Concordia commanding. **Psychomachia** MS., late 10th century. Paris, Bibliothèque Nationale.

2. Marcus Aurelius commanding. Column of Marcus Aurelius, Rome.

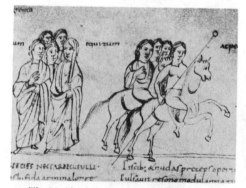

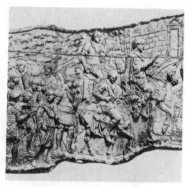

3. The March of the Virtues. Psychomachia MS., late 10th century. Paris, Bibliothèque Nationale.

4. The March of the Romans. Column of Trajan, Rome.

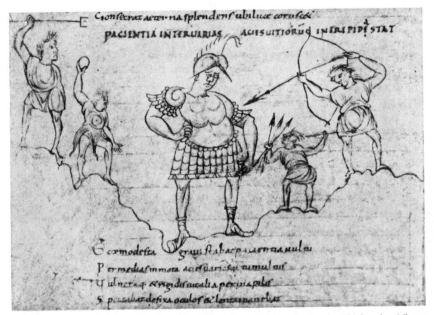

5. Ira in the midst of the Vices. Psychomachia MS., 9th century. Leyden, University Library.

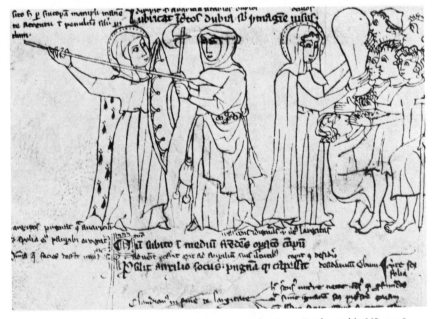

6. Operatio (Largitas) and Avaritia—Operatio and the Poor. Psychomachia MS., 1298.
Paris, Bibliothèque Nationale.

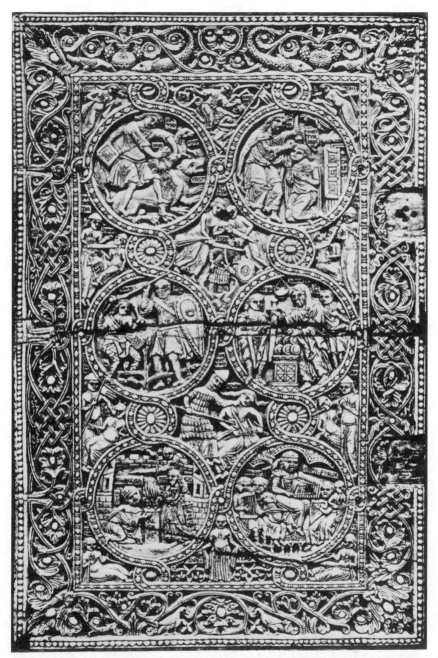

7. Psychomachy. Book-Cover of the Melisenda Psalter, c. 1131—44. London, British Museum.

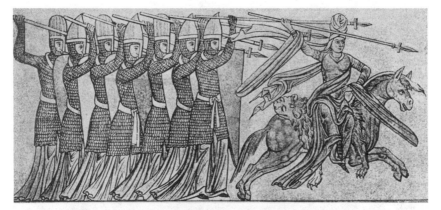

8a. Psychomachy. Hortus Deliciarum, late 12th century.

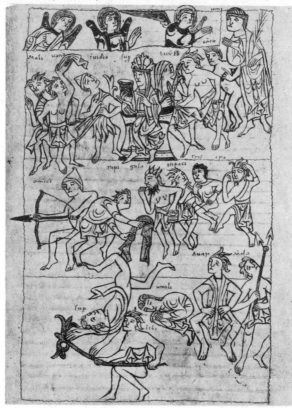

9. The Band of Vices. Moissac MS., late 11th century. Paris, Bibliothèque Nationale.

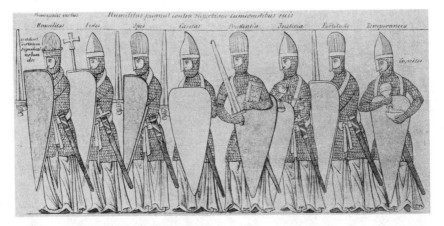

8b. Psychomachy. Hortus Deliciarum, late 12th century.

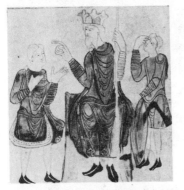

10. Joseph before Pharaoh. English MS.,
11th century. London, British Museum.

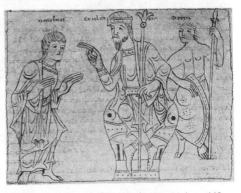

11. Humilitas before Exultatio. Moissac MS.,
late 11th century. Paris, Bibliothèque Nationale.

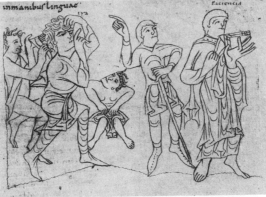

12. Ira and Patientia. Moissac MS., late 11th century.
Paris, Bibliothèque Nationale.

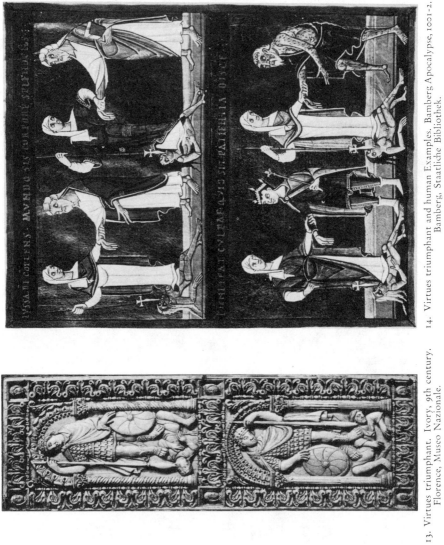

13. Virtues triumphant. Ivory, 9th century. Florence, Museo Nazionale.

14. Virtues triumphant and human Examples. Bamberg Apocalypse, 1001–2. Bamberg, Staatliche Bibliothek.

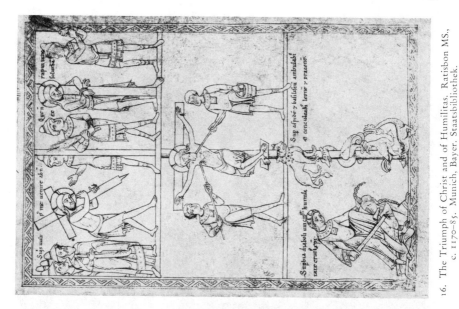

16. The Triumph of Christ and of Humilitas. Ratisbon MS.,
c. 1170–85. Munich, Bayer. Staatsbibliothek.

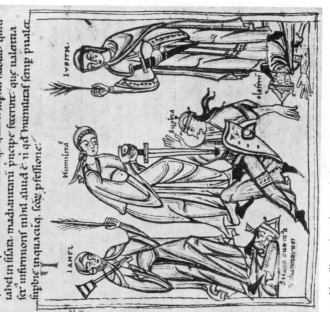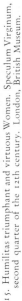

15. Humilitas triumphant and virtuous Women. Speculum Virginum,
second quarter of the 12th century. London, British Museum.

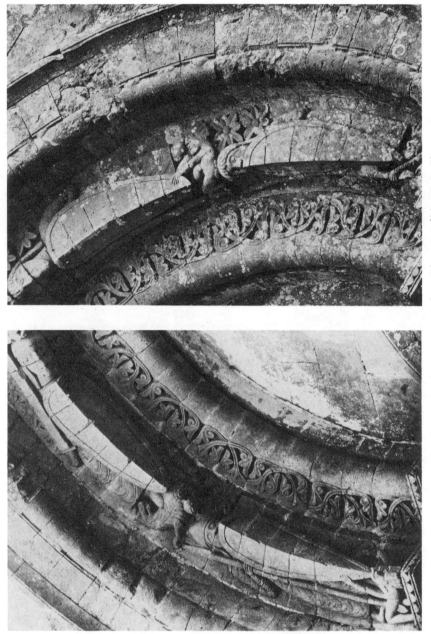

17a and b. Virtues triumphant, c. 1130. Aulnay (Charente-Inférieure), St. Pierre.

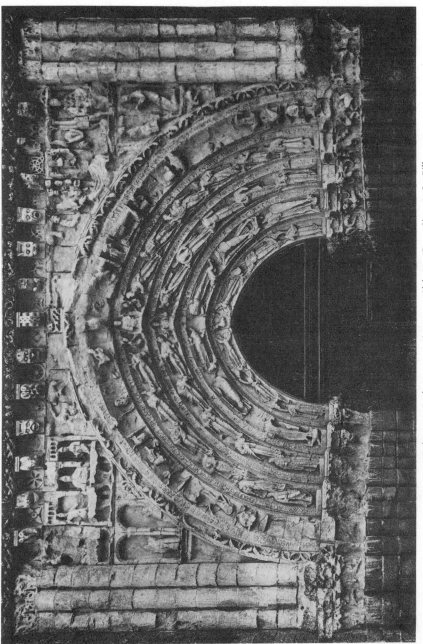

18. Last Judgment Cycle, c. 1135. Argenton-Château (Deux-Sèvres), St. Gilles.

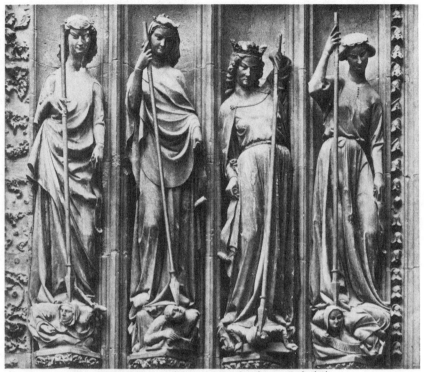

19. Virtues triumphant, c. 1280. Strasbourg Cathedral.

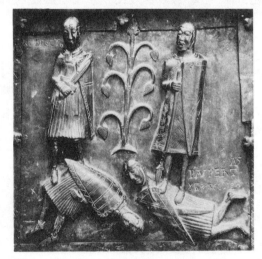

20. Virtues triumphant. Church-Door, 1152—54. Novgorod.

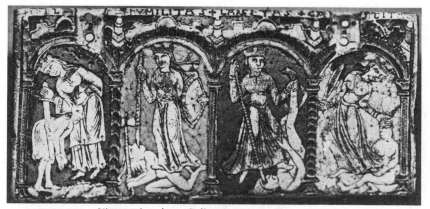

21. Virtues triumphant. Reliquary, c. 1200. Troyes Cathedral.

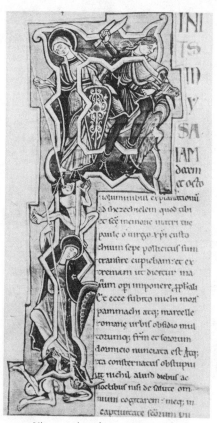

22. Virtues triumphant. French MS., late
12th century. Paris, Bibliothèque Nationale.

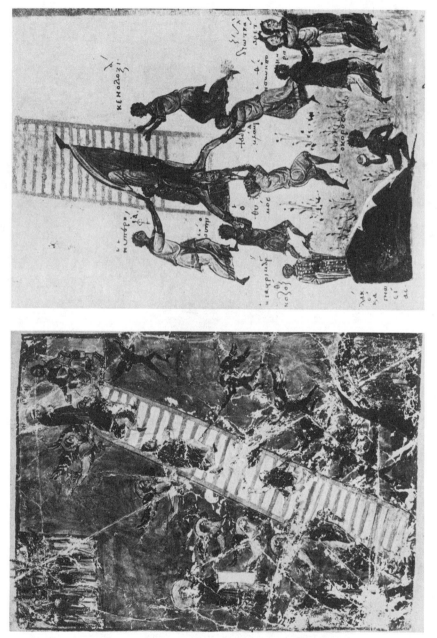

23, 24. The Ladder of Virtue. Klimax MS., 11th century. Rome, Biblioteca Vaticana.

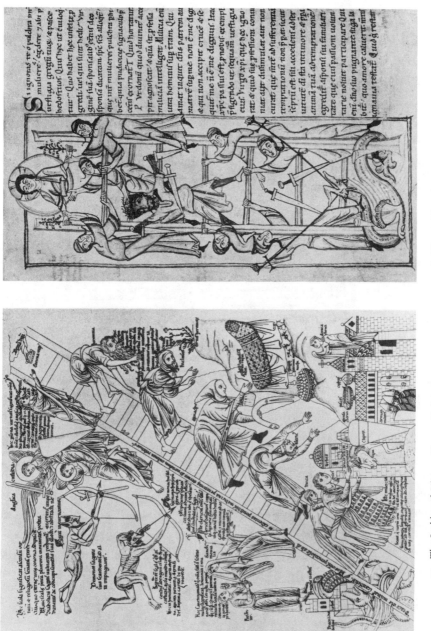

26. The Ladder of Virtue. Speculum Virginum, second quarter of the 12th century. London, British Museum.

25. The Ladder of Virtue. Hortus Deliciarum, late 12th century.

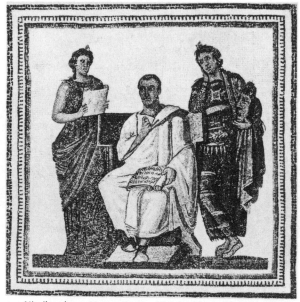

27. Virgil and two Muses. Roman Mosaic. Tunis, Museo del Bardo.

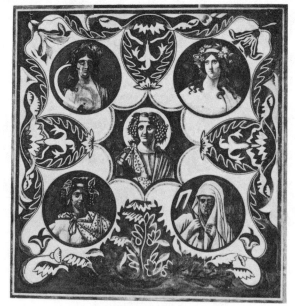

28. Bacchus and the Seasons. Roman Mosaic (from an old drawing).
Algiers, Museum.

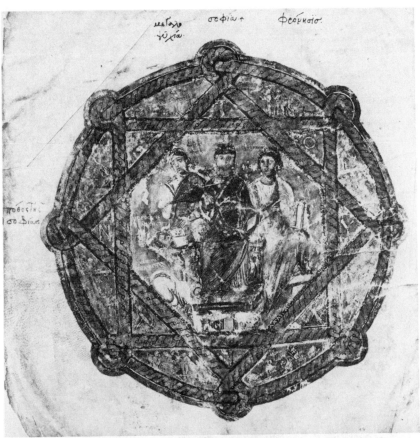

29. Anicia Juliana and two Virtues. Vienna Dioscurides, c. 500–510.

30. Hope. Fresco at Bawît, 5th century.

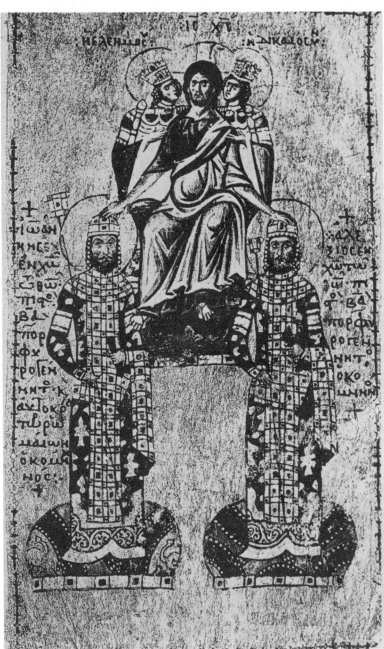

31. Christ and two Virtues. Gospels of John II Komnenos, c. 1118–43.
Rome, Biblioteca Vaticana.

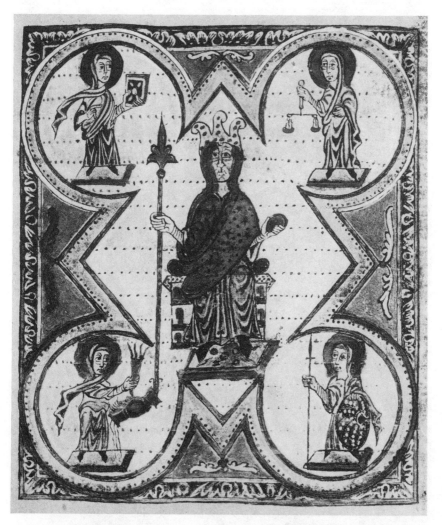

32. Unknown Ruler and the cardinal Virtues. Cambrai Gospels, second half
of the 9th century. Cambrai, Bibliothèque Municipale.

33. Archbishop Frederick and the cardinal Virtues.
Rhenish Lectionary, c. 1130. Cologne Cathedral.

35. Initial-Page with Virtues. Gospels of Hitda of Meschede, c. 1030. Darmstadt, Landesbibliothek.

34. Liturgical Scene with the cardinal Virtues. Rhenish Sacramentary, early 11th century. Paris, Bibliothèque Nationale.

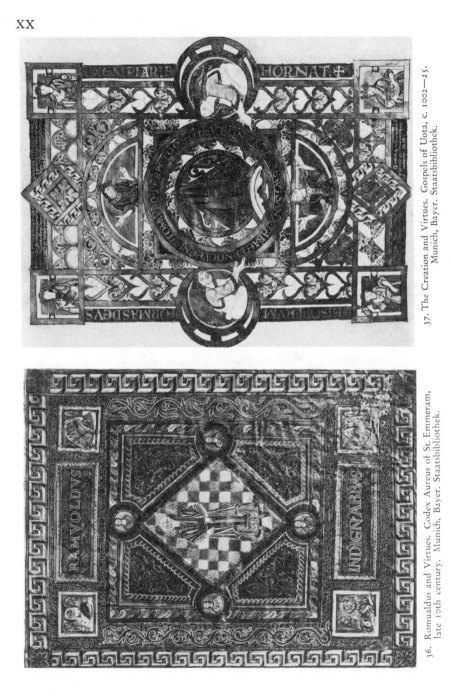

37. The Creation and Virtues. Gospels of Uota, c. 1002—25. Munich, Bayer. Staatsbibliothek.

36. Romualdus and Virtues. Codex Aureus of St. Emmeram, late 10th century. Munich, Bayer. Staatsbibliothek.

38. Henry II and Virtues. Gospels, c. 1014–24. Rome, Biblioteca Vaticana.

39. Pictorial Exegesis of the Book of Job. Floreffe Bible, c. 1155. London, British Museum.

40. Virtue crucifying Christ. Rhenish MS., c. 1250–60.
Cologne, Stadtarchiv.

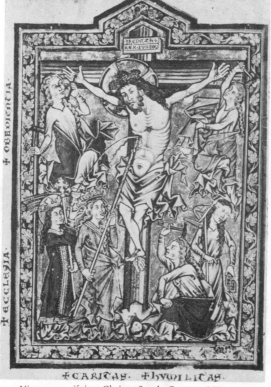

41. Virtues crucifying Christ. South German MS., c. 1260.
Besançon, Bibliothèque Municipale.

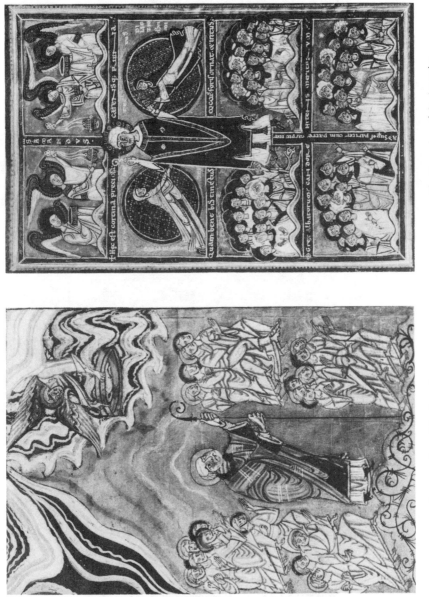

43. The Ascension of St. Amandus.
St. Amand MS., c. 1160. Valenciennes,
Bibliothèque Municipale.

42. The Ascension of St. Amandus.
St. Amand MS., late 11th century.
Valenciennes, Bibliothèque Municipale.

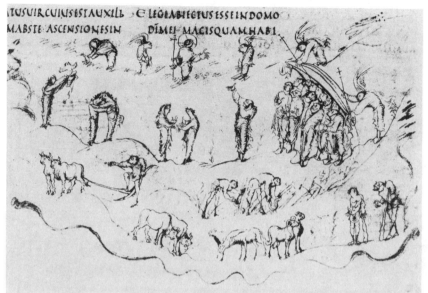

44. Psalm LXXXIV. Utrecht Psalter, 9th century.

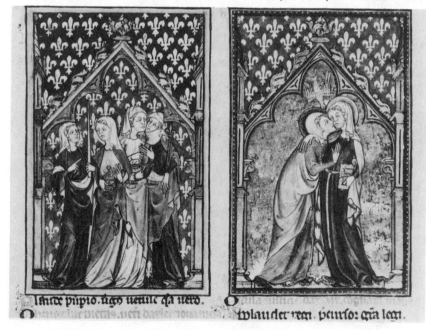

45. Psalm LXXXIV and the Visitation. Peterborough Psalter, mid-13th century.
Brussels, Bibliothèque Royale.

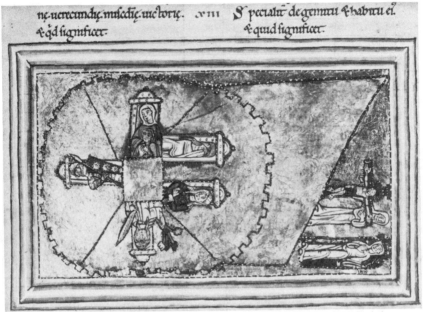

46. Virtues in the Tower. Liber Scivias, c. 1175. Wiesbaden, Landesbibliothek.

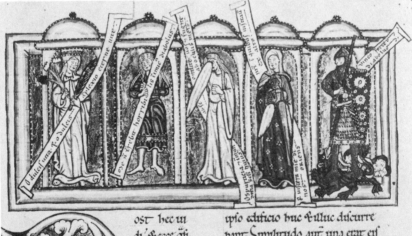

47. Virtues in the Tower. Liber Scivias, c. 1175. Wiesbaden, Landesbibliothek.

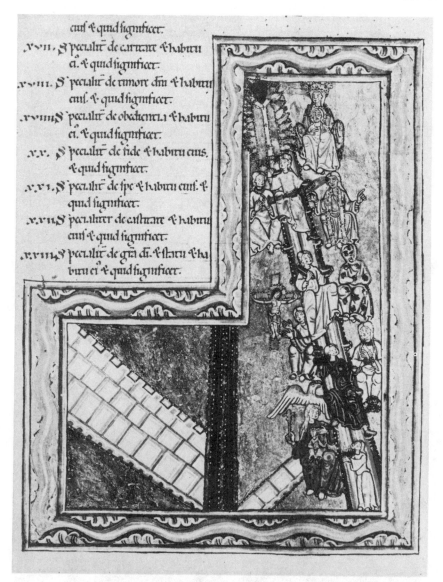

48. Virtues on the Ladder. Liber Scivias, c. 1175. Wiesbaden, Landesbibliothek.

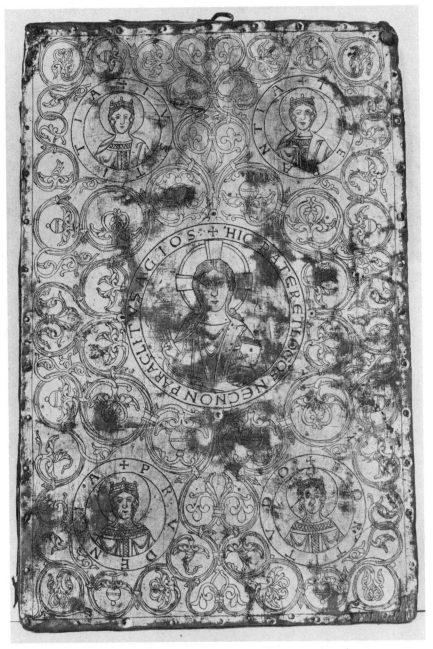

49. Portable Altar with the cardinal Virtues. South German, early 11th century.
Munich, Bayer. Nationalmuseum.

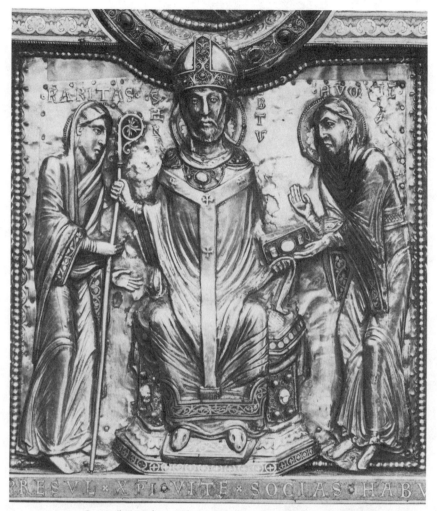

50. St. Heribert and two Virtues. Heribert Shrine, c. 1165–75. Deutz.

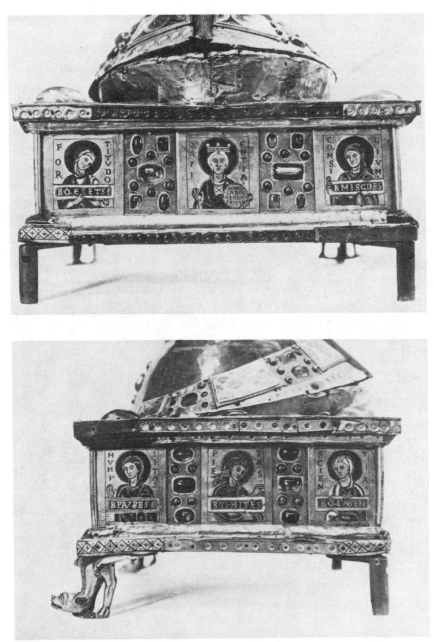

51, 52. The Gifts of the Holy Ghost on the Reliquary of Pope Alexander, c. 1145.
Brussels, Musées Royaux du Cinquantenaire.

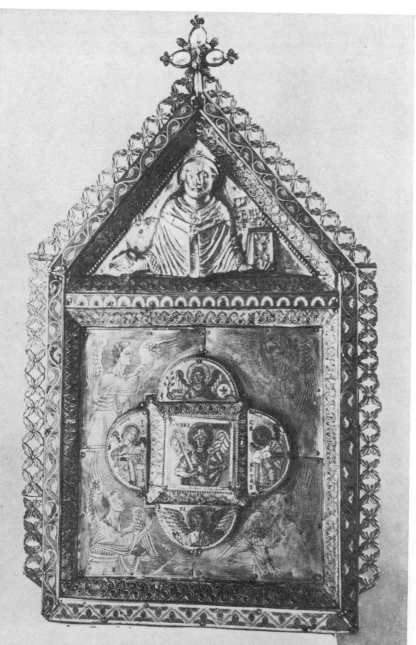

53. Virtues on the Reliquary of St. Gondulf, c. 1160–70.
Brussels, Musées Royaux du Cinquantenaire.

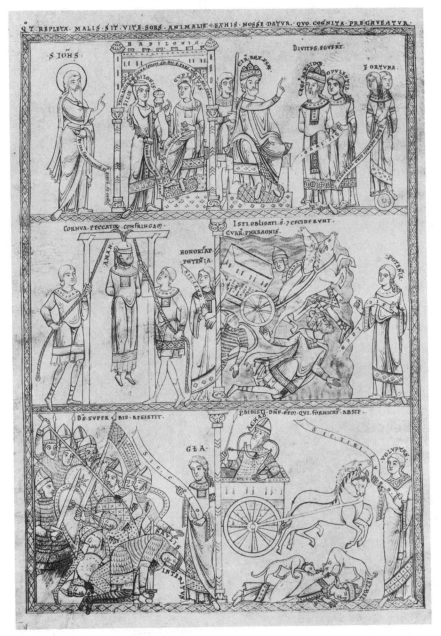

54. Vices and human Examples. Ratisbon MS., 1165. Munich, Bayer. Staatsbibliothek.

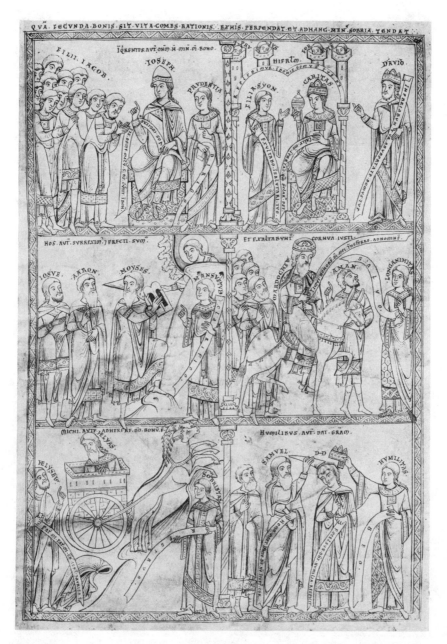

55. Virtues and human Examples. Ratisbon MS., 1165. Munich, Bayer. Staatsbibliothek.

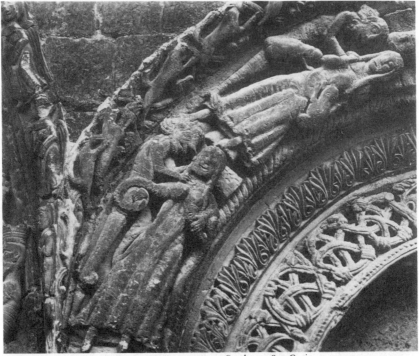

56. The Wanton, c. 1120. Bordeaux, Ste. Croix.

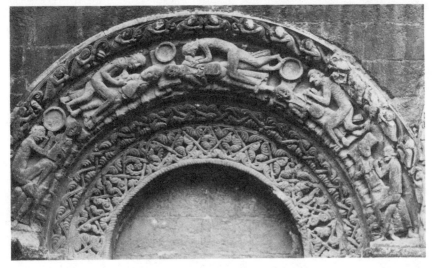

57. The Miser, c. 1120. Bordeaux, Ste. Croix.

59. The Blessed and the Damned.
Prayer-Book of St. Hildegard, c. 1170.
Munich, Bayer. Staatsbibliothek.

58. The Sinners in the Last Judgment.
French Psalter, late 11th century.
Amiens, Bibliothèque Municipale.

61. Moral Exposition of two Monsters, German MS., 12th century. Munich, Bayer. Staatsbibliothek.

60. The Chariot of Avaritia. Hortus Deliciarum, late 12th century.

63. Moral Exposition of the Cherubim. French MS., second half of the 12th century. Frankfort, Stadtbibliothek.

62. Moral Exposition of the Dove. French MS., second half of the 12th century. Frankfort, Stadtbibliothek.

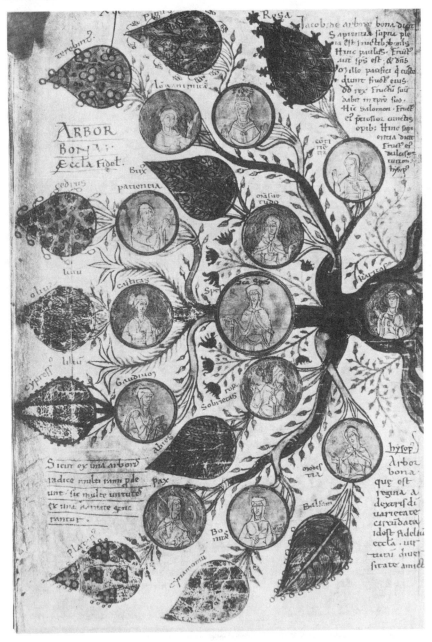

64. The "Arbor bona". Liber floridus, c. 1120. Ghent, Bibliothèque
de l'Université et de la Ville.

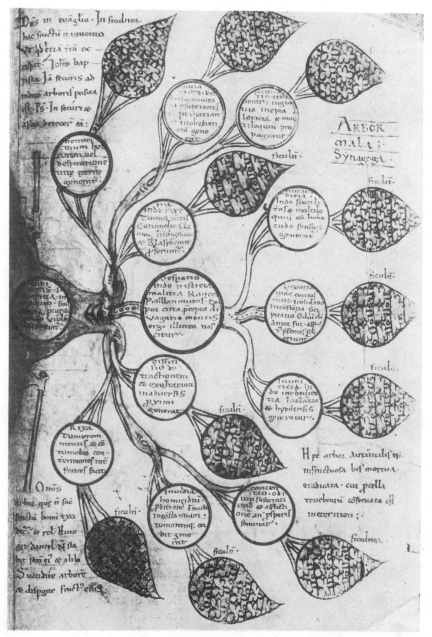

65. The "Arbor mala". Liber floridus, c. 1120. Ghent, Bibliothèque
de l'Université et de la Ville.

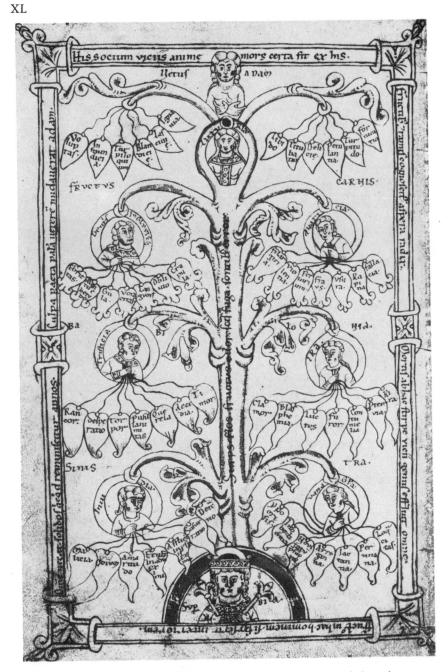

66. The Tree of Vices. De fructibus carnis et spiritus, second quarter of the 12th century.
Salzburg, Studienbibliothek.

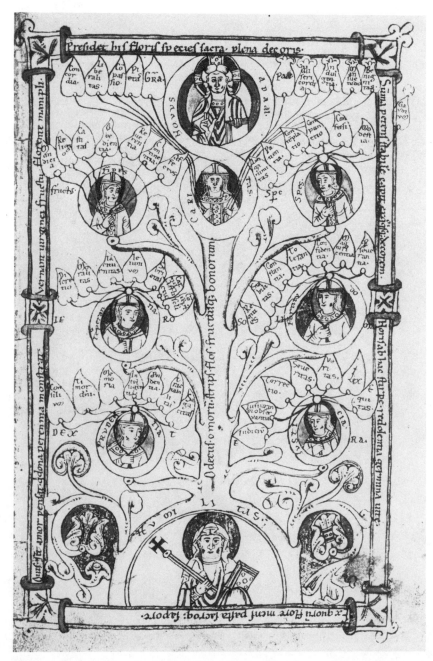

67. The Tree of Virtues. De fructibus carnis et spiritus, second quarter of the 12th century.
Salzburg, Studienbibliothek.

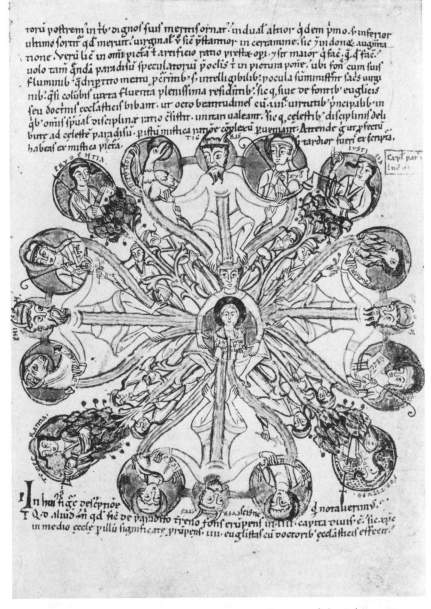

68. The Mystical Paradise. Speculum Virginum, second quarter of the 12th century.
London, British Museum.

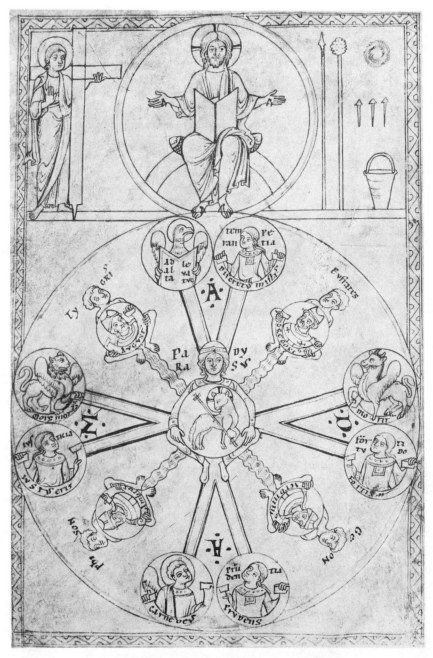

69. The Mystical Paradise, Ratisbon MS., c. 1170—85.
Munich, Bayer. Staatsbibliothek.

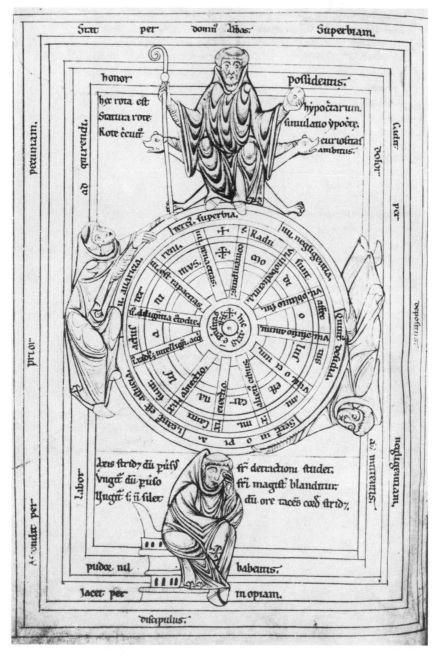

70. The "Rota falsae religionis". Austrian MS., late 12th century.
Heiligenkreuz, Stiftsbibliothek.

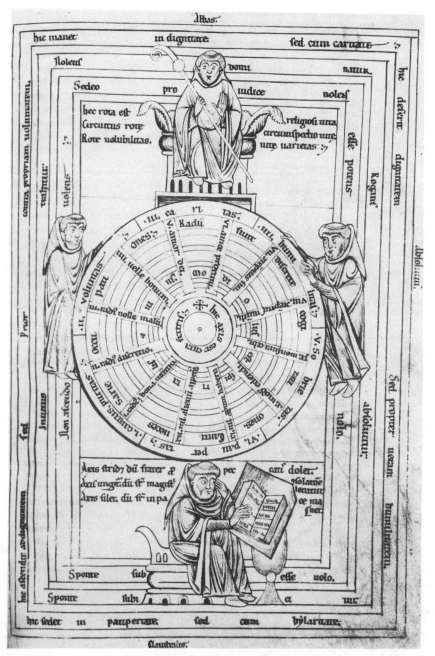

71. The "Rota verae religionis". Austrian MS., late 12th century.
Heiligenkreuz, Stiftsbibliothek.

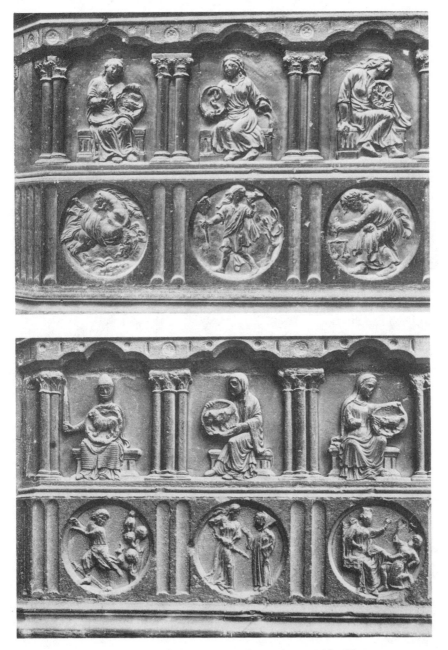

73a. The Virtue and Vice Cycle of Notre-Dame. Right Side I.